Art
Activism

THE REVOLUTIONARY ART, POETRY & REFLECTIONS OF AARON MAYBIN.

BY AARON M. MAYBIN

2017

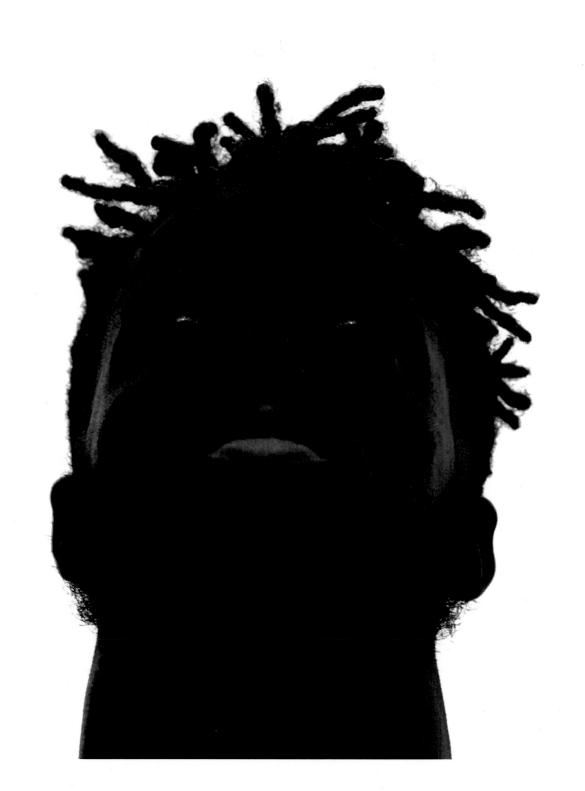

See Me

When I walk into a room
a vision appears in your mind
painting me. Loudly & vividly
in the colors of my history
which, from your point of view
often resembles the hue
of criminality.
It's no mystery, why
you mistreat me.
You see me, only as you wish to see
judging me. so unjustly.
But the vision that you see
looks so much differently
to me

The skin you see
I own it. Proudly
Wearing the palette of my past
written in chocolate, honey, & ebony
Tones
of royalty in the first degree
shimmering with the Afro-Sheen
of Black Excellence personified
In the humanity of who I am
what I and mine are still
Yet to be.

Proud indeed. I am
and always shall I be.
Presenting first my words, to you
painted prophecies, still to see.
The painfully honest truth
buried beneath your false reality.
The roots of my prose go deep,
far beyond the existential moment
you truly believe you can see.
But the depth of this ocean will drown you
If you still can't see what lies beneath.

So before you step
into the rhythm
of my beating Drum,
before you dance or rift
to the sweet dark tones
of my Black Boy Blues,
take a moment or two
to decipher
the hieroglyphic scripts
etched into your monolithic walls
as I break each one
down, like a sinking ship
giving my precious truth to you.

I don't step softly,
I don't speak lightly,
I don't shrink so that you might seem taller,
I don't simplify my mind so you might seem smarter.
I am. Me. Unapologetically.

The songs I sing
Echo loudly & deeply in
The roots of royal Ashanti blood,
The incantations of divine Shaman healers,
The strength of hooded Moorish horsemen,
The seeds of Zulu Kings
The dreams of Ethiopian Queens
The heart of Street Hustlers,
from Baltimore to ivory shores.
The souls of those
long thought to be
long lost in the dark of our yesterdays.
But yet today,
Reborn, in radiant light. Relit
To illuminate the pathway
To all our proud tomorrows.

Ashé

Library of Congress Cataloging-in-Publication Data.

ISBN-13: 978-0692975039 (Aaron Maybin)

ISBN-10: 0692975039

Printed in the United States of America.

All Art & Photography by Aaron M. Maybin.
Book design by Nikiea Redmond.
Back cover photograph by Kyle Pompey.

Table of Contents

FOREWORD

After forty years of mentoring students and most every kind of artist on varying levels, I no longer have an expectation as to whether or not what I have imparted has actually inspired, motivated or encouraged. I believe we live in distractionary times. Many of the students are now adults and many of those have elected not to pursue art as a career. My past focus was on mentoring grade school students and that has evolved into working with emerging artists who require guidance on the various aspects of being an artist, and subsequently, blending the business of art. I created the African American Youth Art Exhibition in 90's in the city of Baltimore to provide an outlet for African American students who often did not have an opportunity to participate in local art related programs or competitions, due to the City's budget cuts. We worked with over one thousand children throughout the decade of hosting this citywide competition. We awarded first, second

and third place awards and also savings bond awards, certificates, and art supply awards to all participating students. The premise was simple, all students were recognized. The talent within Baltimore city was quite impressive. Aaron would place first in his age category in the African American Youth Art Exhibition, and would later become one of my most successful art mentees to date.

I have observed this shy, soft-spoken young man grow over the years into a seasoned artist. Like so many of the children in Baltimore city, Aaron faced numerous challenges with the loss of his mother at an early age. Ironically, I knew his father, all the way from childhood days, and through this friendship with his father, eventually I met Aaron at my studio. I welcomed him into my studio with open arms, just as I had done for so many other students. A few months into our relationship, noting his obvious talent, I shared

by Larry Poncho Brown

a few techniques that he quickly learned, honed and made his own. My style of mentorship is to tailor techniques or lessons specifically to the development of the individual. Early in his life, Aaron was an introspective child with a high level of emotional maturity indicative of many inner-city students. I introduced him to other regional artists in my circle as well as renowned professional artists like Charles Bibbs who often frequented my studio. He had quiet power about him, with a concentration and focus that was unwavering in the studio. He strived to become an avid reader, and his constant learning was a welcomed transformation.

I saw very little of him during his high school years, as athletics became his highest interest. The same unwavering determination he exhibited with art, he now applied to athletics and other interests. The NFL would soon validate his obvious talents. Maybin was selected as the 11th overall pick in the 2009 NFL draft by the Buffalo Bills as a former All-American defensive end at Penn State University. Aaron went on to play in the NFL for the New York Jets and the Cincinnati Bengals in his 5-year career. Aaron also played professionally for the Toronto Argonauts in the Canadian Football League before making the decision to walk away from the game of football to pursue his career as a professional artist, activist, educator and community organizer. Aaron's athletic success exposed another unexpected gift – the gift of philanthropy. His mentality is to 'pay it forward'. Through his nonprofit Project Mayhem foundation, he works to provide creative opportunities for students at Baltimore city schools where arts programs have been de-emphasized. He truly wants art to serve as a form of therapy for children as they cope with trauma in their daily lives.

Something shifted in him when his NFL career ended. Over the years I have organized several multi-artist retreats in various locations in the United States, Africa and Jamaica. Aaron and I had our last artistic-father-son moment at Jamaican Arts Odyssey at Great Huts in Port Antonio, Jamaica during one of those artist retreats. There we were sitting on a cliff over a pristine beach, joined by 8 other artists while creating experimental art in a makeshift studio hut, spiritually and artistically engaging each other in one common workspace. Reconnecting as men after years of separation, and hearing first-hand the impact of his life transition, and sensing his renewed vigor and vision was equally gratifying. He had come full circle in his career. His art, photography, and writing depict many socially relevant themes and issues, drawn from his own personal experiences as a former pro athlete and growing up as a young Black man in America.

He re-embraced and immersed himself in his art in a way with a fervency as never before and it was unmatched by any other artists that I have mentored. His studio was a constant overflow of creativity. He delved deeper into his work. I think it was an escape for him, but more than that, his purpose intensified as he moved beyond paintings and drawings. It began to illustrate subjects beyond the realm of painting; to tell stories, exploring an implied message that evolved more and more, eventually getting louder, growing stronger, exuding power. He purposed to have a message in each work. Newborns and crown themes began to appear, and through a rebirth, this artist was now using his own visual language to depict kings and queens. A storyline of perseverance began to emerge. The upsurge in police brutally in the United States had a strong impact on Aaron and it would become visually apparent in his work. He executed a visual and intellectual dialogue about the "new lynchings" taking place with young men of color. He began

FOREWORD

modern depictions of heroes of times gone by validating his observations, convictions and making a re-documentation of our history. When visiting his studio, one will experience a visual overload of expression. Maybin's paintings are vibrant depictions of mentorship and inspiration, racial strife and communal love, hope and disappointment which adorn all of the walls around him. Splashes of dry paint spatter the walls and floor. As the scale of his work gets larger, his voice tends to gets louder, and he becomes the polar opposite of that soft spoken child I once knew. His paintings have no more boundaries. The truth in his work speaks directly to the plethora of narratives in his head. Asking big questions with his images, he also answers them with imagery and raw grittiness. His images were sensitive, yet unapologetic and still colorful and inviting, compelling you to trust him. Artists rarely acquire that kind of voice, because so many of them are lured into creating pretty pictures for profit. Aaron's work is a sledgehammer of integrity. He can truly paint whatever the hell he wants to paint, and that's a rare, powerful thing. To view his work is to see the world through the eyes of a man who is proud of his people. If you are not used to blatant, unadulterated truth in paintings, then I suppose Aaron's work would not receive a warm welcome. He continues to grow as an artist and person, and has now embarked on yet another milestone, fatherhood, has introduced him to a new reality. Image creators like painters and photographers have an ability to alter the narratives, perceptions of our people, and our history in general. To view his work is to question one's existence. He continues to advocate for public policy to see Art programs restored in the schools and more economic opportunities to be provided for the underprivileged people of Baltimore. Aaron has all the tools for success, it is my hope that he will continue to educate us all through his uncanny revolutionary lens

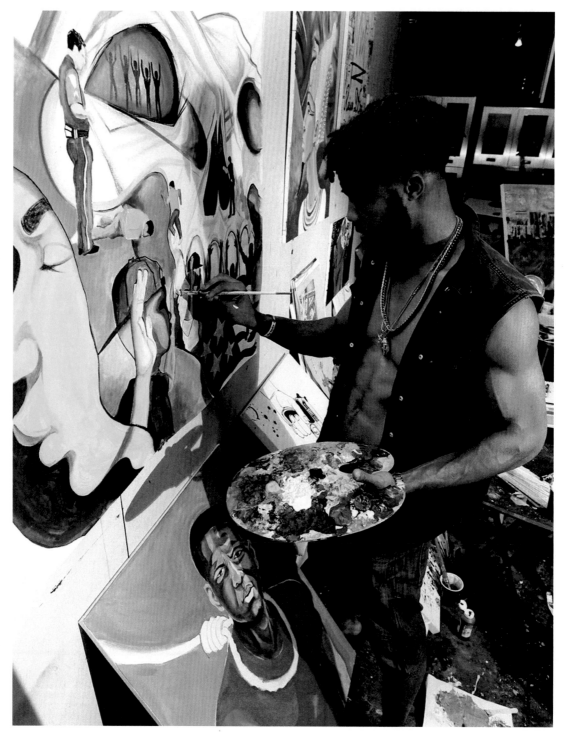

Artist Statement

From the earliest steps of our American journey, Black people have been fighting. We've fought for our freedom from enslavement in the bloodiest war America's ever seen, then had to fight again for our civil rights, taken away from us even after the Constitution was re-written, we were fighting for our God-given humanity in the era of segregation. And still we fight for our very lives, even today, as blue-coated badge-toting cops choose to deny us that same humanity on the streets of cities we've helped to build.

We have fought an endless fight against the bitter sting of racism while our sons, daughters, mothers and fathers battled racist oppression & tyranny overseas and returned to endure the bitter sting of oppression and disenfranchisement at home. And through it all, we overcame the brutalization of hatred and bigotry, time after time. We have fought wars militarily and in civil society to back up our claim to equality in citizenship, to secure for ourselves the basic rights promised all Americans in the U.S. Constitution: the freedom of life, liberty and the pursuit of happiness.

This book was born in this fight, and grew out of the mud of that same struggle.

The fight for respect of our God-given humanity is one that is often expressed in the artistic space because of the dynamic role the arts and artistic individuals have played in the history of this country, and in the history of struggle of African Americans everywhere. We wish to be seen not just as equals despite our differences in color and historical ethnic context, but truly seen simply as human beings, deserving of respect and basic human dignity.

From the painful days of chattel enslavement to the time of Jim-Crow segregation down through the generations, art has always helped to tell the stories of Black people. From the sad, ugly days of second-class citizenship to the civil-rights movement to the high point of self-assertion in the Black Power movement, art has always helped to shape the narrative of our communities. Today, we still find ourselves having to argue that Black Lives Matter in the face of repeated demonstrations of hate, disrespect, and persecution. Art stands as the channel of our independent voices. Art, as always, describes our experiences in undeniable terms, expressing the un-arguable value of our lives and works in American history and culture.

My art is an extension of that reality. It raises to broad public hearing the voices of the unheard and makes unforgettable statements for those of us who are too often forgotten or made to feel invisible by a society that treats us, if we are noticed at all, as an afterthought.

Art is the embodiment of revolutionary action. It is the spark that ignites societal change, to be sure, but also can be the foundation of bridges built between people of different backgrounds, religions, sexuality, and economic class. Art is a part of how we identify who we are and what ideas we represent, both individually and as a society. Such a tool is essential in the fight to break down the many social, cultural and political barriers that divide Americans as a people, bringing us all to a place where we can see past our many differences to find a true common ground in reason and understanding. Art taps into the source of a person, breaking down all silos of race, class, privilege, and gender; allowing us all to connect on the basis of what we feel and the experiences through which we have lived. That is the job of any artist, to make us feel something. Each of us has a story to tell, and art is the vehicle that we use to bring that story to eyes and ears of the world.

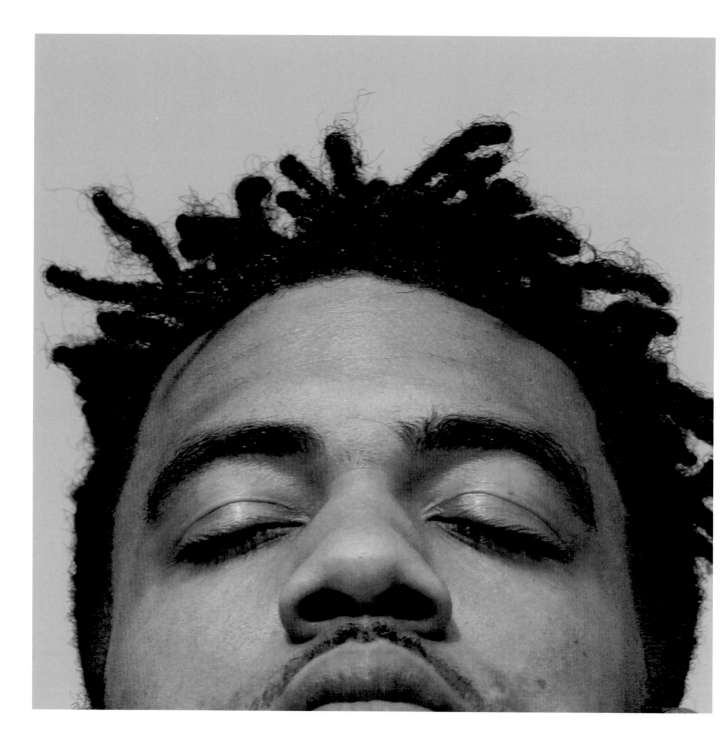

Open Letter

In _Third World_ Baltimore, no one takes time to worry about freshly manicured lawns or boarded-up houses. No — because in the inner city, we spend our time worrying about our starving school system, the constant presence of suffocating poverty, crippling addictions, and the ever-rising murder rate that makes our communities war zones.

Still, I love my city.

As a former professional football player -- being fortunate enough to live many places during my 29 years -- I have watched the sun rise over cliffs in Jamaica and swam with dolphins off Miami Beach. I've seen beauty in many places as I've traveled, but no matter where I've gone or what I've experienced, nothing feels better than coming home to Baltimore, heading down to Lexington Market, and ordering a greasy-ass chicken box with a salty side of fries and a large half-and-half of liquid diabetes to Wash It. All. Down.

A strong sense of community defines Baltimore, despite outsiders' misperceptions.

The Background:
A Community that Raised Me

When I grew up, Ms. Marion was the Grandma of my block; we kids all called her that, even though none of us shared blood relations. She either babysat, fed, clothed, or helped to raise most of the kids in my community. She was a loving woman, but she had a military approach to discipline—she didn't take no shit. And if she caught any of us outside "actin' a fool," she would snatch us up off of the street, whip us in front of the whole 'hood, and send us home to tell our parents exactly why she did it.

That's how the neighborhood was back then. When one person on the block had a kid, everyone in the community shared in the responsibility of helping to raise and keep that child and all the other neighborhood children safe from the dangers lurking around every corner, waiting to swallow us whole.

What I love most about my city is the people— the diverse mixture of personalities and attitudes connected by the same struggles and adversity. There is a unique confidence in a Baltimorean. A Charm City confidence not tied to money or status or anything else. It is as if the people here are born knowing how to crack crabs and ride dirtbikes. Just ask anyone living in this city, not born here . . . we're just different. There's not a lot of admiration or glory to be had in this city, but earning and showing respect goes a long way. I love that about my hometown.

A City of Love in Good Times or Bad

If Baltimore was a woman, she'd be a 35-year-old ex-stripper with neck tattoos, nerd-glasses, and a $400 sew-in. She's a little-bit-ratchet sometimes, with a good job and an attitude problem, but that's your Baby. Sometimes you love her, sometimes you hate her, sometimes you want to light her on fire; but you always stay loyal to her. You may get distracted and cheat sometimes, but you always come home to her, because the love between you is real. She always

To Baltimore

holds you down. Doesn't matter if you are a schoolteacher, a professional athlete, a janitor, mail-man, or the President of the United States. Nobody cares here, we judge your personality; we care about who you are, not what you are. Titles mean nothing to us.

It is hard to show love and compassion in a place where these emotions are often taken for weakness. When acts of violence are socially more easily accepted than compassion, it creates an environment in which people become desensitized to our harsh reality. Since childhood, I can remember being indifferent to the idea of death. Its presence lingered over every block, alleyway, and around every corner of our neighborhood. My childhood friends and I grew too familiar with its shadow. But as difficult as it was to constantly wrestle with the idea of suddenly dying, we knew we couldn't completely escape that possibility. We lost many friends, and even more acquaintances to senseless acts of violence growing up. The trauma of

that kind of environment weighs heavy on a kid. It affects everything, especially the youth's mindset and relationships. Tough love is a part of the mentality of any Baltimore native. Hearing about people I knew being shot, stabbed, or killed in their own neighborhoods became as common a conversation as the weather, or how the Ravens are going to do this football season.

The History that Stirred the Anger

Growing up, stories about police brutality and a corrupt political system get heard so frequently that even the sight of a cop car or uniformed officer is enough to make my friends and me head in the opposite direction. Stories of people like Tyrone West, Jerriel Lyles, Korryn Gaines, Venus Green, Starr Brown, Anthony Anderson, Jacqueline Allen, Keith Davis, Walter Scott, and Chris Brown became common, enough so that it became part of our way of life to know police officers as the enemy, regardless whether you committed a crime or not.

And if you're not familiar with the names of the people I just mentioned, its because they're all local names, Baltimore residents and American citizens that faced harsh violence and unspeakable brutality at the hands of those that are sworn to protect and serve the same communities they now terrorize. Whether you look at the way the officers responsible for Tyrone West's death in their custody were cleared of all charges, despite eyewitness testimony of their vicious assault against him, or the way Chris Brown's Killer, an off-duty cop was let free after killing him in cold blood over a childhood prank. In spite of that innate discomfort and contempt for law enforcement that we all feel growing up here, it almost became normal to us. We almost accepted our roles as the lifelong victims of a corrupt system that would never change. We always saw it as, "this is how things are, how it's always been, and most likely how it's going to be forever." That all changed on April 12th, 2015.

The Day the Picture Changed

On that day, Freddie Gray, 25, was chillin' in his West Baltimore neighborhood when city police officers confronted him. He had committed no crime, and possessed no illegal drugs or paraphernalia. But Freddie did what I, or any other Black man in his right mind would do, facing that fearful challenge — he ran. The officers pursued him, wrestled him to the ground, beat him, and illegally arrested him. Then, ignoring his numerous requests for medical attention after they threw his bound, limp body mercilessly into the back of the police van and drove off without strapping him in, he suffered a catastrophic injury. While rattling around the back of that van in police custody, then taken to a hospital, it turned out that "somehow" Freddie suffered a severed spinal cord. The youthful suspect-without-a-cause slipped into a coma and slowly died, seven days later.

What was really new and different here was the fact that community people recorded the police and their reckless handling of Freddie's already damaged body. The whole city, and eventually the world, saw the officers' lack of concern for his life.

This Time, it was Our City

All of the sudden, we were not watching, talking, and reading about someone in Florida, or Ferguson, Missouri, New York City, or rural South Carolina: this was right here in our own city. Unlike previous incidents, where Baltimore's Black citizens depended on mass media, hearsay and speculation, this time we had a visual account of what had taken place, laid out for the world to see. Suddenly, people all over the world had their eyes on Baltimore. This time, its Black citizens, fed-up with their humanity being so casually disregarded, rose up to fight back in the only way they knew how.

Our city erupted in the wake of Freddie Gray's tragic death, leaving me with a strong sense of conviction and responsibility to do something. We had seen stories just like this unfold before, after the shootings of Trayvon Martin, Michael Brown, and countless others. But the language being spoken on the streets of Baltimore City that night was one of rage, and it was shared by all those who followed the events in those chaos-filled days.

News media outlets, racist antagonists, and police apologists were quick to point out Gray's lengthy arrest record as justification for the Police officers' deadly actions. But to those all to familiar with the system of police harassment in Baltimore City, none of that mattered. This was one of us, and nobody had the right to tell us not to be furious about the killing of one of our sons. This demanded an answer.

A Predictable Eruption

Stores were looted and destroyed, police cars were set ablaze, a state of emergency was declared in the city. Tensions between the community and its police officers were at an all-time high. Our city's youth, feeling forgotten, de-valued, overlooked, and altogether beaten down by the same system that killed Freddie, were out on the front lines facing down an over-militarized police force without any real guidance or

leadership, fighting off tear-gas and rubber bullets with bottles and bricks. There was no organization, no central message . . . just anger, mayhem and more chaos.

I sat there that night watching the news on the edge of my seat, watching the steady escalation of rage boiling over among my city's people, and I couldn't help but to share that same anger. I couldn't join the looters, but I understood their pain, I felt their rage, I shared their desperation. I also could not help feeling a strong sense that it was my responsibility to be out there in the streets myself.

Duty Calls Me to Speak Up
Could I really allow myself to be called a "community leader" or a "real man" while sitting in my comfortable studio painting my life away while my city was literally on fire and our youth were out in mass, running wild in the streets? During times like this, all the leaders we have are needed on the front lines. We need our youth for their fearless passion, but we also need our Ms. Marion's

for their wisdom to guide that passion in the right direction. That is the community that nurtured me, and it is the Baltimore I know and love

When I took my camera into the streets in the following days, I went to capture the real story now unfolding in my city, a story that wasn't being covered by mass media. I looked into the eyes of the officers and armed National Guard troops patrolling my city's streets to see if I found hatred or understanding for a city in pain.

The Scenes that Spoke to Me
I talked to the young boy I had seen on TV the night before, standing bravely to face off against the heavily armed officers in the streets, screaming from the depths of his soul until his lungs burned from the tear gas, and found out what had happened to make him so full of rage. I learned he had lost both of his parents to the system, and now was living in a group home close to the area most heavily occupied by police offers and armed National Guard troops during the uprising. This book

and the images, essays, and poems within are the end-result of what began with those experiences, and it tells much more than the story of looting, burning, devastation and destruction told by the mass media.

Hidden under the turbulent surface of all that chaos and pain was the same sense of a community coming together and fighting to save and restore itself that I fell in love with as a kid. Telling my own version of that story, I wanted to show the good and the bad, in a way that pointed my city as a whole in a better direction. I wanted to show what I saw out there.

Amid the Chaos, a Joining of Hands
I saw opposing gang members embrace each other in peace and unity, marching shoulder to shoulder alongside members of the Christian community, the Nation of Islam, leaders of Temples, Synagogues and political figures coming together in peaceful protests for Justice. I saw Baltimore's people out by the hundreds, cleaning up and repairing damage to local businesses on North Avenue,

Pennsylvania Avenue, along Monument Street, and other areas across the city after the riots. I saw police officers interacting with the people and children in the community in ways that I have never seen them do so before. I saw the Eastside and Westside communities peacefully come together to mourn in a way that, just a few years beforehand, would have ended in bloodshed. I saw a city fighting to heal and redeem itself.

We never were a perfect people, even in our best days. We still had a long way to go, but there was a time where at least on a large scale we understood the importance of standing together against oppression and injustice.

Stepping Up, to the Responsibility Required

As a father, man, and artist, I feel that it is of utmost importance that I use my gifts to reflect real issues facing our culture today. It is my responsibility to teach my son how to grow up and be a man in a society where men who look like him are killed for no reason — just for being. The harsh realities he will face in his life are not dangers from which I can protect him. I cannot shield him from a stray bullet. I cannot prevent an unlawful arrest by a corrupt system of law-enforcement that condemns him for no reason other than the color of his Black skin. I cannot even guarantee that he will receive a proper education from a depleted, underfunded, and undervalued public school system. It is a chilling and helpless feeling.

All I can do is my best to educate my son, and teach him to be a critical thinker. All I can do is show him the best and safest path I know ... And pray he never becomes a tragic casualty of circumstance. I can teach him to use his mind and his reason as tools to overcome the obstacles set in his path: a legacy of 400 years of chattel slavery, institutional racism, handed-down generational trauma, issues of self-hate and years of misinformation, yes. But that still offers no guarantee that he'll safely be able to navigate the minefield set before him as a Black Boy growing up in America.

A Catalyst for Progressive Change

If we don't use Freddie Gray's life, death, and the events that erupted out of the city's unrest as an example and as a catalyst for real progressive change, both in legislation and

our own mindset as a people, he will have died in vain and the cycle will continue.

We don't need more marches with no pragmatic, obtainable objectives in our communities. Instead we need to come together to:

• Organize around specific causes, and figure out how to use our collective voices, funds, and action to see Real Change in our lives and those of our children!

• Create economic infrastructure that provides jobs earning livable wages and opportunities for our people to build livable careers.

• Build up that infrastructure by identifying the cornerstone businesses in the Black community and supporting them with our own dollars.

• Force our politicians to properly fund our starving education system and equip our youth with the tools needed to be successful down the road.

•Set up drug rehabilitation facilities that prioritize holistic mental health and wellness practices over medicating addiction with more addiction.

• More than anything else, we need to STOP KILLING EACH OTHER!!! How can we expect the outside world to value our lives when we don't value them ourselves?

Concluding with Hope, for a Better Future

Martin Luther King once described a riot as, "The language of the unheard." It is my hope that this language doesn't continue to fall on deaf ears. It's my hope that this book will prove that those voices are being heard, and that there are those, like myself, who are committed to fixing the problems at hand and helping to heal the souls of the lost, broken, and forgotten. All I can do is hope that one day, my son reads this letter while looking out at a very different political and social landscape, and wonders how things ever used to be so bad.

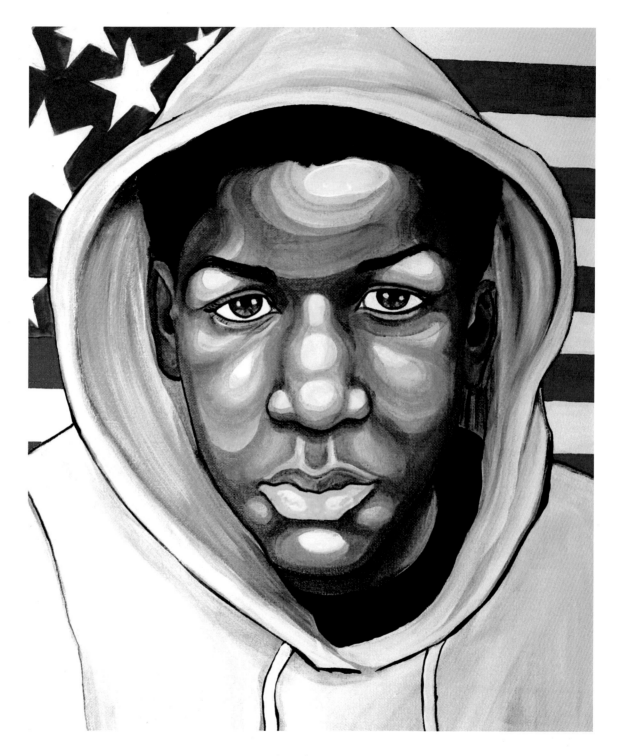

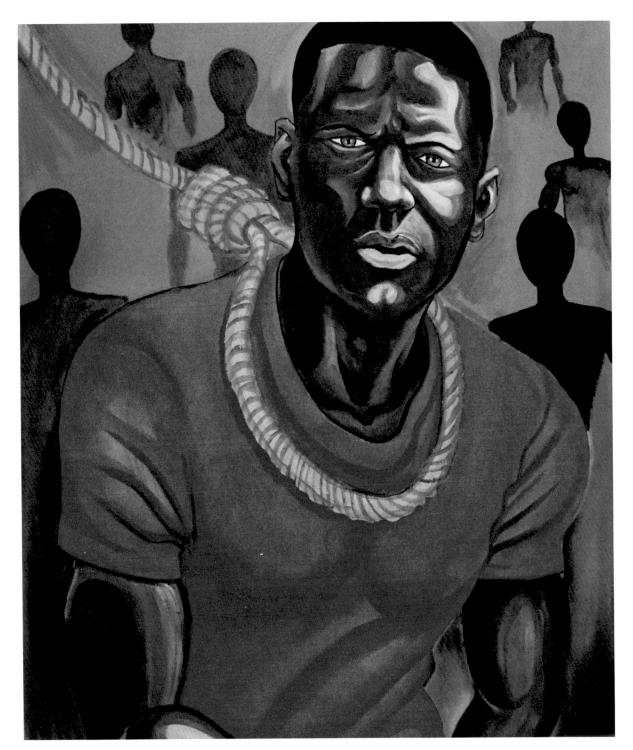

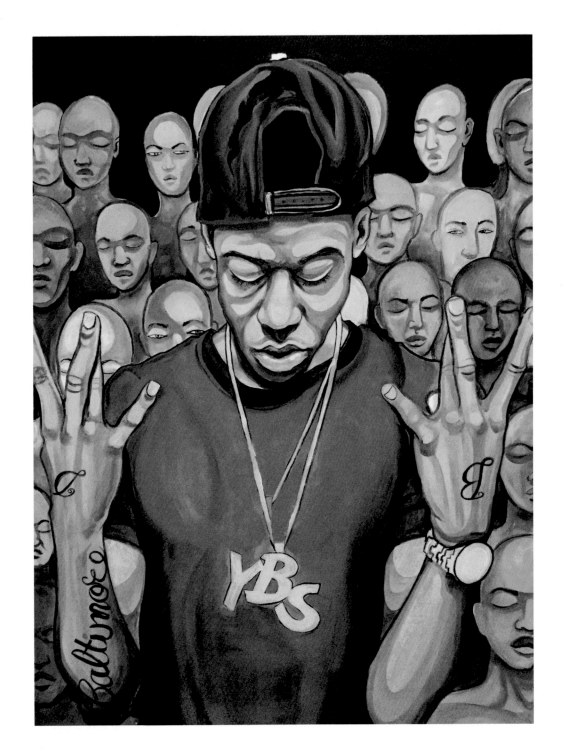

Wake Up

Breaking news,
 Nine shot,
 five dead last night.

Baltimore's gone crazy,

Bodies droppin'
 Left and right,
 Day and night
 With no end in sight.
 Wake Up!
Three-hundred-eighteen murders in Three-hundred-sixty-five days.
 That's twenty-four hours in hell
 relived in Three-hundred-sixty-five ways.
 Three-hundred-eighteen families
 digging Three-hundred-eighteen graves
For Three-hundred-eighteen Kings and Queens
 That should still be here with us today.

 Wake Up!
I wonder….
When are we gonna' get tired
 Of putting our brothers and sisters six-feet-under!
We can't ever build up our nation
 When were still murdering our own culture.
Lost Shooters claiming kingship
 While they're really vultures & thieves.
Robbing Fathers
 From their children,
 And Kings from their Queens,

And children
 Of their chances
 To fulfill potential dreams!

 Wake Up!
This aint no new bit,
 This murder shit,
 This killin' shit,
 This dealing shit
 Been going on since we were too young
 To be hip to how dark this way of life can get!
 Wake Up!
How many of our brothers' lives
 Gotta' be lost in vein?
How many of our babies' mothers
 Gotta' weep n wain?
How many fatherless children
 Does it take to restrain
This trigger-happy mentality
 That remains on my people's brains?
It drives me insane…
To see us all still so mentally chained!
 Wake Up!
How many more days and nights
 Will Baltimore weep?
How many years gonna' pass
 And still find my people sleep?
If I can't wake up white America,
 At least I'll wake My City up,
Till I see all my Kings and Queens
 On their rightful thrones
 With their crowns on.
 And their fists up.
 Wake Up!

We can stand
 Against police brutality
 Like a hobby for some fame;
Act like we really care about justice
 In our fallen soldiers' names.

Black Lives Matter…

But how do we not feel the same
 When were killing our brothers and sisters in vain,
 Free of shame
 Of guilt
 Or pain in this game?
Could it get any more lame than to believe,
 This way of life is sane?
Or to remain Silent in shame
While more of our people are slain?
 Wake Up!
How did they get us to hate ourselves
 And love their wealth?
 How you dream about seeing Heaven
 When you're already living in Hell?
Were too worried about being cool
 But don't address our starving schools,
Not giving our youth the tools
 To understand how to rule.
 Wake Up!
I refuse to be timid or quiet
 I can't be polite anymore!

And our people can't turn a blind eye
 To this senseless violence anymore,
The devil is at war…
And he wants that war ignored in Murderland, Bodymore.
He wants all our Kings dead,
 And our Queens seen as whores,
Wants our sons to be inmates,
 And our daughters to be alone, starving and poor.
 Wake Up!
The education system is failing us
 While dirty ass Cops are killing us,
Fox news is misinforming us,
 While Uncle Sam wants to murder us.
So with all of this stacked against us,
 How can it be?
 That WE STILL MURDER US?!
 Wake Up!
Too many of our people still sleepin'…
 Wake Up!
Too many of our families still out here grievin'…
 Wake Up!
Too many Black kids out here getting targeted for breathin'…
 Wake Up!
We Must Break the Cycle.
 People…Please…Wake up!

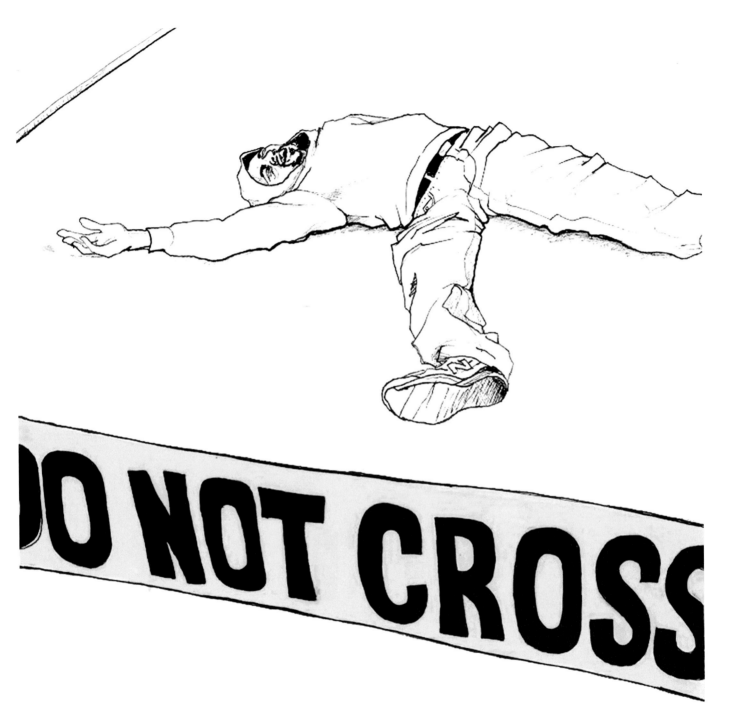

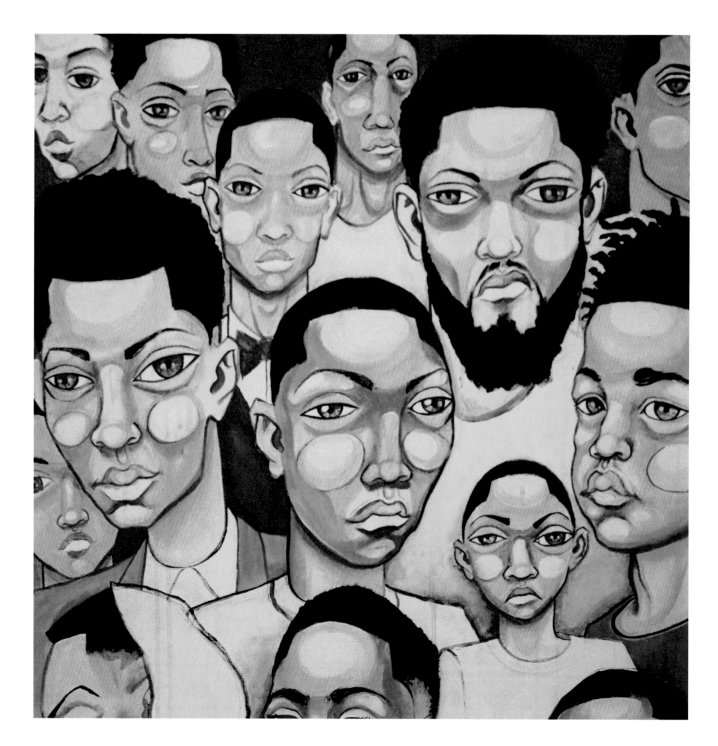

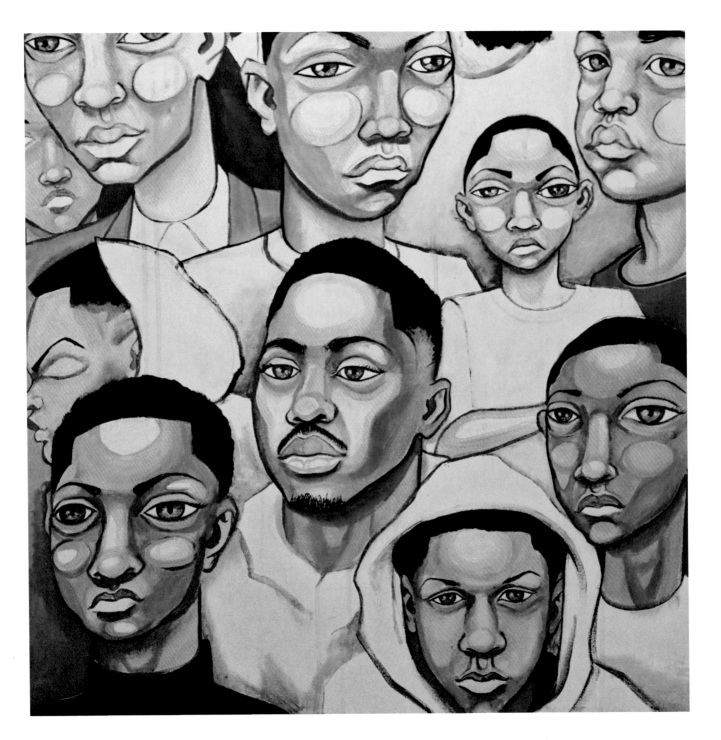

black boy blues

Let me tell u somethin'
'Bout these Black Boy Blues.
So much sadder than a Love song
　　From fragmented points of view.
Police sirens blaring…all-day-long
　　Loud as the sax and the trumpets do.
No peace in the dark hood melodies.
　　Bellowing in the winds of the avenue.
Can you?
　　Tell me?
　　　　Somethin'?
　　　　　　Something bout these Black Boy Blues?

Black Mothers aint never raised no killers,
　　But They aint raise no victims' either.
We all know.
Babies that don't grow. Into soldiers,
　　They get eaten alive 'round here.
　　　　So it turned us that much colder,
　　You gotta live ready-to-die 'round here.
Black Boys Became Militant Soldiers…
　　that aint never been deployed,
　　　　that never tasted joy,
But they stay at war every day 'round here.
That's why we don't watch the news.
Nothing but a replay
　　of what we see.
　　　　In these streets
　　　　All day. Every day
while were just out here
　　trying to live. Trying to be…
　　　　Damn, these Black Boy Blues.

Prison is a false solution
　　for ignorant & feeble minds…
To excuse modern day slavery,

and state sanctioned genocide.
Black Bones in iron cages.
 Institutionally traumatized.
while their families feel their absence
in the land of the colonized

Those are Black Boys' Blues.
 Next door neighbors to success.
Glass-eyed stares of emptiness,
 Into dark shadows of regret.
Sacrificing morals…for cashflow
 All street-rep…but no respect.
That's the song you want for all of us?
 The threat of poverty and death so near?
Cuz were all just one wrong bullet away…
 from being the next hashtag victim 'round here.
But you consistently like to forget
 that vulnerable Black bodies still exist 'round here.

Just the same Black Boy Blues…
 You've always loved to listen to.
 You want the truth?
You protect your buildings,
more than you do Black Bodies around here.
You neglect Black humanity
& respect white property 'round here.
But, what you're not gonna do…
 is just look right past us anymore.
What you're not gonna do… Is stay silent
like you can't see and hear us
 dying from this violence anymore.
What you're not gonna do…
 is ignore our pain,
 like you can't see us suffering anymore.
Act like you don't notice…
 We're being hunted out here like animals
 No
 Not anymore.

It's not enough
for you to close the doors of opportunity in our faces.
You needed to lock em' up,
 bolt them down,
 board them up,
 nail them shut,
 and seal the cracks with cement.
With Unescapable poverty,
 Drug epidemics,
 And Unaffordable rent.
Then you've got the nerve
 to blame us for our own descent.

A lack of opportunity…
 Breeds poverty.
And being poor…
 is a daily fight.
We got open air drug markets
 on every-other-corner
 but not a Whole Foods Market in sight.
We got Liquor stores
 everywhere we turn,
 But not enough free libraries
 to learn to read & write
The hood can be so cold
 that it gets hard to fall asleep at night.
But still, we're told to just hope…
 Hold hands and pray,
 that one blessed day,
 things are all gonna be alright
that's the Black Boy Blues
some u win, but most you lose.
The fight continues.

Art Activism: A Call

"Protest Art" is a broad term, defined as creative works that concern or are produced by activists and social movements. This definition is serviceable for some, but does not begin to narrate the cultural importance of the artwork that ignites, defines, and narrates a movement.

I am not a protest artist. I'm not an abstract artist, I am not a contemporary artist, and I'm sure as hell not a pop artist. Those boxes were not meant to contain me, any more than they were to confine the protagonist in author John A. Williams' novel, The Man Who Cried 'I Am' . "Simply said, I am an Art-Activist.

Art-Activism defined: Storytelling with an agenda

During times of unrest and oppression, there is a critical need for self-representation in the liberation process in order to help ourselves define an independent, unassimilated identity for all oppressed and persecuted Americans through the vehicle of culture. Thus, by controlling the content of our own narrative in our inner-city communities through our collective artistic voice, we can start to define and change that culture for the better by creating new ideals of self-worth and community.

We can use art, music, writing, photography, theatre, and dance as powerful tools to wage war against oppression, misrepresentation, and injustice. We can then begin to define for ourselves what our narrative is, what it should be, and how we can organize and work together towards getting there. We can define for ourselves what success looks like, what true equality and inclusion look like. More importantly, we can define what it should feel like. That is what great artists do: They make us all feel something through their expression of their truths.

Every human being an Activist

Every day, individually, each of us campaigns for some kind of social change, be it on a large scale, nation-wide level or a small, local one. Individually and in groups large and small, we argue over political differences; we debate issues of injustice and institutionalized oppression. We use our own personal stories and life experiences to bend the world to our will.

A writer is an Activist, by definition; so is a painter, a musician and, to be sure, a rapper is an Activist. A mentor is an Activist, and mothers and fathers everywhere are the greatest Activists of all. Everything from a debate or argument, to a protest march or boycott is in some way, a form of Activism. The important question that must be asked: What will you choose to advocate for with your daily platform, and what sacrifices are you willing to make to achieve those goals?

This is no new concept. Throughout the history of Black Americans as a people, art has always played a major role in the narrative of our culture and of how we self-identify. Even in the depths of chattel enslavement, it continued, a legacy of the pre-colonial African cultures that had nurtured our kidnapped ancestors.

Ancient African civilizations used art as a tool to educate, enlighten, document, and tell the stories of our history, heritage, and ways of life. The important thing to keep in mind though is perspective. Who controls the narrative of Black people in America? And how is that narrative being used to portray us, while socializing and indoctrinating the world to view Black America unfairly? Who is telling our story for us?

Most of our society's racist ideas were at some point reinforced through the arts. Whether it be through visual art, theatre, music, or verbal storytelling. From the degrading Blackface characterizations, to the Sambo character in Uncle Tom's Cabin and so many other novels over time, to the racist and savage depictions of Black, Arab, & Asian people in Dr. Seuss' early

To Action

political cartoons. The same way art has been used to demonize, it can be used to humanize.

The same tools that were weaponized against us can be used by artists as tools for our liberation.

Continuing a generations-long struggle
Ever since the founding of this nation, Black Americans, along with the indigenous Native American people, and the Latino community originating in the lands seized from Mexico have been in the position of the persecuted, controlled and oppressed.

Laura Mulvey, a British feminist and film theorist, once said that "Moving from oppression and its mythology to a point of self-definition is a difficult process for any persecuted people, and it requires the people with grievances to construct a long chain of counter-myths and symbols," in order to build pride while raising the awareness and consciousness of the oppressed people.

In short, to establish a new narrative in our communities, we need images and representations of ourselves that allow us to look at our collective place in America, as a people, realistically, and start to look at ourselves, and to look at those in our surrounding communities differently. Accordingly, we need artists to be bold enough to create work that will challenge the culture on those ideals. As a people, we have never been a monolith. And we need representations of ourselves that celebrate our complexity.

H. Rap Brown stated that, "Individuals in our government do not influence politically, economically, or socially, the attitudes and functioning of the system."

From this, a critical question for Artists
So if our country is indeed fueled by a military and prison-industrial-complex that make it profitable to wage war abroad while incarcerating

mass numbers of Black and Brown citizens from our inner city communities on the home front. If indeed our schools profit from the miss-education of our children from a systemic level, profiting as well from the misdiagnosis of our students with learning disabilities and behavioral issues, then why would we ever expect a change to come from the same economic and political power-structure benefiting from our persecution as Black people?

A change in how we are viewed and represented must come, and it can only come from and be forced by the people who that change is meant to serve.

It's important for our artists to play a key role in helping to establish this new narrative by being bold enough to highlight realities of the disparities facing our culture and to use our platforms to point us in a better direction moving forward. Artists represent the visual, verbal, and musical mouthpieces of the movement and are key to any revolution that is to take place. We document history. And we cannot depend on a predominately white news media system to carry our Black revolutionary messages, which conflict with their own economic and social interests. That responsibility rests with the people.

The imperative: Take charge of the narrative

We have to reevaluate our language as it relates to social change. It is time for us to define our own terms of independence and self-definition. Our messages about our people and to our people should come from our people, not from outsiders ignorant of and indifferent to the issues facing our people.

Thus, it is every artist's responsibility to contribute in a positive way to the future of our culture and the story of our communities. Talent is can be either beneficial or destructive in the hands of any artist, of any medium, because that talent can be a positive or negative influence to those who experience it. In other words, you can use that platform to build or destroy your communities. Hip-Hop can be a powerful tool for or against the Black community, and we see examples every day in popularized media portrayals. An artist with a powerful voice can share the gospel of ignorance, addiction, and self-destruction, or that of enlightenment, development and consciousness.

Writing can be a powerful tool for or against the Black community; you can choose to educate and motivate, or to tear down and criticize through your words. Photography can be a powerful tool for or against the Black community. A picture is worth a thousand words—what will the ones attached to your photo say? Painting can be a powerful tool for or against the Black community. How will you choose to portray your people?

Culturally, Blackness is not an accident

As the great 19th-Century Activist and Civil-War veteran Martin R. Delaney famously said, before anything else, I am a Black man — I walk Black, I talk Black, I dress Black, I write Black, I live unapologetically in my Blackness every second of every day. My art is a mirror-reflection of myself and the world as I see it, as a Black man. I use my art as a tool to educate, enlighten, and inspire the minds of the youth and younger generations. I paint with bright and vibrant colors to grab their attention.

Art Activism: A Call To Action

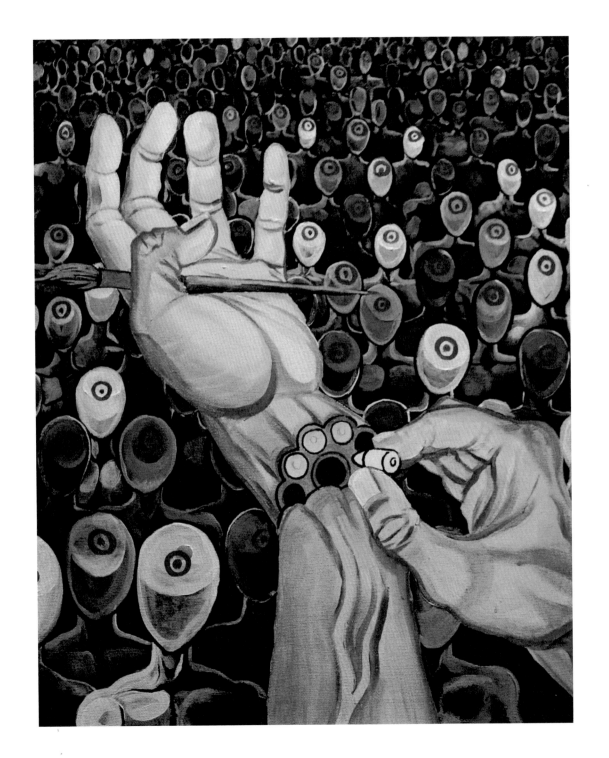

Sometimes, I paint with a slightly cartoonish aesthetic to reach out to their vivid imaginations and expand on those horizons. My artistic messages have no boundaries and no restrictions or limitations to race, gender religion, sexuality or ethnicity; but they are painted from a perspective of a Black man. They're meant to be interpreted openly and critically by all who view them. I'm not looking for compliments or accolades — you can keep those. My goal is to make you feel, to make you think, to provide a platform to ignite important conversations between people of different backgrounds and viewpoints to effect society as a whole, one conversation at a time.

A battle of cultural contention

Our world is at war right now for its moral soul, and I am on the front lines of that war with a loaded clip of ammunition. My brushes serve as the barrels of my rifle, with my paint as my bullets. My only prayer sometimes is that I have enough left in my clip to actually make a change.

I am not alone in this fight either, not by a long shot. In the city of Baltimore alone, a legion has come to the front line: artists like Brian Kirhagis, D. Watkins, Tariq Touré, Devin Allan, Shannon Wallace, Kondwani Fidel, Neptune the poet, Mohamed Tall, Reginald Thomas, & Lady Brion, along with many others, all are doing dynamic groundbreaking work in the Art-Activism space. Each is playing a key role in moving culture forward, controlling the narrative of our community, and ushering in the modern-day Arts Renaissance happening in the city of Baltimore.

This is not an indictment of those artists who choose not to use 100-percent of their platform to fight for the cause, not at all. Rather, it is a call to action for anyone who does not understand the true responsibility of his or her platform. Not all of Black America's leaders asked for their positions of influence, but that does not make them less important to their fans and followers. Leadership is a great responsibility. Our Leaders must lead, but far too many of these leaders have been focused in the wrong direction for far too long.

It's about time we start holding ourselves accountable.

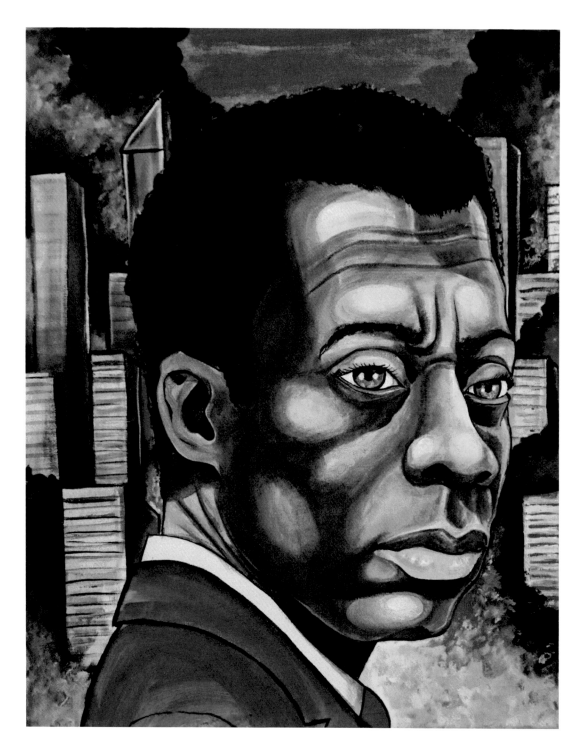

Sobering Truth

All the cries…

Of Ancestors voices,

Heard through Pop-Pop's silent sermons

Where he spoke as if words cost him money

Past history seen through Grandma's eyes

With futures promise of her prayers

The sting of Daddy's whippings

That always came with a pre-and-post-whipping-lecture

Followed by the loving embrace

of a father fearful for his child's future.

The salt of Mommas tears, on her tongue.

Tears of fear. Tears of joy. Tears of hope

Cannot stop…

The bullets aimed at our young.

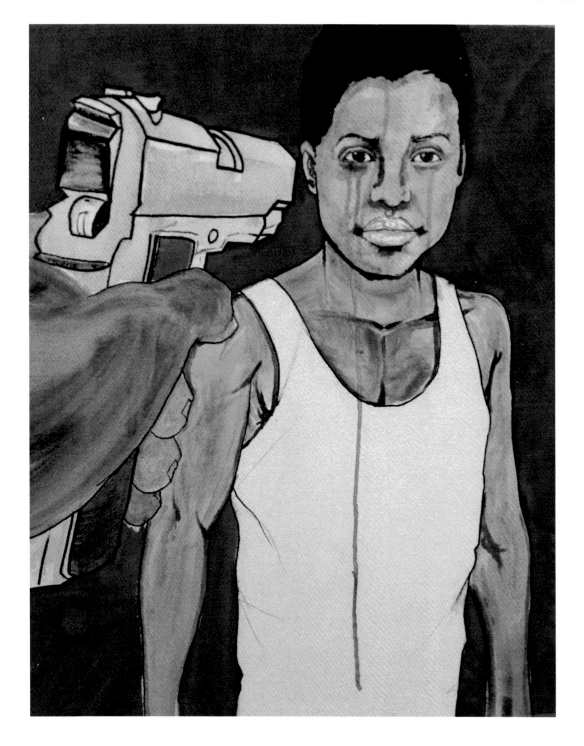

Nobody Told Us
(We were at war today)

Nobody told us,
>When we woke this morning,
>>That this was an important day.

We got up, got dressed, packed our book-bags
The same,
>Same way.
>>Same way we do every day.

Took our busses to school.
Went to class,
>Played it cool,
>>talked about how them cops Killed Freddie Gray.
"Shit-was-wrong, man."
>"them cops was foul."
>>"they should all be in jail right now!"
"But that's just how it goes 'round the way."

Then we got the call…
>It echoed through the halls
School was lettin' out early today.

But still, nobody told us
That a war was beginning today

We showed up…
>for some fun.
Cops showed up…
>with their guns.
Is this mall a warzone today?
"Sir…"
"What did we do?"
>"We're all just coming from school!"

"We catch our bus home from this mall
every day!"

We looked for busses,
Only to find more cops
>and your tanks.
>Ayo,
"These aint the type of games
that we play."

We had on book bags…
>You had on riot gear
But we never been the type
>To run or cower in fear.
If a war has begun, we will fight it as one.
We're 'bout tired of running today!

We're not running…
>No More!
We're not stopping…
>No More!
We're not keepin' quiet…
NO MORE!

Don't ask us to calm down
To hold hands and pray

That aint stop y'all from Killing Freddie Gray!

Every day,
>you abuse us.
Every night,
>you pursue us…

Dehumanize us in every way.

If Backed into a corner
 We fight!
When set upon,
 We strike.
We gotta' to watch
 our own backs
 out here
every day.
but when being constantly attacked,
 just for being young, poor, and Black,
it forces us to repeatedly say…

We will fight you
 until we can't fight you no more…
But Nobody…
 Told us…
 We were at war today.

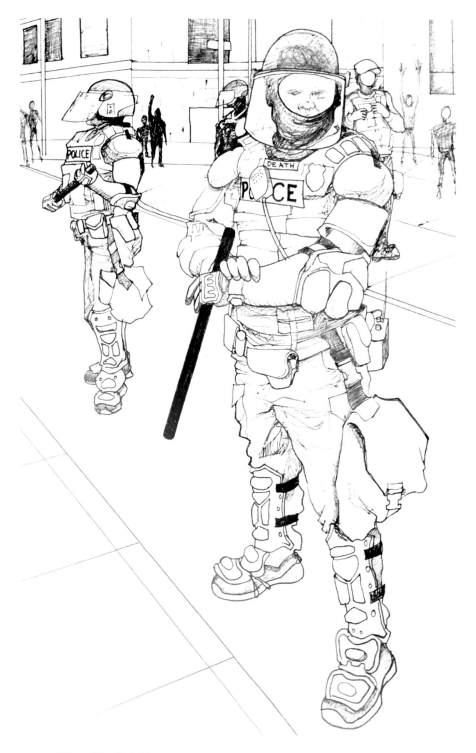

Here We Are
(Baltimore)

Oh Baltimore,
　　　My Baltimore…
We fought for you,
　　　We bled for you,
　　　　　We shed tears for you,
Yet, here we are….
We looted you,
　　　We burned you,
　　　　　Went to war in the streets
　　　　　Over
　　　　　You.

But, Here we are…

Our politicians promised to save you,
　　　Our pastors vowed to redeem you,
　　　　　Our people worked to restore you, and still…
Here we are….

After all the marching,
　　　All the singing,
　　　　　All the protests,
　　　　　　　All the hearings,
　　　　　　　　　All the public forums
　　　　　　　　　　　About progress.

Here we are….

After all the looting and burning,

After all of the proclamations
　　　About Black Lives Matter,
Here we are….
After all
　　　The cries for justice,
After all
　　　Those demonstrations of unity,
After all
　　　The media cameras
　　　　　Have come and gone,
　　　　　　　With no real action taken
　　　　　　　　　And no battles won.

Here we are….

A month later,
Baltimore
　　　Is in the midst
　　　　　Of its deadliest month in 43 years.
What happened?
　　　To all those cries
　　　　　For peace and justice?
Cause all I can hear now
　　　Is the silence…
　　　　　Of mother's mourning tears.

Here we are….

Back to reality,

The cameras have gone
　　And I remain here the same,

Wondering…

Where are all those "preachers" and "leaders"?
　　That were just out here weeks ago
　　　　Chasing fame off of Freddie's name?
Here we are….

Still divided,
　　Still seeing bodies drop
　　　　Every day to this senseless violence.
Still making orphans
　　Out of our babies,
　　　　And Widows
　　　　　　Out of our ladies

Here we are….

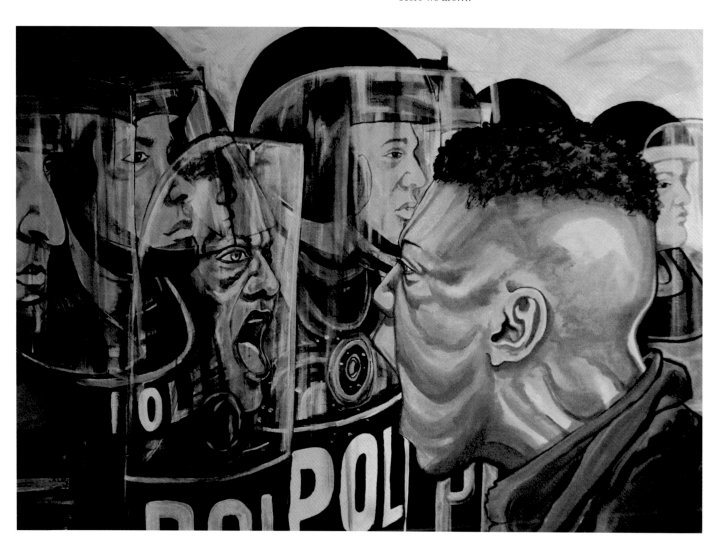

Let Your Voice Be Heard

Let your voice be heard
Move minds and hearts alike, with your words,
And when they refuse to hear you,
Scream Louder with a shattering sound.
Shout Harder with a deafening cry
Breaking barriers of the silos where bigotry resides
Searing their ears
With a thunderous sound
That was bound to turn ignorant heads
of those who have lost their way
To a place where they can hear and see
The logic in what you say.
With my mother's eyes tearing-up
In the background
Smiling.
Knowing, deep down
That sound was something
She long-waited to hear,
Breaking its way through
To the truth

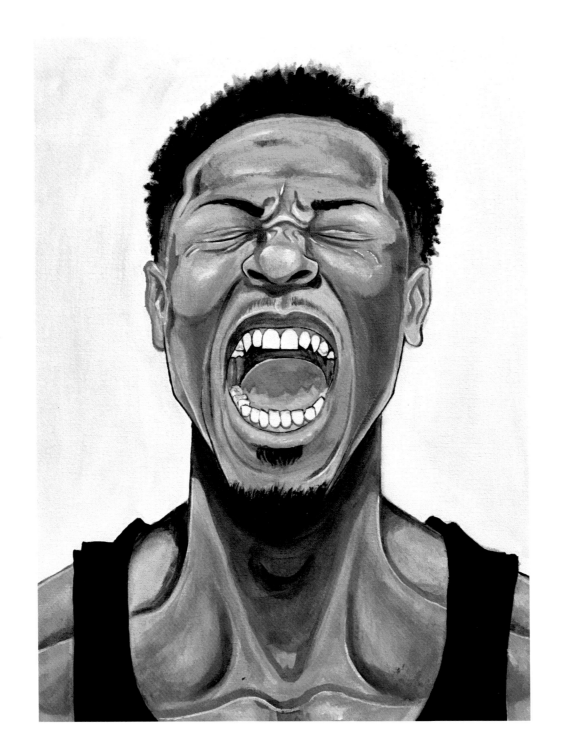

Letters 2 Langston

A
Dream
Differed
Often finds
It's way
Eventually
To rage…

Conundrum for the Ages

Here. We stand.
Stolen bodies. On stolen land.
Familiar. Strangers.
On even stranger sands.
Miles of dead. Space between us.
Bonded by cotton pickin'
And penny pinchin'
And our scarred & tattered backs
And our swollen bloody hands.
A country. Of foreign men.
A country. Of forgotten women
A country. Of lost children
Born in genocide, rape, theft, and death.
A country.
Built on backs of Black Kings. And Queens. Made slaves.

Passionate.
Repetitive.
Defense of bad logic.
Main historical causes of the world's misery.
That's what these stars and stripes mean to me.
I've spent my lifetime
judging the distance
Between the American Dream
& it's darker reality…
Why do we run from our truth?
Sanitizing our history books,
Misseducating our youth.

The past don't wanna be changed
It wants to remain.
The same.
So whenever we push forward,
The past pushes us right back.
Tellin' us to stop the complaining,

"This isn't just because y'all are Black."
So…. does Making America Great again…
Really Just mean making her people hate again?

Let's get one thing straight,
We are not America's children.
We never suckled from her breast.
We built her and sustained her…
With our blood & with our sweat.
As citizens, We're her parents.
Even tho she likes to forget…

We picked the cotton,
And the tobacco.
We dammed the rivers.
We built the bridges,
and the railroads.
We worked the shipyards.
Built giant structures
Into the sky.
We fought for a country
that stole & enslaved us.
For our own 'freedom' we bled. And we died.

Who fought for humanity?
Who bled for dignity?
Who died for freedom?
Who won this country's Liberty?
Who struggled for equality?
Who?
That Who. That who would be… We
Now please tell me,
How can it be?
That you're more of an American than me?

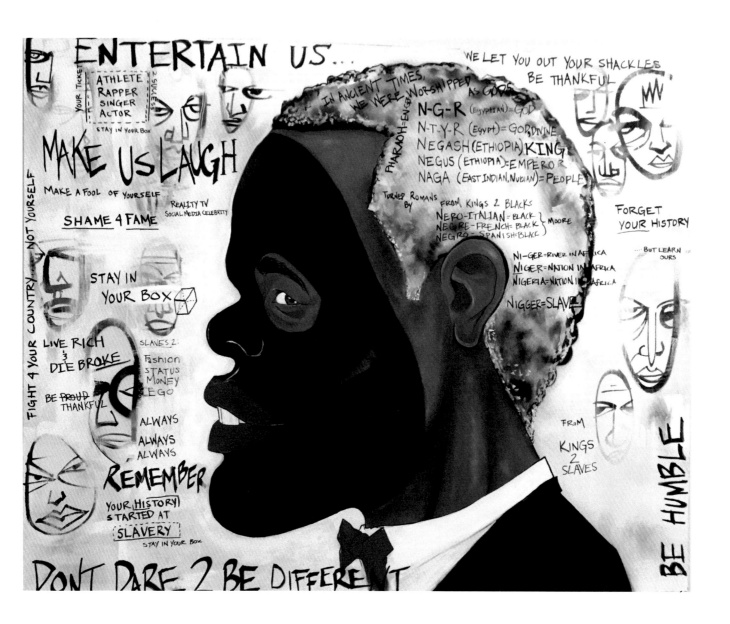

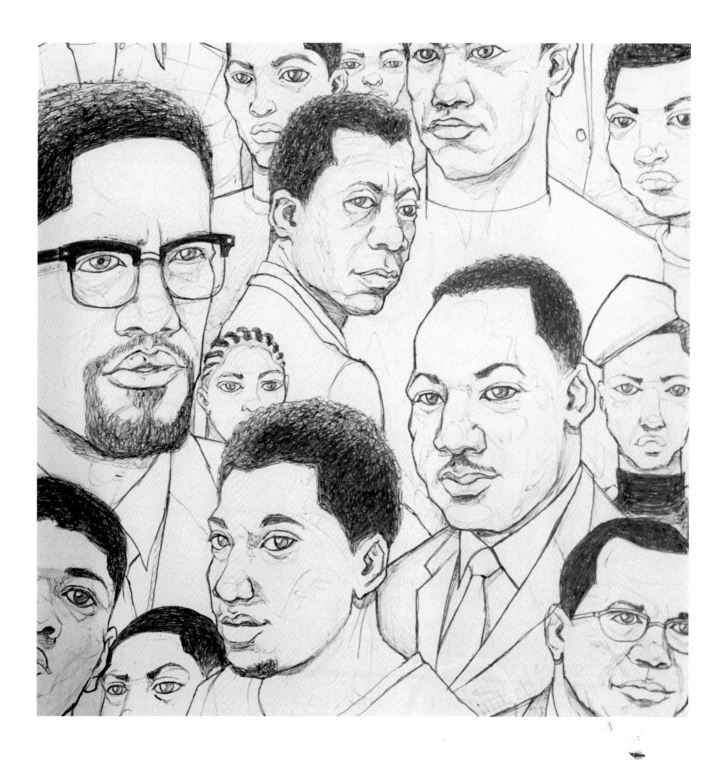

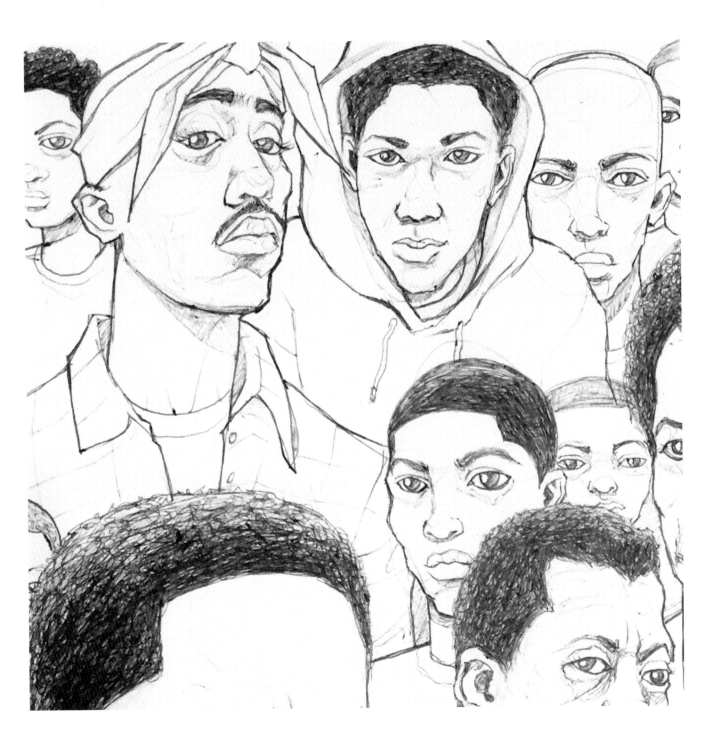

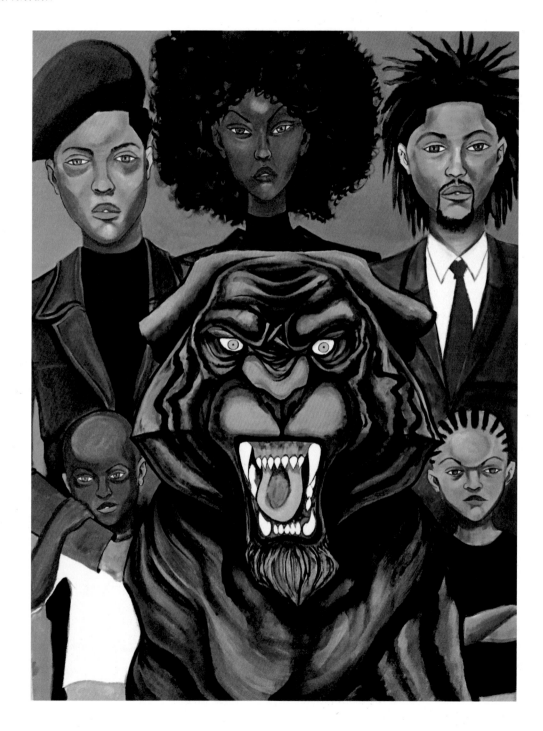

What is Black Power in 2017?

There is nothing in the world scarier to America's "larger society" than Black Power. In the history of this nation, Black and Brown people have been treated horribly by the country we built with so much free labor — the same country whose Founders violently uprooted us from our homeland, separated us from our native language, religion, identity, and culture, then subjugated us to brutal lives of enslavement. We have faced adversity and overcome vicious attempts to de-humanize us at every turn. The bitterness of that opposition, the pain and intensity of that struggle might surely have erased a weaker people off the face of the planet.

In spite of 245 years of chattel slavery that only ended in a bloody Civil War that only ended when 200,000 Black soldiers, sailors and spies joined the front lines, we have progressed.

In spite of the racist Jim Crow Laws imposed in the Post-Reconstruction era when the highest court in the land refused to enforce the U.S. Constitution to the detriment of countless Black bodies, we continued to march forward.

In spite of the economic and political disenfranchisement, institutional racism, and a broken education system designed to cripple Black people intellectually and culturally in this so-called modern era, Black people in this country continue to survive, innovate, succeed, and achieve in every field of human endeavor, in the face of overwhelming odds, because of our Black Power.

Our own 'Uncomfortable Truth'
The term Black Power itself has always made the white power-structure as well as most white people in general, uncomfortable to say the least. This is in large part due to a lack of knowledge about what the ideology actually means. The basic premise is that overall equality can never be achieved, as long as Black people in this country continue to operate from a position of deficiency. We don't advocate for power so that we can abuse it as the white power-structure has in the past. The ultimate goal is not the dominance and exploitation of other racial groups, but an equal share in the total power of the society for all people everywhere. But that starts with us focusing on ourselves first. Powerlessness always breeds a race of beggars, and as a people we are fed up with begging for crumbs off the plate of the same democracy our mothers, fathers and ancestors fought and bled to build. Our seat at the table of society's benefits, with an equally well-served plate of our own, have been earned, over and over and over again. The time is long past for America to admit that we deserve it.

Genesis of our self-assertion

The original ideology of Black Power started in urban neighborhoods in mid-1960s America, but civil rights activist Stokely Carmichael formally introduced it as a slogan in 1966 and cemented it in the sphere of social relevance with his book Black Power: The politics of liberation in 1967. In that time-period after the passing of the Civil Rights Act of 1964, the Voting Rights Act in 1965, and the assassination of Malcolm X and Dr. Martin Luther King and a nation-wide legal assault on Black leadership organizations, Black advancement on any front was met with vicious white hostility, great repression and violence.

There was a noticeable decline in the activity and visibility of major civil-rights organizations like the Southern Christian Leadership Conference (SCLC) across the country. Civil-disobedience organizations such as the Student Nonviolent Coordinating Committee and the Congress of Racial Equality, stalwarts in the fight against segregation, imploded in the late 1960s. Older organizations like the National Urban League and the NAACP shifted focus to civil-rights enforcement issues after those historic milestones, not seeing as much need to expand on the true definition of equality at a time where the priority was still gaining full access to jobs, education, and housing. The time has come for us to revisit and re-define our definition of equality.

The battle had really just begun

Long after the March on Washington, many of our people confined to the ghettos of our northern and western cities across the country were left isolated and desperate, locked out of employment and worse still, locked out of social progress after the jobs opened to Blacks in the "Fabulous Fifties, moved away from the hood. So many had moved North during the Great Migration, when World War II's defense buildup opened new doors for Black people to careers in industry. Still others move North after the war, when mechanical harvesters lessened Southern farmers' need for field-hand labor while the post-war Marshall Plan years' industrial expansion beckoned even more to leave the fields. Those jobs moved out to the suburbs on Dwight D. Eisenhower's new Interstate Highway system when developers like William Levitt and Sons built their new, white enclaves far from the reach of urban mass transportation,

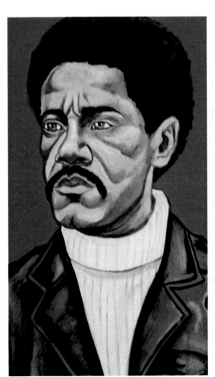

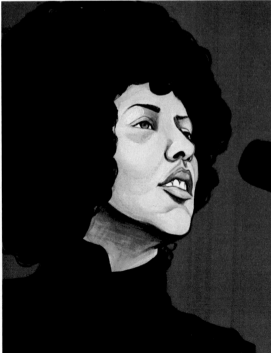

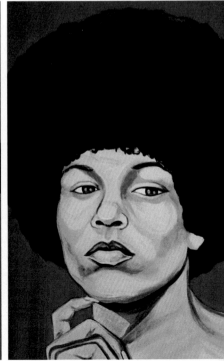

and the factory jobs followed, leaving Black urban populations vulnerable and unemployed. For Blacks in the inner city, true equality and economic opportunity were still many worlds away.

Younger Activists took up the Call

Throughout the late 1960s and early '70s, the younger, more street-savvy civil-rights activists, like Carmichael, H. Rap Brown, Elaine Brown, Amiri Baraka, Huey Newton, Fred Hampton, Katherine Cleaver, and countless others worked tirelessly to define Black Power as the next phase in the Black Liberation Movement. They awakened the minds of the people to the concept of embracing Black Beauty. They challenged a new and younger generation of leadership to realize self-determination, intellectual exploration of Black consciousness, self-respect, and self-defense for

Black America by calling for a broad experimentation of Black liberation and political self-governing of our own communities.

The Black Panther Party created the free breakfast for children program, a nationwide effort to offer free breakfast before school for kids in our underprivileged communities. They asserted their vast knowledge of the law by openly exercising their constitutional right to bear arms, taking their weapons onto the floor of the California State Legislature in an act of protest against the proposed "Panther Bill" and onto the streets of their own communities. There, they policed the police — making sure police officers were not infringing on Black citizens' constitutional rights during traffic stops and arrests. For all of the Panthers' efforts, most of the leaders

of this great movement were targeted, hunted down, falsely imprisoned, or assassinated by law enforcement, supported and encouraged by the Federal Bureau of Investigation's Cointelpro program of illegal spying and covert-action targeting of civil rights groups.

So there should be no question about why so many Black people have no trust in the Federal government.

Ugly oppression in a land proclaiming freedom

How could Black and Brown people in America win not only full citizenship rights, but also actual economic and political power for themselves in a country fueled by their oppression? Over the next 40 years, we received many concessions out of necessity, such as access to political office, affirmative action

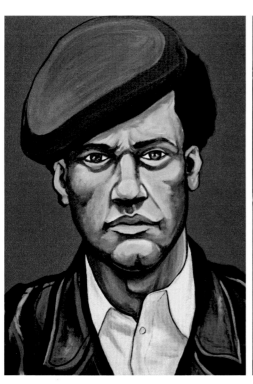

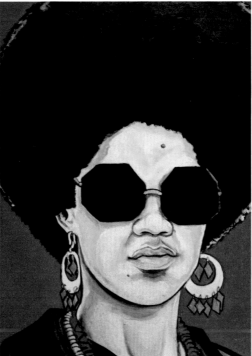

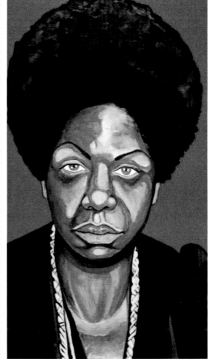

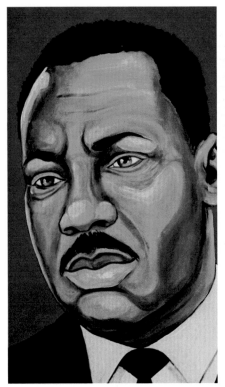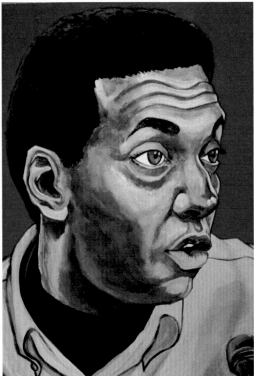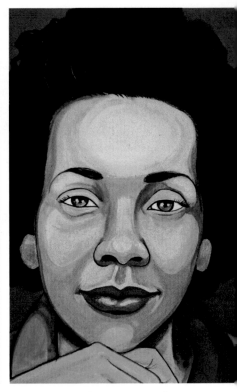

in employment, higher education and housing. Poorer members of our citizenry received food aid and welfare. We even got a President of The United States of America that looked like us, a Black face on the machine of oppression.

Amid all that well-publicized government action, we also have seen less-publicized backward progress. The population of our jails and prisons has risen to more than 2.3 million in half that time, prompted by a war on drugs that has fueled a prison-industrial-complex that functions with a population of which 75-percent of the inmates are Black or Hispanic. Even though there is no statistical evidence that Blacks use or sell drugs at higher rates than white people. We are being targeted.

We have seen the state of our inner-city public schools deteriorate and their

funding evaporate while the private sector has grown and big businesses continue to receive tax breaks and make millions on the backs of taxpayers.

We have seen our children misdiagnosed, miseducated, and misunderstood in our crumbling public school system while over 1.1 million fathers sit caged behind bars instead of being present in the lives of their kids. We have seen our communities turned into warzones where the colonized, disenfranchised, and the oppressed are free to kill each other or be killed by the police, or by the poisoned food we are left access to in the many food deserts we occupy.

The frustration grows
How do you bring about a change when the entire system is fueled by your own self-destruction? You have to burn that system to the ground. We cannot expect

any more concessions or progressive reform from that same system that we believe to be broken. We have to take the responsibility upon ourselves to take back our communities through actions, not words or rallies, or empty threats and vailed promises — absent the ability to provide certain resources for ourselves.

It is impossible to have true power without ownership.

And what do we own? Nothing. What place do we have to call our own that is worth taking care of? Nowhere.

When you look across the country, every major city has a China-town, a Jewish quarter, and a Little Italy. All races and cultures have places, clubs, and safe havens where they can still feel at home in a foreign land,

where they can experience their own culture, dine on their native cuisine, shop in familiar establishments, and support their own businesses in as authentic a way as can be done in a foreign country. They own banks and have forged housing and labor unions to lobby on their behalf. They all have their own nations within this country—a home away from home

But where is our nation?
Where is Black America's safe haven? Where is our hub for our native cuisine and Black-owned businesses? Where are our Black banks? There is no such place out here for us; our neighborhood hub is anywhere drowning in poverty and crime and sickness and drug abuse. Our native cuisine consists of chicken boxes of pigeon wings, half and half's of iced

tea and diabetes, and steak subs drowned in grease, mayonnaise, and pretty much anything else that clogs arteries, raises cholesterol, makes us sick, and kills us way too early. America throws a dinner party every night for the rich and the bourgeoisie, but never, not once, was there ever a place at that table set for me.

Black Power is Black self-determination; Black self-identity, Black Consciousness, Black Love, but now more than ever, it has to mean Black Unity—a united revolutionary opposition to the oppressive power structure set against us.

And if you have a problem with me referring to the power-structure as oppressive, you need to re-assess your own reality.

Oppression by definition
Any system that has only five percent of the world's population and 25 percent of the world's prison population is, in fact oppressive. Any system where one in three Black boys is statistically destined for a life in and out of the prison system is, in fact, oppressive. Any system that can claim to be the greatest country in the world while what we really do lead the world in is dysfunction:

• The highest incarceration rates, largest prison population;
• The most reported murders; The most reported rapes;
• The highest rates of crime;
• The biggest amount of arms exports;
• The highest rate of illegal drug use and illegal prescription drug consumption;
• The highest military spending;

• The biggest elections spending, but the most government waste after elections are won; and

• The biggest national debt —
this country is, in fact, oppressive.

In actuality, America is one of the most oppressive, dangerous, corrupt, hypocritical and deceitful countries in the world today.

A unvalued underclass

Where is a Black man or woman's place economically in this country? What are we needed for? What is our use? What resources do we provide? For capitalism to truly remain sustainable, there has to be a permanent underclass. The invisible ones, the forgotten ones, the ones who are willing to do the jobs that nobody else wants — the labor jobs that pay little wages and require the most work. For a long time, those invisible ones were just those with ebony skin.

With a largely growing population of immigrants moving to America, willing to work jobs for less pay and no benefits, there is no real need for the Black man or woman as a manual laborer anymore. Unless, that is, if it comes as free labor from our prison population, which has further eroded the job opportunities for what's left of the Black working class.

More than at any other time, Black Power has to mean unity and solidarity. And that unity must also be expressed through the spending, or lack thereof of the Black Dollar.

The Black Dollar is one of the most powerful resources that we have, and we need to make better use of it. Black people in this country have $2 trillion of annual spending power.

Time to create new cornerstones

Imagine if we identify the cornerstone Black businesses and business owners in all of our communities across the nation, the ones creating jobs and other economic opportunity for members of the community, and start supporting them with Black Dollars. If used correctly, that spending power could be translated to our own schools, banks, unions, housing and jobs… there is no limit to what we can build when we organize and mobilize our vast resources.

There is plenty we can do right now.

We can start weekly literacy and tutoring programs in our most impoverished communities, run by community leaders and role-model figures that the people in the community trust and can relate to. We also need a major community investment in our Public education system. Our young scholars need more field-trips and site based learning experiences. We need more book clubs and debate teams with relatable cultural content. We should be partnering with tech companies to provide training and resources for our students in industries that will set them up well financially for life.

We also have to address the prevailing issues of misogyny, sexism, and homophobia that still divides us as a people. We have to get past these problems in order to get anything accomplished, people. We can't raise hell on behalf of injustice against Black men but then be silent when it affects Black women, Brown people, or the Black LBGTQ community. All of our struggles are connected.

We can start holding our churches, mosques, and community organizations accountable to the missions that they are supposed to stand for in the role of uplifting the Black community. They should be finding ways to create jobs and economic opportunity for the people in their congregations and the people in their neighborhoods.

Close the gaps, child by child

They (Churches) should be finding ways to help to close the gap in the education of our children. Sunday school should also help to prepare them for what they face in their own school; if they can learn about doctrine then we can also teach them about their real history. They also need to start using the lands and property that they own to start hosting community gardens and food-banks with fresh produce, especially in our food desert areas where people need access to them the most. All of these things would start us down the road towards being more self-sufficient.

We also need to take full advantage of the Black Vote.

Although historically, the vote has been used as a tool of oppression against us, we cannot deny its importance. Many people may not be familiar with Malcom X's perspective on the subject of "The Ballet or the Bullet," but the basic premise is sound: If Black Americans believe neither candidate of either political party is a suitable choice to champion the causes important to Black people, then we shouldn't vote for either until a proper candidate is presented to us.

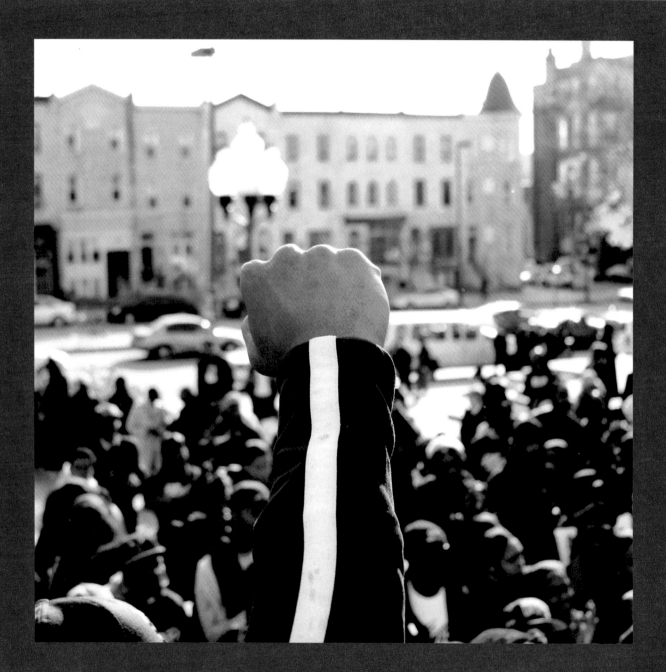

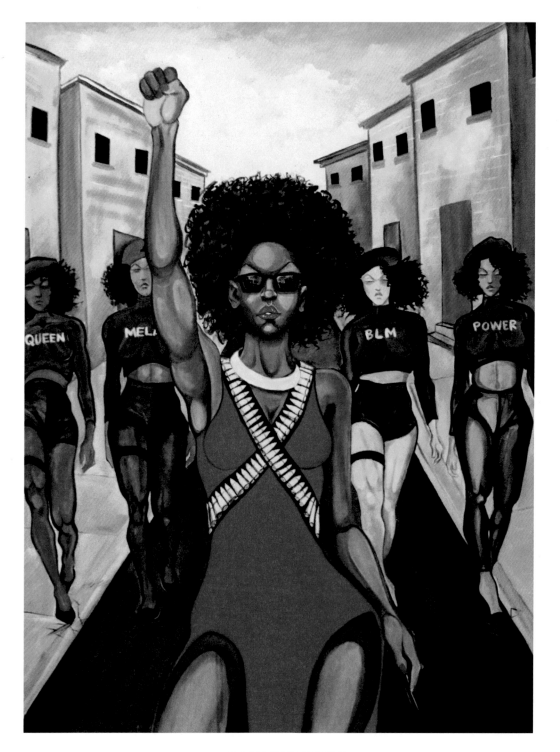

Seeing the problem's not enough

While we may not acknowledge a commitment of our politicians to advocate on our behalf and represent the best interest of our people, we still have work to do. When we don't make sure all of our people are registered to vote, when we fail to make a record of what our most-pressing issues are as a community, we allow them to be ignored, marginalized, and overlooked, rather than at the forefront of all political campaigns. Most of the issues facing the Black electorate on a large scale are state-sanctioned, not federal. That, in turn, makes local governor, mayoral and City Council elections much more important than the presidential. The president could not fix all of our problems if he wanted to.

We have to re-educate ourselves on the voting process as a whole — fighting mass incarceration with a mass- education effort.

We cannot just think that we are winning by electing Black public officials to office, because only Black politicians can so easily get away with neglecting the issues facing Black people. "All Black" aint never meant "all good" for Black People. We need to start identifying young leaders at a community level and grooming them over time to build our own political candidates.

Lessons from Obama's presidency

As we saw with the Obama presidency, when you have a powerless Black man as the face of a nation, there can be no implied racism from the power structure itself — because of course no country with a Black man as president could ever be racist in its treatment of Black people. Powerless? When a man elected to the nation's highest office cannot get Congress to support initiatives like the Dreamers Act, and then the courts overrule his administrative command to stop immigration officers from throwing Central American refugee children back into the dangerous lands their parents wanted them to escape, that's powerless. When a Black man elected president cannot get his judicial appointees – and even Cabinet appointees -- confirmed by Republican lawmakers who, not so long ago protested to Democrats that Republican Presidents deserved to have their "own men" in office, that's powerless. Its also hypocrisy.

The system mandates the actions of the individual in office, and the individual does not influence the attitudes of an already functioning system. So this system, the same one that was birthed from acts of wholesale enslavement, rape, theft, violence and genocide; the same system that was built on the bones of Black and Native American people, and continues to profit from their dehumanization, must be changed, both socially and through public policy. If we can organize 50,000 voters in the city of Baltimore, and others around the country, with the same grievances under one political organization and all agree only to vote for the candidates who are willing to address those issues, we can begin to manifest that change. City by city, state by state, from the projects all the way up to the White House.

Eyes on the occupiers

We also need to protect our communities and ourselves by monitoring the actions of our occupying army, embodied in our renegade Police Department. By recording all interactions with law enforcement, especially at traffic stops, we can begin to identify corrupt police officers specifically, and start to lobby against them to get them off our streets. We have to remember that the police themselves are public servants, they are supposed to work for us — so we, the American taxpayers, are the ones that they should also answer and be accountable to.

Though the majority of my content comes from a deep place of love for my people as well as my country and the idea of what it's supposed to represent, most will condemn my perspective, calling it divisive and racially insensitive.

But let's imagine for a second that you are in a 400-meter relay race against 4 other teams, but your starting point is 100 meters behind the rest of them. Is your team wrong for doing whatever is necessary to make up the difference? All we want is for the starting point for all of the teams to be the same. So until that happens, we have to focus on running our race.

Black Power, a proper goal

Black Power is Black Consciousness, Black Pride, Black Nation-building, not Black Supremacy. When have we ever as a people manipulated laws and institutions to subjugate white people, or any people for that matter?

Black Power is a reactionary response to the systemic and generational constructs of white supremacy that prevent any African Americans from exercising their constitutional rights to life, liberty, and the pursuit of happiness. #BlackLivesMatter does not mean that all lives do not matter.

But the fact remains: All lives aren't six times as likely to spend significant time in jail.

All lives don't end up dead in overwhelming numbers at the hands of renegade law-enforcement officers.
All lives don't grow up living in colonized, impoverished communities drenched in drug addiction, sickness and violence while being expected to turn out normal.

All lives aren't studying in overcrowded, understaffed and underfunded school systems with 10-year-old textbooks, 90-degree-temperature broom closets for classrooms, unhealthy food, and unfit learning conditions and then expected to get a decent education.

All lives aren't statistically more likely to end up in jail or dead than in college by the time they are 21.

All lives don't matter as long as the Black ones are being exterminated.

And until the genocide ends, all lives will have to wait their damn turn.

In-clusion, or ex-clusion
Black Power is not a movement of exclusion, but one of inclusion.

We cannot be operating and organizing in independent siloes on our path towards the liberation of our communities. Black Power is for the Black communities, the Brown communities, the Latino communities, the indigenous Native American communities, Indian communities, Palestinian communities, and African communities.

This struggle crosses state lines and across the great seas and oceans, to the lands where our people still are being persecuted on the other side of the world. It intersects with the plight of women's rights, feminist movements, and the ongoing struggles of the LBGT community. Black Power is the platform by which we declare that we all stand together in solidarity against any structures and institutions that would seek to objectify, exclude, persecute or oppress the unalienable human rights of any people based on race, gender, sexuality, religion, or class. We are all stolen bodies on stolen land, and our futures are indeed intertwined moving forward.

This country was built with 400 years of Black Power, none of our wars would have been won without the skill and ingenuity of Black Power, and many of the great accomplishments in this country's history were achieved by the resourcefulness of Black Power. A great deal of the inventions and patents we use to this day come from the intellect of Black Power, and if this country still has a future, then that future will be cloaked in the excellence of Black Power!

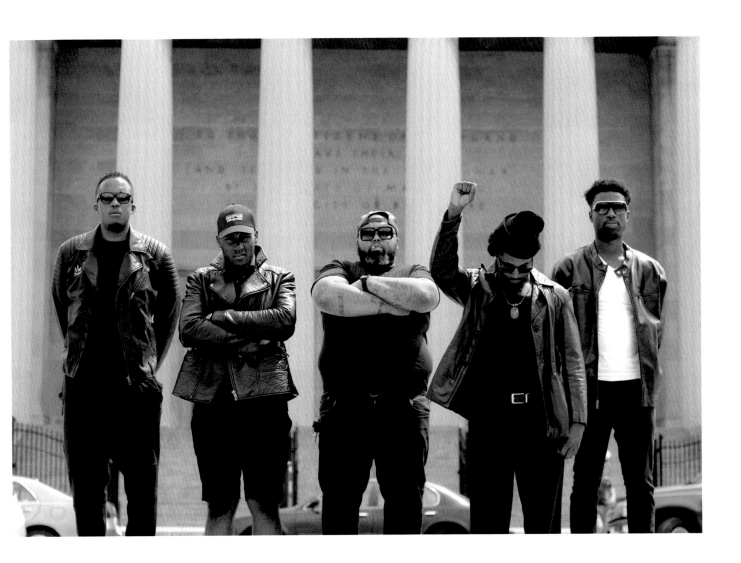

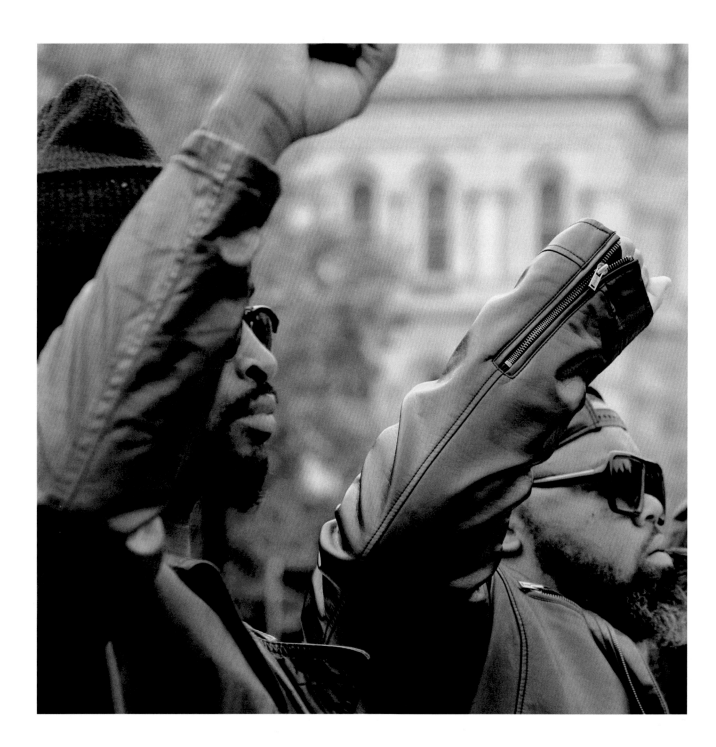

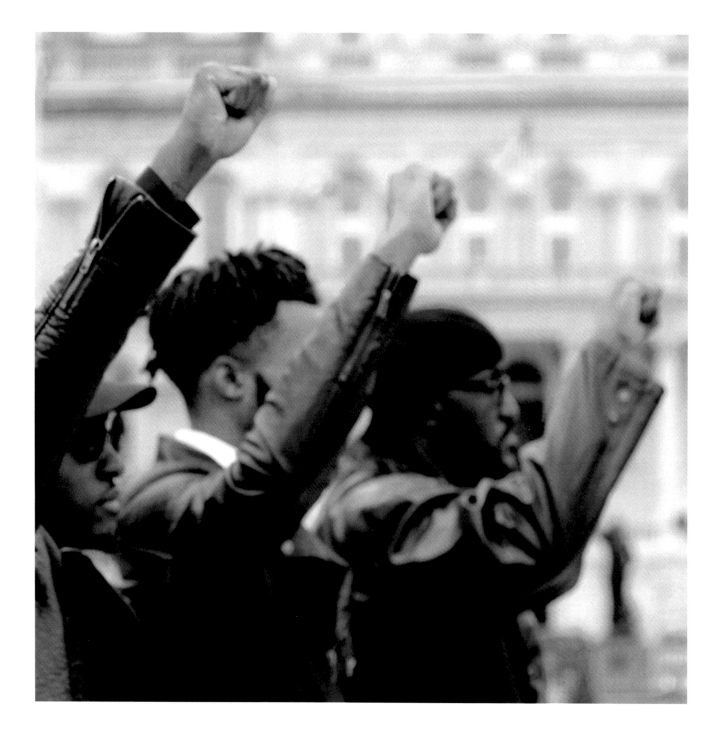

Welcome to America

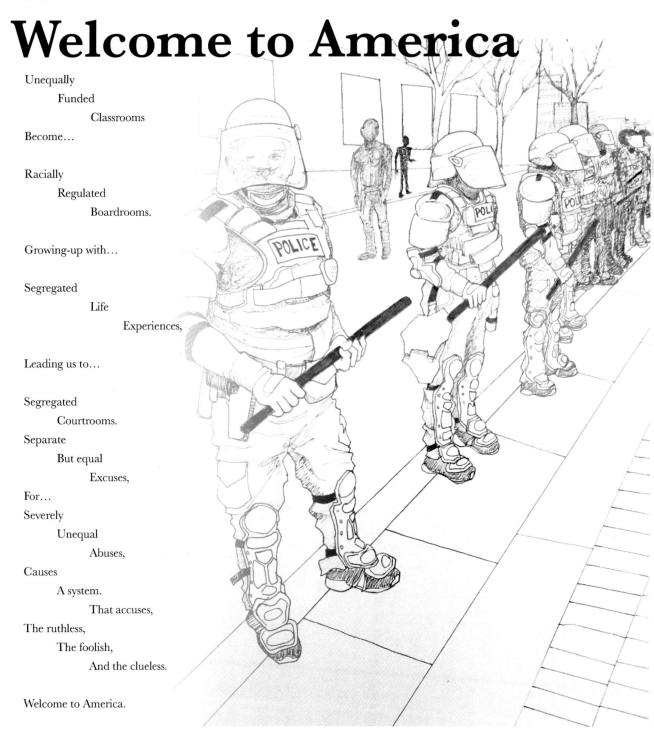

Unequally
Funded
Classrooms
Become…

Racially
Regulated
Boardrooms.

Growing-up with…

Segregated
Life
Experiences,

Leading us to…

Segregated
Courtrooms.
Separate
But equal
Excuses,
For…
Severely
Unequal
Abuses,
Causes
A system.
That accuses,
The ruthless,
The foolish,
And the clueless.

Welcome to America.

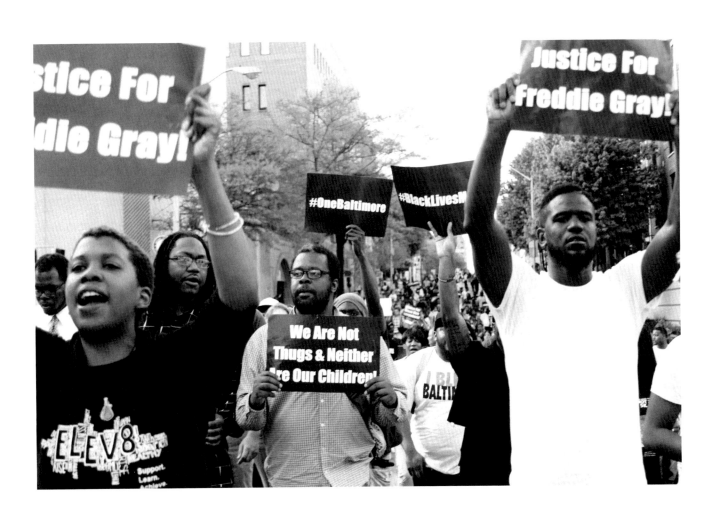

Hustlers' Tales

Nobody forced me
To sell dope.
They just paved the road
to destruction—in Gold.
Now I'm sitting here
Locked away in a cage,
Contemplating my eternal soul.

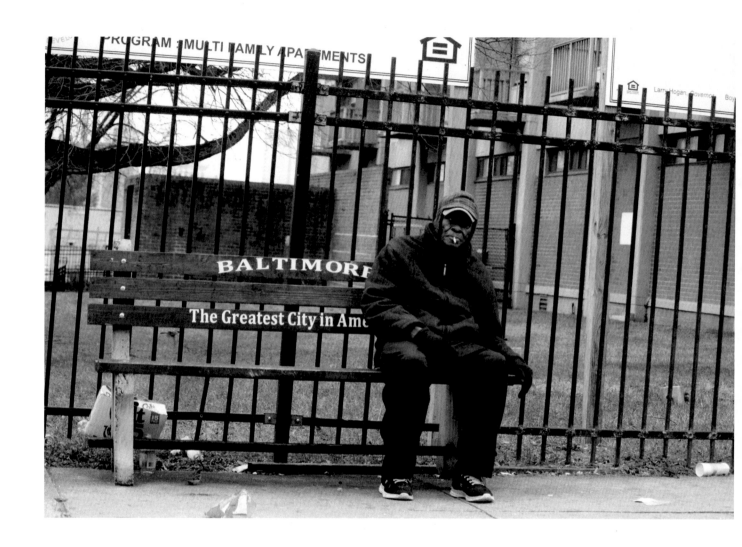

Homeless in the City

Poverty Party V.I.P's
Lifetime memberships
in the tribe of lost boys
And broken men.
Faces cracked,
Scarred…
& worn from the years.
Casual strangers,
Tend to Present eminent danger
To those that don't care
To see their pain.
Black dead faces…
Frozen. Stagnant. and still.
As if the night meant
to leave them there,
And trapped them
in these streets against their will.
One day I asked one of them,
What does a good day consist of?
He said," Panhandling and selling loose-ones n' socks
In these streets,
For a good quick come up,
To put some hot food and cold liquor
In my hollow & empty gut.
Before I close my eyes
to find some sleep tonight.
And awake in the morning,
with my eyes frozen shut."

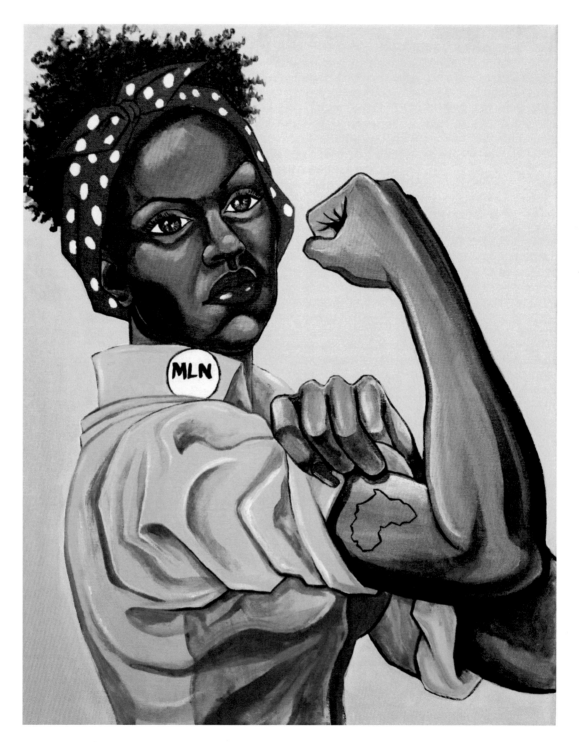

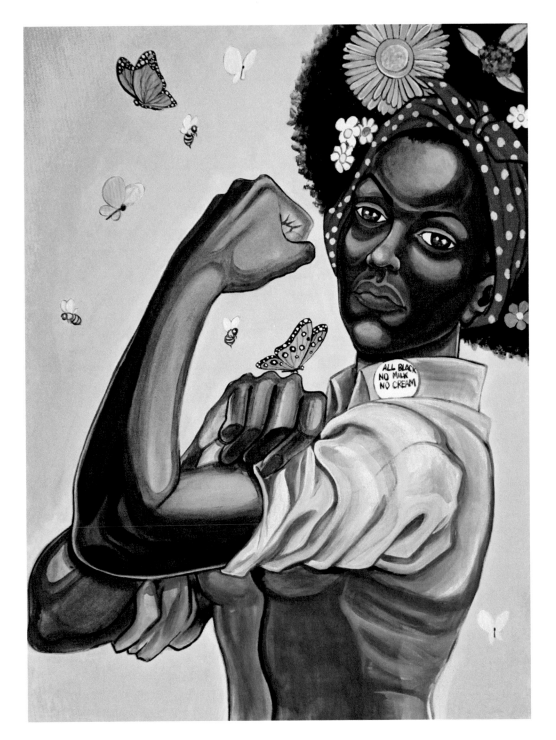

Black Girl Magic

Everyone knows about Black Girl Magic. It's the magic of your Mom, Grandma or Auntie who used to make urban legends of themselves by always doing more with less. They are 'Hood scientists and street magicians, turning half-empty cabinets of random groceries into five-course gourmet meals. Turning curly and tightly knotted Afros into elaborate and complex hairstyles of corn-rows and Bantu knots and beautiful tapestries

of barrettes and buns and clips and pins and bands, and twisted locks wrapped in kenté-cloth and tribal textures and every color under the sun.

And that was before the lady ever broke out the hot comb.

The Black woman is an artist in her being, making the balancing act of keeping families fed, clothed and loved, nurtured and

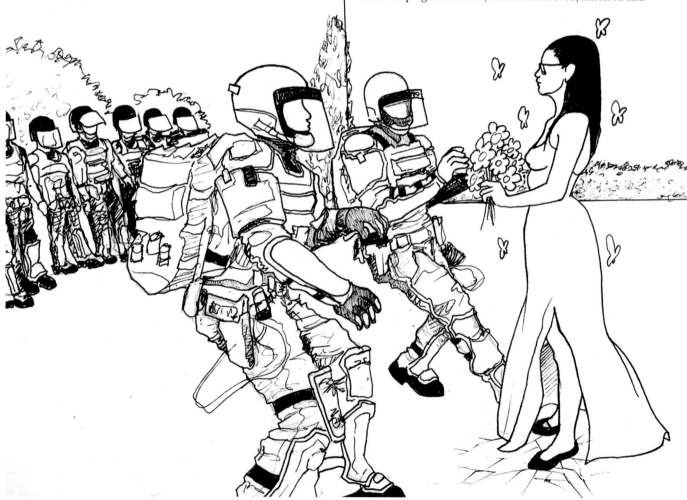

provided for look easy as the simplicity of riding a bike or jumping rope. The Black woman is the embodiment of urban folklore; day after day year after year, Black women remain consistently resilient, resourceful, graceful and powerful in the face of oppression, violence, aggression, and prejudice.

Their strength a gift from above

The Black Woman is God's reflection. She is Harriet Tubman, Assata Shakur, and Angela Davis, she is Nina Simone and Maya Angelou. She is as bold as Josephine Baker and as gentle as Anita. The strength of Black women is evident in every element of their being; it's in their resilience, their optimism, their compassion, and their consistency.

They are the heirs to the thrones of those who survived the middle passage. They're the ones that posses the everyday quiet strength and steady wisdom that overpowers grim circumstance or bleak adversity. So why don't we celebrate them more?

It's incredible to me how our female creative genius often goes without recognition and rightful celebration. The Black woman is constantly standing up and showing up in support and defense of Black men, celebrating us for our accomplishments and demanding justice for violations against us. They are our backbones when we stand and our crutches when we fall. They speak up for us when our voices go unheard. In spite of this, Black men seldom reciprocate that same support.

Disrespect from too many men, into too many places

Every day, all over the world, Black women face violence, oppression, systemic racism, and the hyper-sexualization of their bodies by men with fragile masculinity issues, patriarchal society structures, and living in a society meant to destroy everything that they are. This even applies largely to the relationship between them and Black men.

I remember being a kid, watching the neighborhood girls often being hounded, hassled, and cat-called all day while simply trying to walk down the street to the store, or home from school, or to her car. I think about how common it was to hear them being called bitch or whore by Black men who five minutes' earlier were asking for their phone numbers. I remember having a conversation with a woman that said being a Black woman that likes Hip-Hop is a lot like being in an abusive relationship. Reflecting on this, I think about how frustrating it must be for women to feel constantly attacked from every direction, even in the lyrics of the most popular music that they hear every day over the air waves and in recordings.

Sometimes, normality is abnormal

The problem with societal norms and our established gender roles is that we usually seem to think about issues of inequality and injustice in a vacuum, and it generally ends up being discussed strictly from the male perspective. That usually leaves the female voice and perspective unheard, unaccounted for, and largely unaddressed. That's one of the many ways sexism runs deeper than racism.

For some of us men, acknowledging patriarchy and male privilege can feel a lot like a slow, agonizing death, not because we don't recognize it, but because it's the only identity we know. From a young age, we are molded and socialized by society to view the world from a position of male privilege. We are taught that we are the leaders and that the world was made to bend itself to our will. This can be a difficult vision of the world from which to disassociate ourselves. It is the same way of thinking that sees women marginalized and devalued in the workplace, where a lot of talented, well qualified women are passed over consistently for promotions and wage increases while men without the same qualifications gain the career rewards. All this happening despite the fact that Black women are now reported to be the most educated racial group in the country, over Asian woman, white women, and even white men.

What we men must do

Our job as Black men should be to acknowledge our position of male privilege and use that position to help create safe, inclusive spaces for our women to excel and thrive in all environments that we share. This is something about which I have to check myself constantly. No matter how inclusive I consider my perspective to be, my vantage point is still that of a Black man, so I am constantly finding new ways of forcing myself to try viewing all situations from both the man's and the woman's perspectives, to practice being open to understanding other arguments besides my own.

It is not our place as Black men to define anything for our women. They can speak for themselves, the same as they can define who they are and what they want for themselves. They are more than capable of determining for themselves how they choose to be defined and represented. It is their choice of which oppressive structures they wish to challenge and how they choose to frame that challenge. The way they dress, how they date, the way they choose to identify based on gender and sexuality is completely up to them, and those characteristics should never be used as tools for oppression against them, especially from Black Men.

We will all rise together or fall together

In a world where both men and women of color are being persecuted, we all need to be uplifted, valued, and celebrated by one another in the same way as members of many other cultures do. We should be proud of our respect and admiration for each other and be eager to hold each other up.

I admire the Black woman for her ability to make holding the world together look so easy. I admire her because I know that it isn't easy — it is hard as hell. And no matter how effortless she makes it look, she should never be taken for granted. I admire her for her ability to be strong for others, when she barely has enough strength saved for herself. I admire her for her style, for her grace, for her ambition, her compassion and her ferocious energy.

There is no stronger human being in the world than the Black woman. In spite of every oppressive structure and systemic obstacle set in her path, As Maya Angelou so eloquently once stated, still she rises. She finds a way, not to just survive, but to thrive. She has every right in the world to be audacious, to be fearless in her desires and ambitions. Every Black woman deserves to be celebrated for her Black Girl Magic.

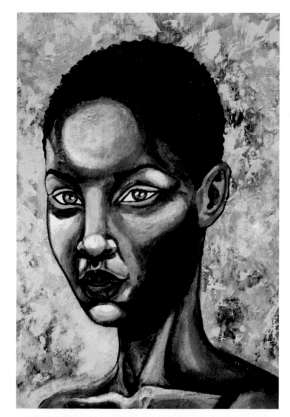

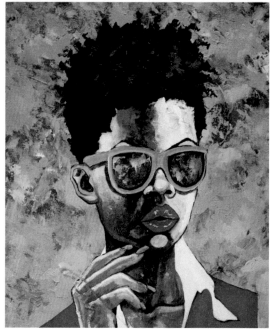

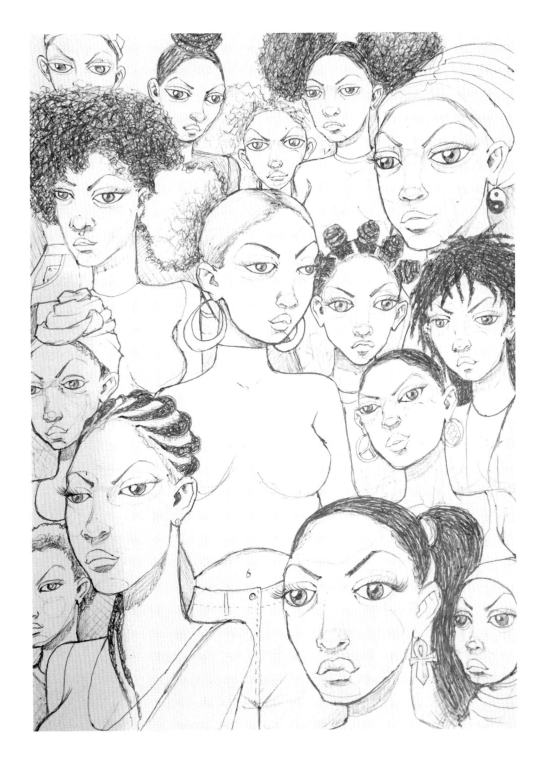

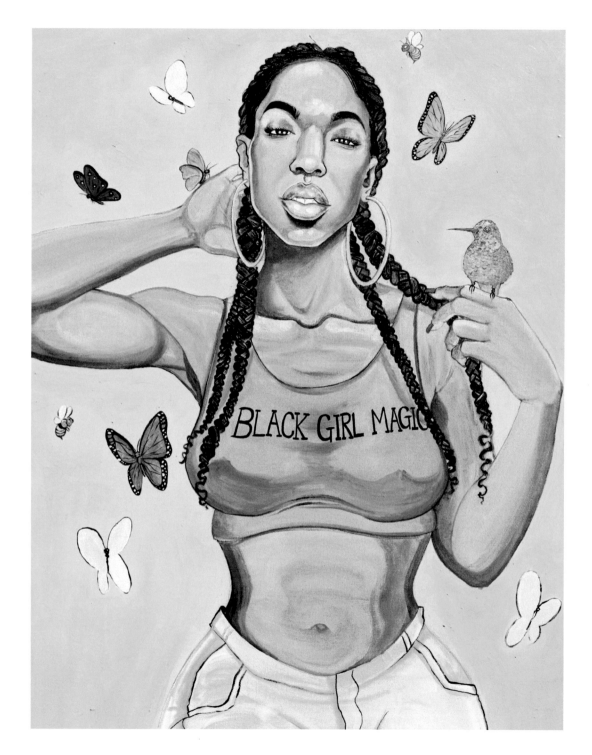

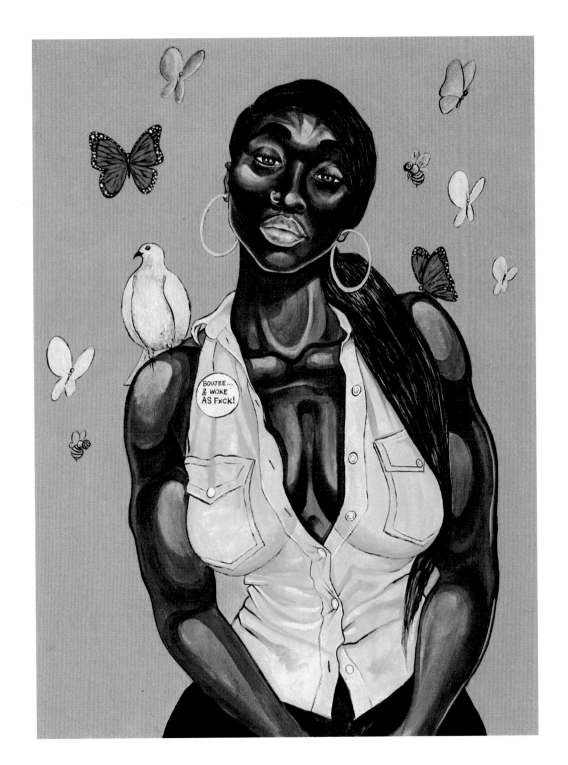

Muse

Take the head-wrap off
Let your hair down
Now mess it up,
I like it like that
Put on that little black dress that I like
Let's create
Slow down time for a bit and kick-back
Slow dance with me to Anita
Let's forget the day and time
We'll take pictures
I'll write some poetry
 Help me figure out this next rhyme
Turn the music up for me
Hennessey and Apple Juice?
 Sure…
Two ice cubes please
Sit still… just like that
I want to paint you in this light
Slow down
 Sit still…
 Lean back a bit…
Now hold it…

That's what I like
Let's converse without speaking
Let's be intimate without touching
Let's climax together without sex
Let's talk about the pyramids
Come with me for a walk
What inspires you?
 Is that why we connect?
Sing for me…please?
Soup, Sage, and Spades while we talk
Hughes, Bop, and Bach while we dance
Warm tea and honey when we sing
Ginger, gin, or Jim (Beam if your feeling sick)
Forget our comfort zones and have a fling
Let's be foolish
Let's have fun together
Let's enjoy the bliss of being free
Let's create around the world together
Just you,
 Your wildest dreams
And me…

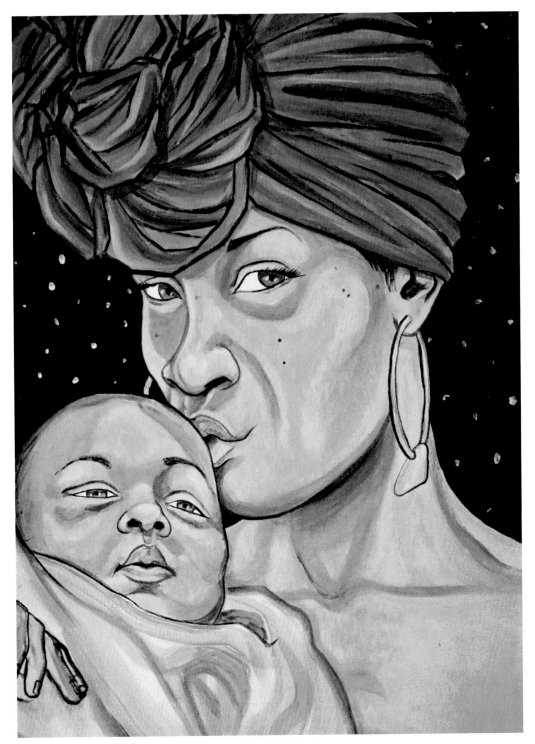

A Black Love

Beloved,

It is with a heavy heart and humble tongue that I write this letter to you now. Before you or I had shape, form, or purpose, we were one: One spirit, one body, one mind. But I came into this world forever in your debt, because there is no "me" without "you." From the time I was made in your womb, for months I was nurtured by your warmth and your love, until you pushed me out kicking and screaming into this world, then nursed me from your own supply to make me strong. You made me. You raised me, you've consoled me, you've protected me. You've taught me, shaped and formed me. All that I am is a result of the strength and love of the Black woman.

Time and time again, you have defended me, you've fought for me. You have raised your voice on my behalf, protected me, shed your own blood, and died for me. When the world told me I was nothing, you reminded me that you could see greatness in me. When the enemy tried to demonize and humiliate me -- called me a thug, a nigger, a statistic, a failure, and a predator -- you picked my head

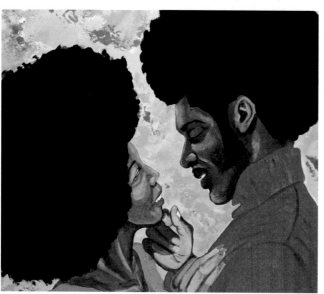

up, wiped the tears of shame from my face, looked me in my eyes, and called me a King. When the world tried to break my body, you shielded me with your own.

I have seen your love

I have seen your tears water the cold concrete streets when my blood was spilled. I have seen your glaring eyes pierce through the souls of those who sought to bring me harm. It is as if the world itself decided to beat me, break me, and bury me so that you could pick up the pieces and build me back up, brick by brick. And every time that I have found myself as such, you have always been there, as my shadow, my confidant, my friend.

After seeing the sum of all my parts, and realizing that even divinely made beings can be fragile, broken, and empty, still, you loved me. After peeling back the layers of a manufactured persona and looking beneath the masks of all the illusions and fake emotion, you saw me, at my worst, but still, as someone not just worthy of love, but deserving of it. That is the kind of unconditional love that can only come from a Black woman. For that, I thank you.

The angel in my ear

You have been my biggest fan when I've done well, and been my most needed critic to hold me accountable when I've fallen short. You are the voice of reason in my ear when my own conscience is jaded and cloudy. You have reinforced my internal resolve when my tank was on empty. You have sacrificed for me, you've prayed for me, you've supported me, you've believed in me. You have been the anchor to my ship that has kept me from drifting off into the abyss.

So I'll admit that when I look at myself, I'm often ashamed that I have continuously fallen short of deserving the love that you always have so passionately, openly, and unselfishly shown me. And as I write this letter to you, I'm embarrassed that I ever could have

Letter

treated you like you were merely a resource or a tool to be used at my convenience and discretion, rather than my partner and companion, the better half of the best parts of me.

I have taken your love for granted, I have taken your commitment for granted, I've taken your compassion and understanding for granted. I've taken you for granted. I have taken from you, but given you little of myself in return; only that with which I'm comfortable. Which is even worse sometimes, because of the fact that your love for me has never been conditional.

Regrets that burden me

So it is with a humble heart and sincerest regrets that I say to you that I am sorry. I am sorry for letting you down when you needed me to be there for you. I am sorry for not stepping up beside you at times when you stood alone. I am sorry for staying silent when you needed a voice raised on your behalf. I'm sorry for every time that I stood aside and allowed someone to make you feel uncomfortable in your own skin.

I'm sorry for every stone that I contributed to building these mountains of silence and empty space that now sits between us. Because every missed opportunity to appreciate you and every unsaid "I love you" that went unspoken was a piece of my own heart that I chipped away. I am sorry for not loving, supporting, protecting, appreciating and lifting you up as a strong and beautiful Black woman, the same way that you always, thanklessly, have done for me.

If you are angry at my absence, believe me when I say that I understand. If you are hurt by my silence, I can relate. If you feel betrayed by my apathy, I can sympathize, if you are fed up with my inconsistency, believe me, I feel you. But please, don't give up. Don not give up on me. Don't give up on us.

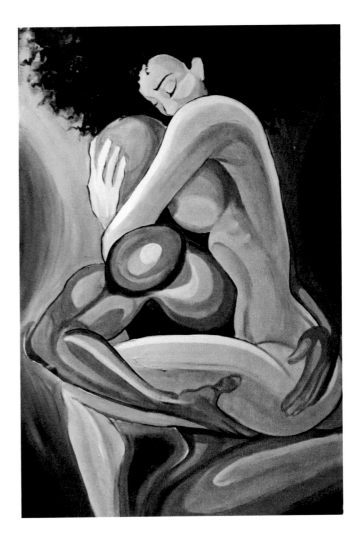

Hear me now, and we can grow together

All I ask, as sincerely as I know how, is that you hold on to that same confidence and belief you once had that told you that I could be better. The same belief you instilled and reinforced within me. I can, and I will be better. We all will. We have to, because there is no other alternative. Our fates are, and always have been intertwined. My successes are yours, just as much as your failures are mine. So if you see that I need guidance or instruction, teach me. If you need my wisdom or understanding, be willing to listen, so we can grow together, so we can learn together, so we can build together.

Please understand that my evolution is a process. The world tried to steal my love from me. Taught me not to love myself, not to love my own skin, or my hair, or my nose, or my lips. The Outsiders who brought our ancestors to the New World taught me to hate and devalue myself, to feel as if I was a fool. And that self-hate was made real by the way I would feel when I saw my own reflection in you. As I learn how to love myself, I move closer to truly understanding how to love you in the way you deserve to be loved, without boundaries or limits. I am not excusing my past behavior or trying to justify my acts of indifference. I am acknowledging that each step that I am able to take toward finding myself allows me to take another step toward finding you. All I ask is that you continue to walk with me, because I cannot make this journey alone.

A legacy we must recover

We share a stolen history. A legacy of family, culture, language, dialect and traditions that we both long for, but will never know as our own. The only history we both know is that we are the descendants of a mighty people -- stolen bodies on stolen land. The living, breathing embodiments of Charles Darwin's theory of survival of the fittest, through lineage dating back to the dark passage that saw all the weakest of our people discarded as useless cargo, thrown over the edge of ships sailing across the sea, to a land where we were never meant to roam or live free. But we want our birthright back, this land belongs to you and me.

Our power has kept us alive. Our Blackness has tied us together. But our love is what will not allow us to be broken apart. Our community is depending on us to build each other up as we address confronting the systems set against us together, and in this, I will not fail you. I refuse to. I promise to fight for you as ferociously as you have always fought for me.

For all these things, I love you

I love you for your passion. I have a deep admiration for your strength, and for your resilience. I love you for the fact that no matter how hard they tried, our oppressors could not break you, or your undying spirit. Enduring misogyny, rape, the destructiveness of patriarchal society structures, along with all the other obstacles set against you, still, you rise.

In the face of every obstacle and roadblock set in your path, you remain steadfast, resilient and committed. And at this point, I need you more than ever before.

I'll need you to help me keep my balance as I try to juggle the issues of life while staying on the path towards my goals. I'll need you to stand beside me in good times, so you can watch for the coming bumps ahead on this long road still yet before us. Sometimes the weight of the world will be too heavy for me to bear alone, and I'll need your strength and resilience to help me shoulder the load. At times I'll keep you in front of me, trusting in your vision and guidance to lead us through. Sometimes I'll need you to stay behind me, so whatever's coming at me won't come close to touching you. But no matter what the situation, I'll need you to help me make it through.

For our sake, for our children's' sake, for our futures sake.

An ode, and a promise

This letter is an ode to Black Love, because it is real, because it still exists, and because it is one of the few connections that we still have left that can never be broken. This letter is an appreciation note for Black women, because when I look at all of you, I see God's face—and when you touch me, I feel her love. Most importantly, it is a promise and a vow to our children, that I will not allow our love to die before they have a chance to learn and understand it, so that one day, they can know it for themselves. Because above all things, the greatest gift that God has given me is your Love. I anxiously wait for your response. Let us tell the world the story of Black Love. Together.

A Black Love Letter

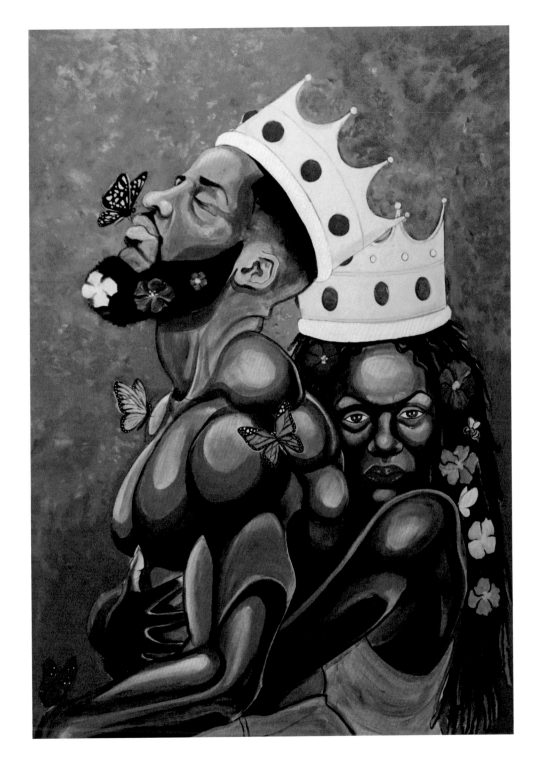

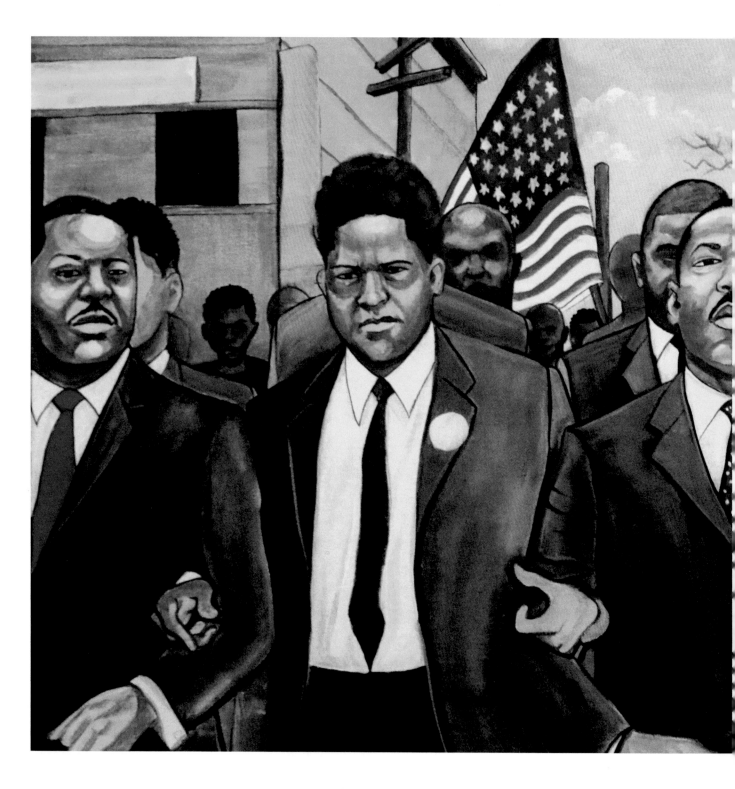

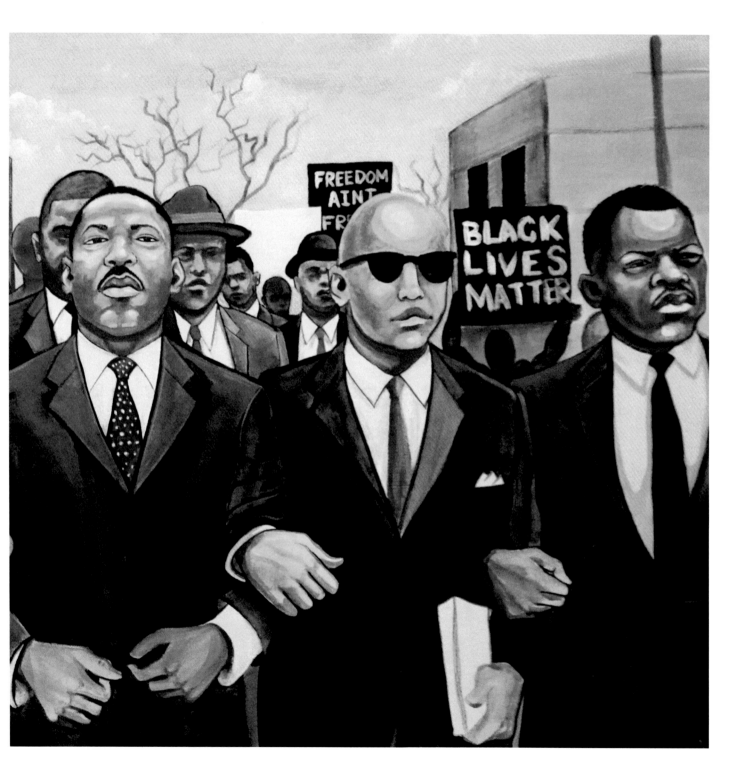

Where Were You?

Where were you?
When all this madness first began?
On the front lines?
The sidelines?
Or were you cheering in the stands?
The first time you heard
Someone you knew
Was gunned down in the streets,
Were you screaming Black Lives Matter then...?
Or Thank God it wasn't me?
When did it become
About "me"
More than "we"
In a world where were all being hung
From the exact same tree?
When did we
Become judge & jury,
On who and what
Others could be?
Shooting shots
In the dark,
Just hoping to hit
Anyone doing better than me.
Where were you?
When our city first erupted
In anger and rage?
Where were you?

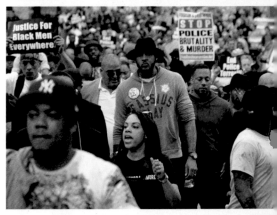

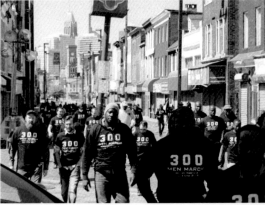

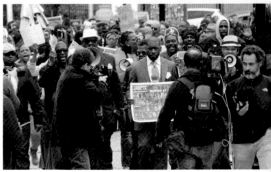

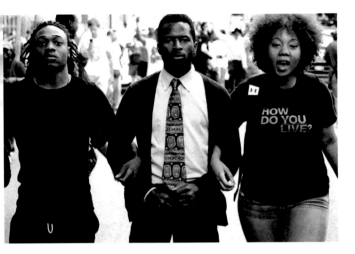

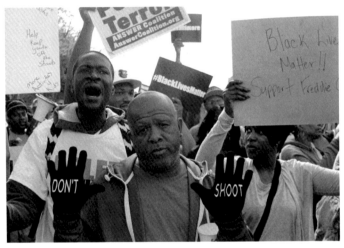

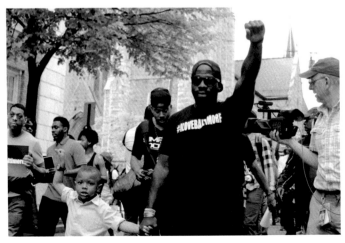

Before all the cameras came
And provided you a stage?
Were you on the front lines then?
Trying to enlighten and save,
Or were you too busy,
On IG, chasing likes off the popular page?
Where were you?
When our kids became disengaged?
To the resentment of death,
Before coming of age?
Did you care to take time?
To change their young minds?
Or show them a better path,
Than that of violence and crime?
Were you out educating them then?
Were you out motivating them then?
Sacrificing and investing your heart and soul into them
then?
Where were you?
When our small businesses first began to fail?
Or when they started starving out our schools
And putting our babies in jail,
Parents spending
College tuition
And life savings
…On bail.
Entire generation's future
Being impaled,
And derailed
As we war
With each other

While evil prevails.
From where
Does this jealousy
And resentment come?
If we continue hating one another
Can this war ever be won?
Can we learn to disagree?
Without pulling the trigger of a gun?
Or will we continue down this self-destructive path
As we kill ourselves…
One by one?
So I ask u again
From the depths of my soul,
Where are you?
What are you doing?
To make sure we turn this tide?
What are you doing?
To help end this cycle
Of self-hate and Genocide?
What are you doing?
To feed the hungry

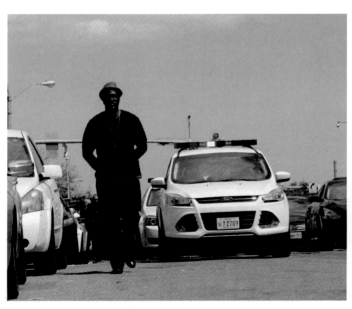

And educate the deprived?
What are you doing?
To give our youth
A chance to live their lives?
Free of the weight of the chains
Still holding our people behind?
Are you willing?
To Fight for it?
Are you willing?
To die for it?
When it all goes down,
Will you lay your life on the line for it?
Years from now,
Will you still be down?
To speak up for it?
Or will you have moved
To the next popular cause
When it gets cool to stand up for it?

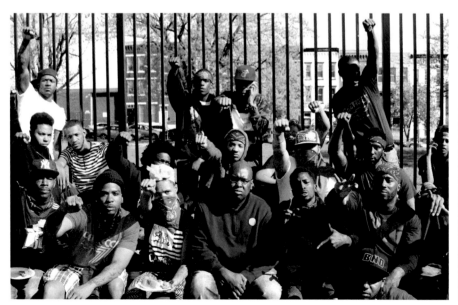
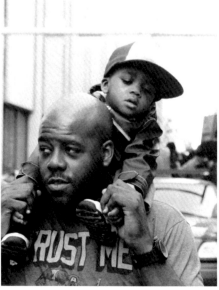

April Showers

Let the April showers wash away
All the sorrow, heartache, and pain.
To purify the soul of one
who has found themselves lost in the rain
Let the April showers cleanse
The blood-drenched shirt upon my chest
To make my body whole again
And give my spirit rest
Let the April showers make full again
The void left in the heart
Of the man who sees no worth in life
when his is falling apart
Let the April showers cry for me
A thousand lonely tears
To keep me sane and help me tame
My inner demons and fears
Let the April showers provide
playgrounds of puddles in the fields for the young.
So their innocence is held tight
As a note in a song that is sung
Let the April showers bring
Me the will to fight-on for another year
And to hold on to the love
And beauty in the lives of the ones I hold so dear
Let the April showers make streams that flow…
flow as steady and smooth as can be.
Let those streams carry me to rivers that run
Until we reach the gentle sea
Let the April showers guide
And create a path in this life 4 me

Blood on Leaves 2015

BY: AARON MAYBIN AND JALELAH AHMED

Blood…
Our blood
Painted the stripes of this flag,
Built the foundation
Of this nation
That we now call our land.
But our story runs deep…

They used to hang us…

Our feet dangling in the air
From the arms of maple trees.
Blood and sweat mixed together
Running down the maple's leaves.
Bittersweet nectar, dripping
Down the sides of the batons,
Rows of Renegade cops
With their Billy clubs drawn,
Rodney King screams out,
"Can't we all just get along?"
Now they choke us…
Eric Garner pleads for life
11 times he cried out
"I can't breathe."
The officer's arm is now the new noose
Swinging from the trees.
His last breath escapes him,
Like the guilty verdict did the Cops that murdered him.
We just can't win.
Not this game we weren't taught how to play,
But were really good at catching footballs,
With hoop dreams of ballin' in the NBA.
Shooting threes,
catchin' Alley oops,
Hanging from the rim,
Like Jesse Thornton's lynched body
Was left
Swaying in
The wind.

We know all our sports heroes.
But, why aren't we taught to remember him?
That same strange fruit still hangs
From the branches of these poplar trees,
We stopped picking cotton
But indeed have forgotten
There is still blood on these maple leaves.
Billy's song still echoes eerily
Through the blocks of my city streets,
While my people blindly wander the wilderness,
Ignorant of the devil's deceit.

They used to hang us…

Our feet dangling in the air
From the arms of maple trees.
Blood and sweat mixed together
dripping down the maple's leaves.
Now they choke us,
They imprison us;
They shoot us down in the streets.
Legal Lynchings still get sanctioned
Even tho they took off the white sheets
Black Bodies still get ravaged
Because they gave up the white hoods
To become some dirty ass police.
We still pleading
Begging for our lives,
Choking,
Gasping,
Screaming out,
"We still can't breathe."
We even wage wars amongst each other
Gunning our own brothers down in the streets
Staying ignorant of the vicious cycle
We allow to be made complete.
The cries of the unheard are still falling on deaf ears,
Because nobody really cares about Black Lives round' here.

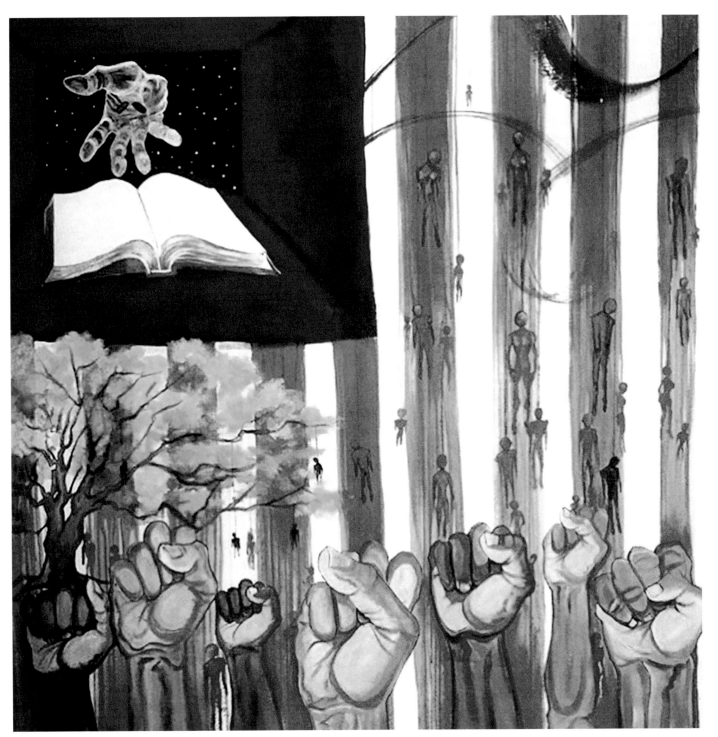

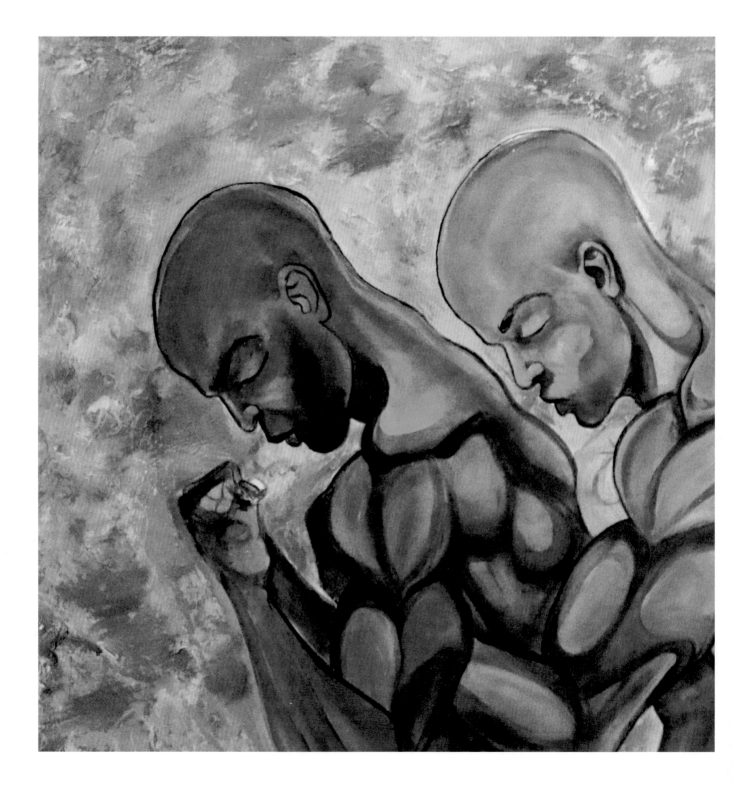

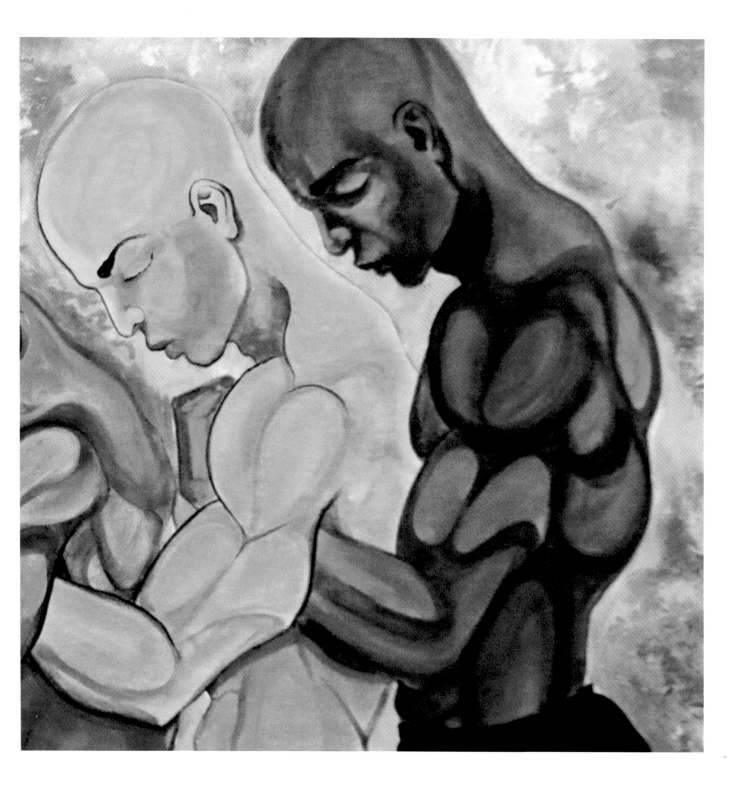

The Other

For most Black Baltimoreans, the "BlackLivesMatter" movement started when the city first erupted in the aftermath of the police murder of a young and unarmed Black man named Freddie Gray. But for me, it started on June 15, 2012 with the murder of another unarmed young Black man by the hands of a renegade cop. That young man was 17-year-old Chris Brown.

Chris was as far as you get from your typical young Black teenager, he was no troubled youth —he was special.

Chris was an amazing kid. He was the kind of child that young parents dream about having and raising. He was the kind of child you really only meet once in a lifetime. He was really the kind of young man that a father would be happy to have date his daughter.

How often do you hear that about a kid from Baltimore?

Chris Brown was respectful, kind, gentle, humble, and even a little shy. He had a smile that automatically disarmed you and made you feel at ease, and he had kind eyes that always seemed to be looking for your approval. When he spoke, his voice was calm, and a little high-pitched for someone his age and size. He had a pleasant and easygoing personality that radiated off him like the light from a star. Even when he was upset or frustrated with himself, he had a certain understanding and compassion towards his opposition that is rare to find in a teenager from the Baltimore area.

A young man with a future

Chris was a rising junior at Randallstown High School in Baltimore County, Maryland. He was a good kid, and a model student. He was a member of the ROTC and the wrestling team. He was on the Usher Board at his church. His teachers at school dubbed him "Mr. Congeniality" because of his charming personality.

I met Chris when he attended an annual football camp put on by myself and two other former professional athletes from the Baltimore area. The camp was a week long, and very interactive in nature. The goal was for all of the camp coaches and mentors to spend as much one-on-one time as possible with the youth in attendance.

For two years, Chris Brown was one of our best and brightest young men in the camp. He was indeed a joy to work with. He was kind to all his peers — even the ones that would occasionally tease him --- he was a hard worker, and he was a perfectionist whenever he was asked to do something.

"Did I do a good job coach?"

"Was I running hard enough coach?" His voice still plays back in my head to this day.

He was curious about life and not afraid of asking questions. I knew that he was the kind of young man that could do pretty much whatever he decided that he wanted to do with his life, and I was excited to see what he had in store for his future.

Chris Brown

His bright tomorrows were shuttered

That future would never come, as Chris' life was stolen from us on a hot summer afternoon.

On the day of June 15th Chris was at Randallstown High when he was approached by some friends about participating in a prank known as "knicker-knocking" after school. It composed of ringing doorbells and running away, and throwing small rocks at random houses in their neighborhood in Randallstown.

Chris opposed the idea because some of the neighbors had complained to the police. He had even commented to his mother two weeks earlier about the pranking, saying that he had tried to talk his friends out of doing it themselves. But for whatever reason, this time, this day, he decided to "go along with the pack" as he reluctantly agreed to go.

On the last stop of the outing, the boys hurled one last rock at the door of the house they approached, the home of James D. LaBoard, an off duty nine-year veteran of the Baltimore County Police Department.

A chase turned tragic

According to the testimony of a friend in attendance named Drailen, Chris was standing in the street at the time, far from the group of teens who threw the stone, but he was slowed by a knee brace that he was wearing when the group took off running.

Out of the house comes LaBoard.

The boys scatter; he chases a group of them through the neighborhood, between houses and across lawns, finally finding and cornering Chris in the bushes of one of the neighbors' yards. After refusing to come out of the bushes, the officer pulled him out of the bushes and according to police reports, "a fight broke out between the two."

Till this day, I can still picture Chris that evening, hiding in the bushes, in fear for his life, breathing heavily in the hot summer air, hoping not to be found by the predator giving chase. Then, while being pulled out of the bushes, I'm sure he realized at that moment that he was in a struggle for his life.

By the end of the confrontation, Chris was dead, and the officer claimed self-defense. The death was ruled a homicide by the state medical examiner, who informed the Police Department that Chris died of asphyxiation.

He was choked to death.

News that destroyed my night

I found out about the story on the news that night.

It was a normal night in Baltimore; I was in the middle of a conversation with friends at my studio when I heard the news anchor say that another kid had been killed by a police officer.

When I focused my attention on the TV screen, I went numb when I saw Chris' face. I could not believe it.

"That can't be him, man — no way! That can't be Chris that got killed!"

This could not be real. I have dealt with thousands of youngsters over the years through work in the schools and through my foundation, but never one quite like Chris. I've worked with many kids with behavioral problems of many types, but that wasn't a part of Chris' nature.

"This had to be a mistake."

I immediately called one of his coaches, almost expecting him to tell me that it was all a sick joke, or that Chris had a twin brother I had never met who was the true victim of this crime.

I received no such consolation.

"COACH! You watching the news, man? Tell me they got this wrong. . . ."

Disheartening answers

"They got it right bro, it was Chris. He's gone man . . . Chris is dead." My heart sunk a foot into my chest as I hung up the phone and sat deep into my seat, still in disbelief.
My thoughts automatically went out to his mother and how broken-hearted she must have been. Chris was her world. I remembered having several conversations with her about her son, and how great of a job she was doing of raising him. I could not imagine what she was going through at that moment. According to LaBoard, Chris "engaged him in a physical fight."

A fight that ended with the young man in a choke-hold, gasping for air until life left his young Black body.

A life lost over a childish teenage prank. A son stolen from his mother at the precipice of his reaching adulthood, and her so close to successfully raising a young Black boy into a great young man. All those sleepless nights spent worrying about his safety. All those years spent working so hard to provide him with food,

clothes, education, shelter, camps, school trips — all crushed by the choke-hold of a pissed off agent of the law.

A loss felt by all

All that promise and potential for his future life success, all those dreams that he had for his future and all the potential he had to achieve them, snatched away, stolen from the world in an instant over a bad choice in judgment.

A reluctant decision by a teenage boy, to accompany his friends out to do something wrong, resulted in his own loss of life.

The officer said that Christopher Brown engaged him in the altercation. That is a hard story for me to believe, that just wasn't the young man that I knew. The boy I knew was kind and intelligent, he was empathetic, and he was the one that would try to break up a fight, not start one. He was the one who would try to meet aggression with understanding and compassion.

Even seconds before the altercation that resulted in his death began, he was on the phone with his friends who had kept running and left him in harms way, telling them to get themselves to safety. He was truly a selfless human being.

A trial with an unjust verdict

The officer was indicted for the homicide and faced a maximum of 10 years in prison for his cowardly and inhumane actions on that night. After a four-day trial, he was found not guilty.

The man that chased Chris Brown throughout an entire neighborhood, pulled him out of the bushes he was hiding in, fought him, subdued him, and choked the life out of him in cold blood, with a choke-hold that isn't even taught to Baltimore County Cops is not a murderer?
How is this possible?

Chris did not even throw the stone that struck his door, he was

not encouraging his friends to do it, but when LaBoard chased him, he ran and he hid, justifiably afraid for his life. At what point can any of that be considered being an aggressive suspect? It takes a cold and heartless soul in a man to choke someone to death, to squeeze so tightly around someone's throat for a long enough a time that life leaves their body.

The face of a man who killed

When news first broke about the story, the media withheld the name and identity of the officer in question. I was almost certain from the facts of the story that this murderer cop was a racist white man. Race had to play a role in some way in this scenario. But when the media finally released the identity of Officer James D. LaBoard, I was shocked to see the face of a Black man who very easily could be mistaken for one of my own family members.

A hot feeling of disgust and rage immediately took over my body — I felt sick. What had happened to Chris was inexcusable for a cop of any race or gender, but the fact that it was a Black police officer that killed him in this heinous way was just disgusting to me. If there was anyone that could and should have found understanding or empathy for a kid in Chris' position, it should have been LaBoard. Officer LaBoard is the worst kind of Black man. Worse than that, he's the worst kind of cop, he's the worst type of human being, the kind that believes that his badge is a shield of impunity, giving him the right to chase, assault, and even kill another human being without fear of consequence or responsibility.

No consideration at all

A boy that posed no threat to Officer LaBoard at all, a young man that deserved a future. LaBoard came outside of his house in a rage, looking for a target. When he saw Chris, a young Black teen like he once was, he didn't think to talk to him, he

didn't try to question him about the incident, he chose to look at him the same way that most of his white coworkers would see him, as less than a human being. And officers like LaBoard are supported by a corrupt system of racist law enforcement that justifies him in such an act.

So if someone was to throw a rock at my door, and I were to chase them through the streets of my neighborhood, find where they were hiding, and murder them in cold blood, would I receive the same understanding for the validity of my actions as officer LaBoard? The only thing separating him from me is six years of life experience and a Badge, so how is the vindication of his actions anything short of legalized murder?

It's no different. LaBoard is just a murderer with a badge and some stripes on his shoulder to justify it.

The evidence does not lie

Even the prosecuting State's Attorney agreed that officer LaBoard used excessive force "but the jury has the ultimate decision." Adding insult to injury after a family has been robbed of their child, and justice for a son's humanity, it came out that the medical examiner's report did not even agree that Brown's wounds were consistent with an attempt to "assault" the officer. The report stated that the scratches on Chris Brown's arms were consistent with the teen struggling to pull LaBoard's arms from around his throat — as he should have been.

What else would you expect him to do? When someone is literally being choked to death, their only option is to die, or struggle like hell to get free.

If Chris Brown was fighting at all, he was fighting for his life. There is no evidence to support the defense theory that Chris was the aggressor in this case. All evidence pointed toward an

enraged officer pursuing and killing a young Black man because he believes in the strength of the impunity in his actions.

Justice denied

It's been a little over four years since Chris Brown's Murder.

There is no more talk of justice for Chris, or of all of the unanswered questions his family still has surrounding his death. There were no mass protests or riots in the wake his death, or of Officer LaBoard's acquittal. The state would like to settle out of court and forget that Chris Brown ever lived or existed at all. Its leaders would like his family to lay his body to rest, suffer silently and mourn quietly, when they still don't have answers or justice over the loss of his life.

How is this possible? How can it still be so easy to erase a Black boy's life in this, the land of the free?

I often wonder if Chris Brown's murder had taken place inside of Baltimore City lines, would he have been the spark that ignited Baltimore's Blacklivesmatter movement before Freddie Gray was killed?

Not that it matters at all.
Either way, Chris Brown still would be dead, and this is no new occurrence. Young Black males have been killed by police officers long before Chris, and Freddie, and Mike Brown, and Tamir Rice and many others were even born, before our parents were born, and before their parents were born. Law-enforcement officials in this country have had a long history in the destruction of Black bodies since they first started by arresting freed slaves for bogus petty crimes like refusing to honor sharecropping agreements. This society has gotten to a point where we are so desensitized to the bitter regularity of police brutality and state-sanctioned violence against young Black men that we're not even phased by the harsh reality of its existence anymore.

Can't help wonder 'What if?'

I often times wonder what the reaction would have been if something like this had happened to the other Chris Brown, the famous one, the singing, dancing, entertaining prince of R&B music and Pop culture, with millions of fans and followers across the globe. Of course, I would never in a million years wish that on any man, but I do wonder if the verdict would have been the same if what happened to Chris Brown of Randallstown High had happened to someone so famous. Would we be able to generate enough media attention to bring the world's eyes to the obvious injustice that took place in this case?

And of course, there's the obvious question. What if Chris Brown was white? Would that have been enough to get people to see LaBoard as the killer that he is?

I can't lie and say that I don't feel guilty myself for not being able to raise that amount of attention on young Chris's behalf. The fact that LaBoard could simply walk away from such a crime with no real consequences makes me sick whenever I think about Chris. He was a main part of the reason for the shift and transition in the themes of my artwork and writing to address issues like police brutality and the tyranny of government and politics against young people of color across the country. To make sure the real stories of people like Chris get told, by someone who knew him. Chris Brown's life and his story will never be forgotten, because he will continue to live on forever in my life's work.

Justifiable Homicide

Why was he standing there?
Why did he resist?
What did he have in his pocket?
What was he doing there in the first place?
Why was he even on the road?
Why was he breathing?

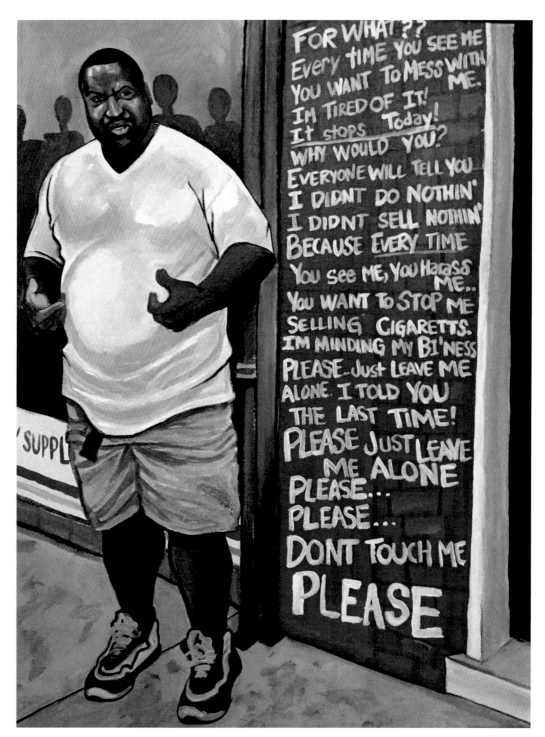

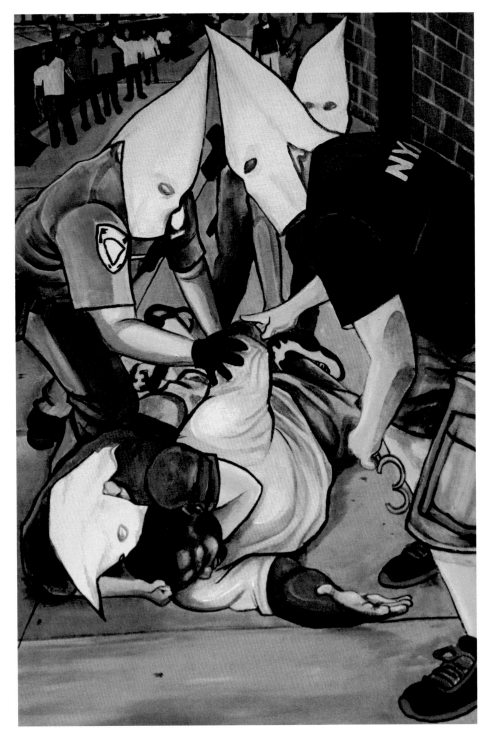

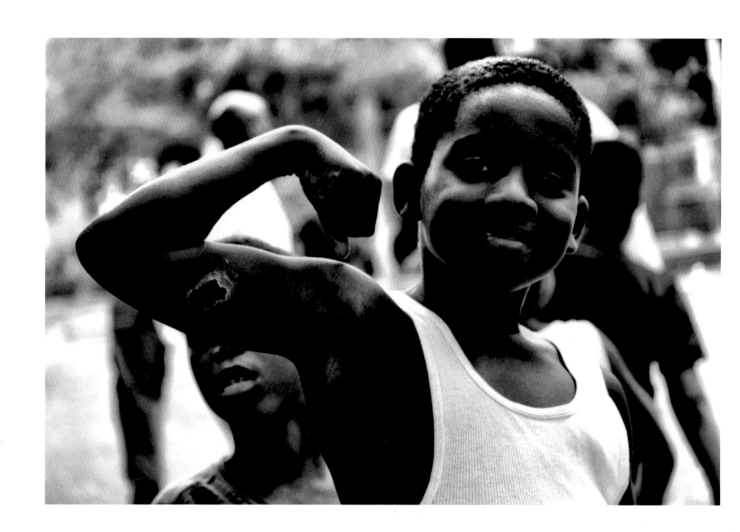

Our Wars Aint the Same

Most of my homies
got a battle scar or two.
They aint never been in the army.
But they grew up in the trenches.
So they do, as soldiers do.
Some got cut open by blades and bullets
 Some were tore apart by trauma
tryna mask their mental illness
They aint tryna hear about goin' to Afghanistan
To kill & steal for Uncle Sam.
They grew up fighting that-old-cracker every day,
 Just trying to provide for the fam.
But that's the type of childhood
 White America would never understand.
Because what kind of twisted reality
 Forces a young boy
 To become a grown ass man?

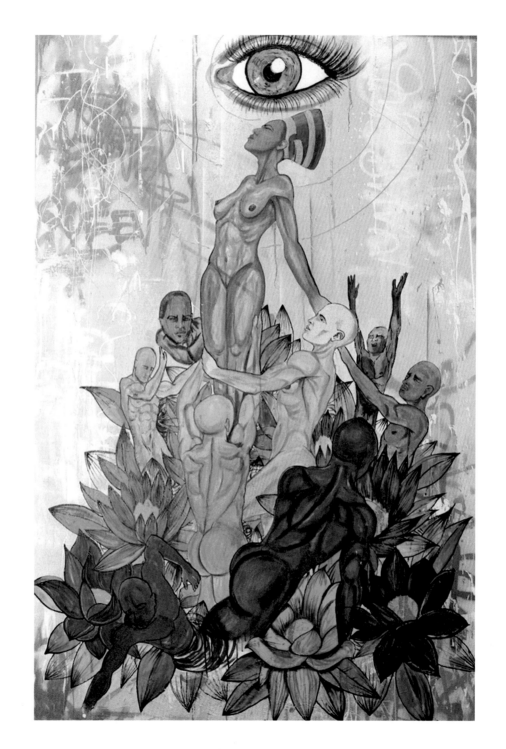

Black (His)tory

History…
History is exhausted.
Tired of being erased
Tired of being rewritten
Tired of being repressed
Tired of being suppressed.
Well…
I'll be damned,

History is a Black (Womb)Man…

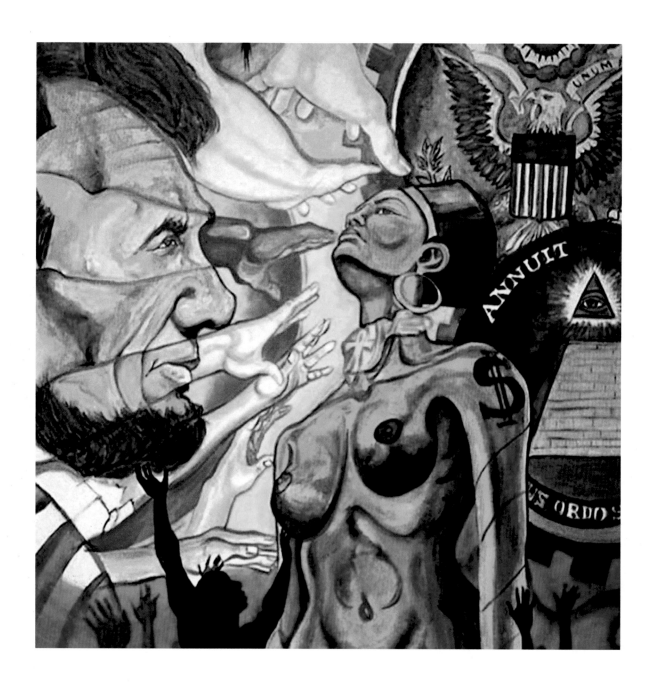

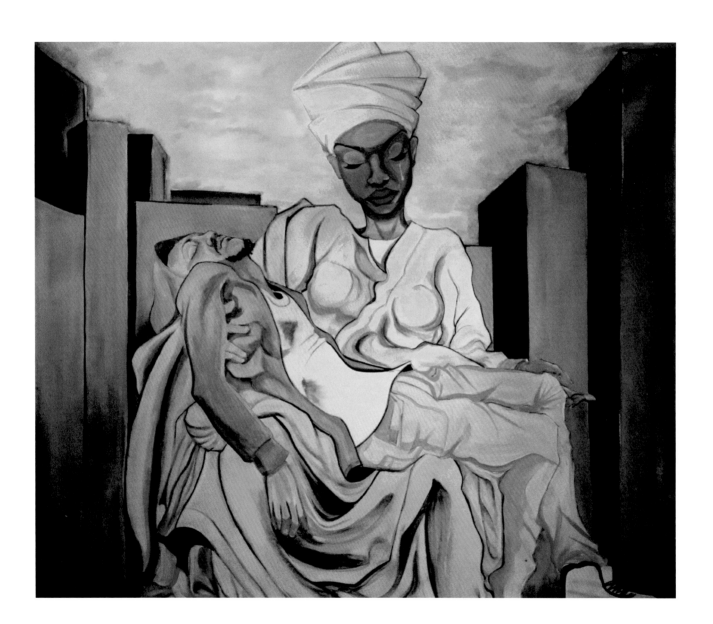

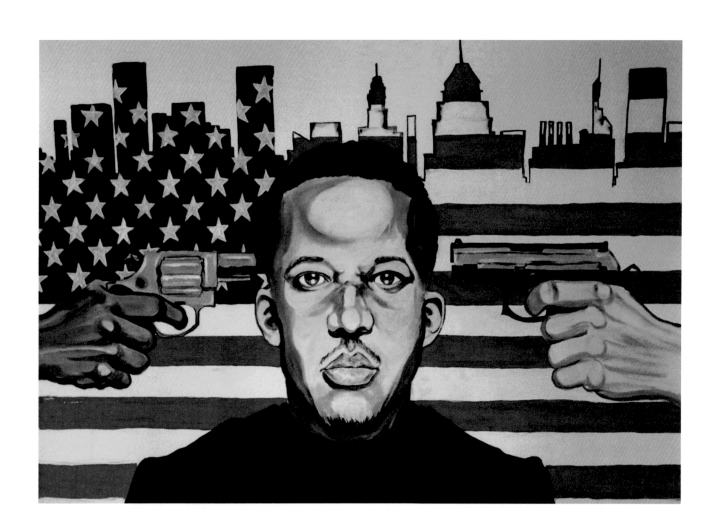

Genocide

Black
　　Bodies.

　　Lay
Still.
　　Broken
Against cold dark stone.
　　Without breathing,
　　　　Without moving
　　　　　　Without being…
　　Empty.
　　Black.
　　Vessels.
Existing…
　　Only in their stillness.
Shirts drenched
　　With blood
Splattered across　　fractured flesh,
　　Torn apart.
　　　　By hot steel.
Making red rivers
That flow. Through. Concrete corridors
Broken.

Statues.
　　Of antiquity.
Chalked outlines, only
Pay homage.　　alone.
　　To ancestors.
Who longed. To Be. free
Mothers kneeling…
　　　　In shadows.
　　Weeping.
　　Wailing.
Mourning.
　　Drowning the streets
　　With:
　　　　The emptiness of memory
　　The pain of regret…
　　　　Too great to bear.
The reality of loss…
　　　　A deeper despair….

Can you?
　　Feel their pain?
　　　　Do you even care?

To All Black Children

You are Black seeds of royalty.
Relics of Antiquity.
Greatness personified in flesh and bone
You are the legacy of rich history,
Deep as the oceans we crossed in bondage
The world wants you to believe
That your history began in chains on a ship,
But you are seeds of a mighty nation
Of tribes and traditions and rituals
Rooted in deep knowledge and understanding.
They want you to forget
How we forged great pyramids out of sand and stone.
You wont be told
About how your people lighted ancient cities at night.
They don't want you to learn
That we gave civilization to the world.
You are the spirit of
Kings and Queens,
and Pharaohs and Moors,
And Alchemists and scientists,
And Philosophers and Lords...
You are the reparations...
Our people begged and prayed for.
Your eyes are as the moon,
Reflecting the sun's light on the world.
Your skin is black steel,
Dipped in gold and sprinkled with magic.
Live every day of your life...
In the essence of your own greatness.

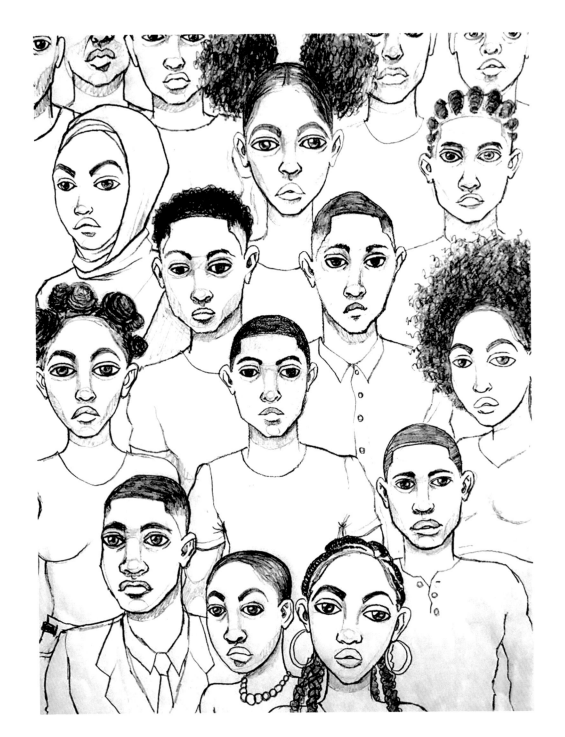

Stoop Kids

I come from boys
 That threw rocks
 As big as grapefruits
Against boarded up,
 Abandoned tombs,
 Of urban ruin.
And played about,
 Scraping elbows,
 And knees…
On broken glass,
 And shattered dreams.
I come from boys…
That forged mighty kingdoms,
 And great fortresses.
Crafted from sticks,
 And rocks,
 And leaves.
That climbed light poles…
 In back alleyways,
 And broke Milk crates to their will…
Making way
 For our first Hoop-Dreams.
Baltimore Folklore.

I come from boys…
That fashioned noble telescopes.
 From Flintstone push-pops.
And made wooden wagons
 Into sports-cars,
And pennies
 Into spinning tops
Who made waterparks
 From fire hydrants.
And were fed by the sun.
 (Till-we-all-smelled-like-outside)
I come from boys…
Too gifted
 To pity.
Too genius
 To contain.
Too great
 To be stopped
 by anybody.
But too poor…
 To play the game.

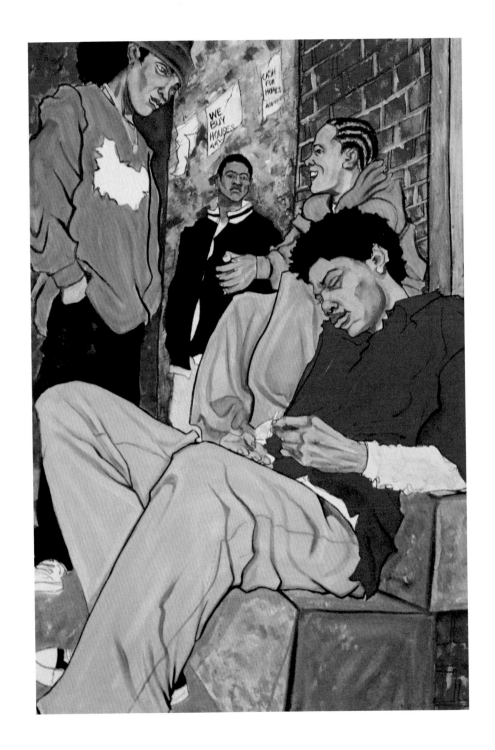

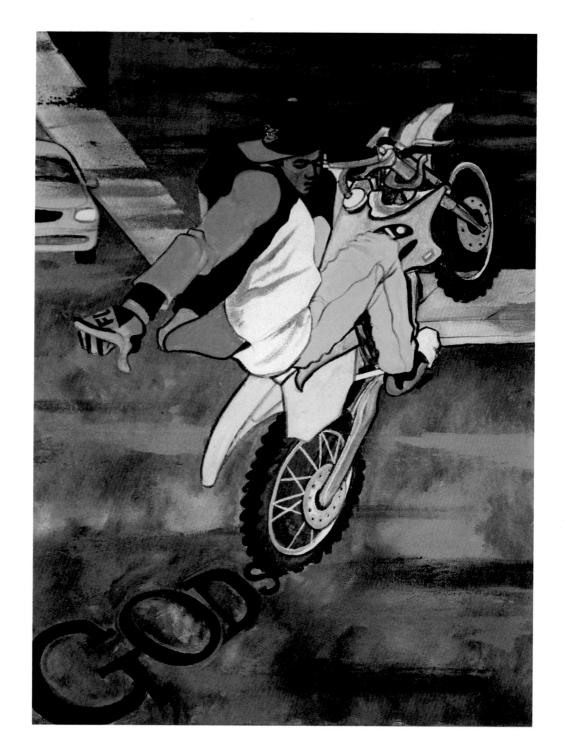

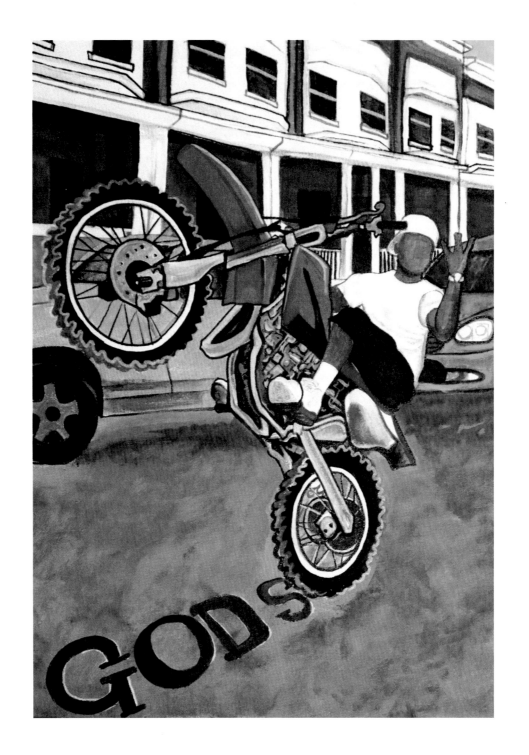

Ghetto Dreams, Corporate Nightmares

The American Dream consists of freedom, the opportunity for prosperity, success, and upward social mobility for families and children, achieved through hard work and with few barriers.

The American Dream lives in gated communities, owning houses with white picket fences and two-acre yards. It includes early-retirement plans, exotic trips around the world, private-school education, weekly Whole Foods shopping sprees, and family camping trips to Lake Tahoe.

The American Dream smells like apple pie fresh out of the oven, and has the sweet rich taste of opportunity and liberty.

Most Black people in America never got a slice of that pie. Most of us seldom see those gated communities, and a relatively few of us are ever privileged enough to understand what white picket fences are even built for in the first place. The dish we are served is much colder. Far too many of us live in the Ghetto, so our dreams are much different and a lot less glamorous.

The Dream's ugly other side

Ghetto Dreams for us inner-city dwellers consist of overgrown littered football fields and hoop dreams, hip-hop, sex, drugs and quick cash. The opportunity to beat the odds of poverty, poor education, crime, jail, or death just to achieve a life of suffocating debt, addiction, and depression is the road most traveled by those who come from the bottom.

The Ghetto Dream often lives in Public Housing projects, renting four walls, a stove, and a toilet with no lights, central air, or hot water. It includes lead poisoning, impoverished communities, mass violence, crippling addiction, disenfranchisement, mass incarceration, and miseducation.

Ghetto Dreams smell like leftover pigs' feet and two-day-old chitlins reheated in the microwave on a Styrofoam plate. They taste salty as fresh tears and as bitter as forgotten dreams and broken promises.

Money has a different look, here

The wealthy, the rich, and the upper-middle class Americans grow up learning about investments, mutual funds, stock-market investments, and IRAs. All of that is like a foreign language to most young people growing up in the Ghetto. All they know is economic deprivation, and their parents can teach them little about money beyond lessons of disappointment, debt and despair. All those youngsters dream about are Diamonds and dimes. Fast money, fast cars and "fly" clothes are the recipe for urban royalty and the key to any pretty

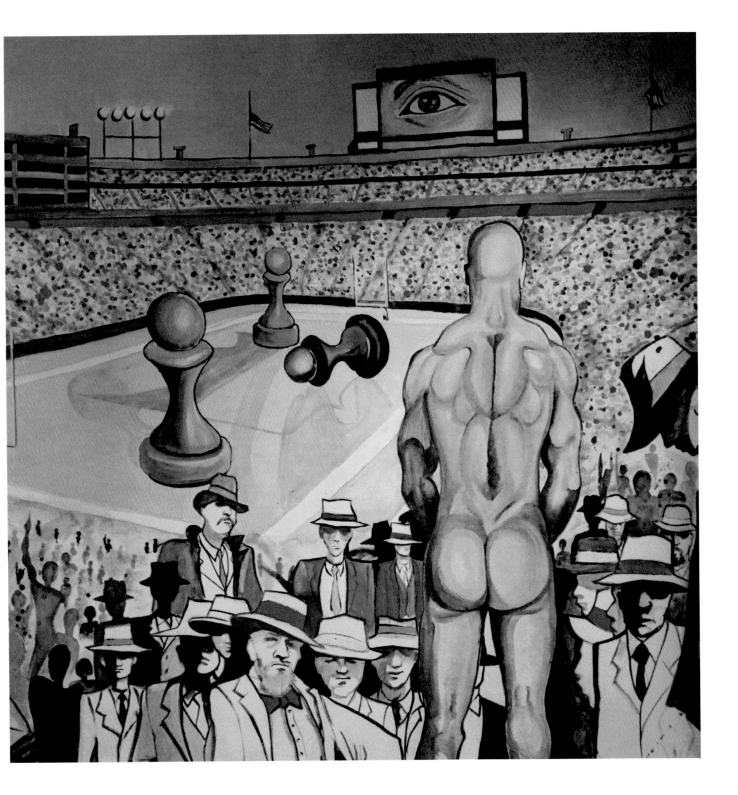

woman's attention in this under-served community. Street smarts and 'Hood etiquette are more valuable than anything expected to be found hidden away in some schoolbook, to most youths in the 'Hood.

Their credo thus cannot be a surprise: If we can't know wealth, we will do damned-near anything not to know broke anymore, to find a way out of that environment.

Growing up as a Black body inside this concrete maze is not easy.

To the Mainstream, we are faceless

To most American Dreamers, a Black person living in the 'Hood is just another faceless, nameless member of the dangerous, colonized and impoverished sector of neighborhoods they fear, ignore, and altogether want to forget about.

Without access to jobs, economic opportunity, and resources, most Black youths in the ghetto see limited pathways out of their present circumstances. With so many of the members of the Black middle class continuing to move away from the inner city to the suburbs, there are fewer and fewer areas in which Blacks are allowed to believe we can succeed at young ages in this country. There are even fewer examples shown to our youth of success stories to which they

can relate and aspire to emulate. This in some way contributes to the reason that our young people idolize drug culture. When almost all the people you personally know that are making a lot of money are the neighborhood drug dealers, its easy to understand why that can be seen as a viable option to a young mind. We idolize and emulate lifestyles that we feel like we have access to.

Rapper Notorious BIG, an icon and pioneer of the Hip-Hop movement, said it best when he described what most kids in the 'Hood feel they have to do to escape when he spit the line:

"Either you sell crack rock or you've got a wicked jump shot."

The sports option

I was never one for the street life or a fan of gunplay or an admirer of the drug game, so according to BIG, I only had one other choice. I chose option B.

When I was a kid, sports quickly became the central priority in my life. That was going to be my "way out."

From the time I started grade school on the West Side of Baltimore City, I was always bigger and better physically developed than most of my peers. They

all were into "Air Jordans" and dirt-bikes, but I just liked to draw and paint. Long before I discovered a love for sports, people would see me and say to my parents that I had a future as a pro athlete because of my size and stature. Some would say that I would grow up to play basketball. Some thought I was better suited for football. Looking back, I find it hard to say at what exact point I started to take these declarations seriously. But I can definitely remember the specific moment when football became the main focus of my life and my most likely way out of a life of poverty.

The arena of inspiration

I was 11 years old at the time. My father had taken me to a Baltimore Ravens game. It was my first time ever attending a game at Ravens Stadium.

My father worked for the Baltimore City Fire Department and, through his job, was able to get tickets to bring two of my cousins and myself along with him to a game. The atmosphere in the stadium that night was electric: Tens of thousands of people from all neighborhoods and all walks of life, different races, backgrounds and social statuses. All were crammed into this coliseum-like arena in a sea of purple and black, all of them screaming at the top of their lungs for hours on

end in support of their Home Team. I found myself lost in the energy of that experience, it washed over me as it did everyone else in that stadium. I was hooked.

After the game, my father took us youngsters to the back of the stadium, next to the players' parking lot.

We waited for hours as player after player emerged from the stadium doors, signed autographs for the hundreds of kids franticly waiting for an opportunity to meet their heroes, myself included, and made his way to the adjacent parking lot, where he then reclaimed one of the countless exotic luxury vehicles parked within, and drove off.

Suddenly, a touchable hero

I was in shock; this was the first time that I had ever been this close to professional athletes. It was also the first time I had seen so many rich men whose skin was the same color as mine, walking around in expensive, well-tailored suits, wearing flashy jewelry and driving nice cars. These were our real heroes in the 'Hood; the ones we would argue over impersonating in the sand-lot games around the way. I considered them the closest thing living to the cartoon super-heroes I had seen on TV and idolized

growing up. But this was the first time I had ever seen them up close, with my own two eyes.

Just as I started to calm down and try not to act so excited, out came Ray Lewis, one of the biggest icons and cult figures in Baltimore sports history, and arguably the greatest defensive players to ever play the game of professional football.

The crowd went nuts.

To most Baltimoreans, Ray Lewis was much more than a professional athlete. He was royalty. He was the heart and soul of the Ravens franchise and the motivating force behind both of the team's Super Bowl rings. A statue of him now sits outside the stadium in tribute to his accomplishments. He walked out of the stadium that night, headed past the knot of people chanting his name, directly toward his car. At that point, we kids crowded there lost all pride and composure. We went wild, shouting from the top of our lungs, pleading with him to come over and sign autographs for us. Now that I think back on it, we all probably looked pretty pathetic.

"Ray, Please! Mr. Ray, Mr. LewisPlease!" All you could hear in the pandemonium were loud cries for his attention.

He and I made eye contact, and he reluctantly came over to us, signed our items, posed for a few pictures, and went on to his car driving off quietly into the night.

That was the night my life changed.

A football epiphany

Up until that point, I thought NFL players were like Gods. As a young kid, watching them on TV, I thought they basically looked super-human. Almost all of the grown men I knew spent hours thinking about them every day, talking about them, arguing over every detail and subject, from whose favorite team was better to which team was going to win this year's Super Bowl.

But that night, I realized something that changed my outlook on my future forever. All of these men that I thought were super-heroes actually were mortal men.

I had shaken their massive hands and felt the pressure of their grip on my small fingers. Sure, they were bigger, faster and stronger than the average man, but they were still just men. There was nothing separating them from me except for years of experience, hard work, dedication, and discipline. It was that night that I told my parents exactly what I was going to do with my life.

I was going to be a professional football player. I decided, right then and there, that this was what I was going to do with my life.

Dreams that become traps

It worked for me, but for so many others, the pursuit of that dream has become the biggest problem. Thousands of Black kids grow up thinking that sports and fame will be their quick tickets out of the Ghetto to a better life, when it's a path actually open to just a very few.

They grow up thinking they are destined for lives as NFL stars, Rap icons, Hoop legends, models, or movie stars instead of doctors, educators, scientists, writers, artists, and lawyers. Too many Blacks spend their younger years prioritizing sports and neighborhood lifestyles over their education, only to find themselves becoming under-educated and untrained adults facing down the harsh reality of bills, debt, and having children without the resources to provide for them.

In many ways, I am one of the lucky ones.

Divine favor, here and there

Although it was partially my dedication, discipline, athletic ability, and passion that led to my collegiate and Pro Ball success,

there was also a lot of divine favor and I'm sure some blind luck also (even though I've never really believed in the concept of luck). Many of the men I played with along the way also were talented and very hard workers in their own right, but they were not as lucky.

Most of those men were cast aside much earlier than myself, collateral damage of a violent sport. That is what the sports hoopla doesn't reveal in your childhood: You can be the most athletically gifted, physically talented and emotionally dedicated person, and still not get a shot.

For most of my time as a pro athlete, I opened my home to teammates who were uncertain of their position with the franchise, to live with me as they tried to save as much money as possible while on the team roster. I can still recall the first time that I remember had to loan $200 to a teammate to keep his cell phone on. Or the countless meals I paid for when it became clear my teammates did not have enough money to blow on an expensive dinner.

A harsh sports reality

Contrary to popular belief, most NFL players are far from rich. There are 53 players on each team roster at a time.

There are 32 NFL franchises carrying a total of 1,696 players. There are 320 players on practice squads. There are another 1,000 or so players considered viable "Free Agents," available to be picked up by teams in need. Most of those Free Agents spend their entire year training and waiting on calls that almost never come from any team looking for their services. Most of them struggle to find work and to pay for shelter, food, and bills while they are in the wilderness, each one waiting for his next opportunity.

So out of the millions of young people running around our inner-city streets, wholeheartedly believing they are the future stars of the NFL or the NBA, only a few thousand will ever have a realistic shot at that opportunity to be a franchise player that makes millions.

The ones who do make it serve as exemplars to the next generation: One day, you, too, could aspire to the same ideas of greatness. But why do we as a culture celebrate and idolize athletes and entertainers the way we do? Why is an athlete put up on this pedestal, while our doctors, educators and other intellectually gifted individuals are overlooked?

The answer is because the athletes and celebrities embody a realization of the Ghetto Dreams to which we as a culture aspire to attain for ourselves from a young age.

And it is our athletes and entertainers who themselves perpetuate the belief in Ghetto Dreams.

Lifestyles of hubris

Given just enough money to finally buy into the illusion of the American Dream, most professional athletes choose to spend all that new money on what they have always been taught by our culture to idolize growing up: jewelry, cars, clothes, houses, expensive trips, and beautiful women. They live hubristic lifestyles drenched in materialism instead of equity. Most never take the time to learn about money and finance, or about investing wisely to generate sustainable income. So after their playing careers end, the former sports stars quickly find themselves pulled back down into the same drowning sea of poverty in which they grew up. And after years spent in the education system, most are still unfit and unequipped to face the demands of corporate America. All of that aggression, all of that strength and skill that took years to develop is now worthless to them when now facing real life after the last game-closing whistle.

Each of us all, in our own ways, realized the Ghetto Dream, and saw it become the Corporate Nightmare.

Beneath the gladiator myth, a sad story

When you think of today's version of professional football players, the most common description is to call them modern-day-gladiators. That is a title even I accepted for years -- before I realized its harsh irony.

We tend to glorify the memory of the mighty gladiators that went to war on the Coliseum sands against each other. We remember and glorify the names of a famous few, painting them as heroes. I used to love those books and movies myself. We often forget that those gladiators were slaves, fighting for their lives and freedom. They were fed better than the average citizens; the most profitable and famous among them were allowed to live in homes that were more luxurious than those afforded the average man. But that did not change the fact that each gladiator still was a slave, considered the property of whoever owned him.

Most would fight and be killed or severely wounded for life, without most free citizens ever knowing their real names, without fame or glory, just there for the audience's sport.

As civil rights activist Stokely Carmichael points out, "the Roman Empire's greatest pastimes were watching men kill each other or lions eating up men — they were considered a civilized people. The fact is that their civilization, as they called it, stemmed from their oppression of other peoples, which allowed them a certain luxury, at the expense of other people." Much as the US has today.

Time moves on, but remnants will always remain.

Blinded to real pathways to success

We athletes have all been fooled to think we're all free, but the only difference between then and now is that the gladiators wear shoulder pads and a helmet, and today young Blacks grow up brainwashed to see fewer and fewer paths to success. We will gladly sign our lives over to any owner or industry for a chance at fame and fortune, regardless of the price that comes with it.

But any system where you are told what to think, say, and do, isn't free. To be told where to go, how to live, how to speak, and what issues to speak on, is to be told whom it's OK for you to be.

I don't need to be told. I have always known exactly who I am, which is why I was never properly programed for that environment. I refuse to be controlled, or contained in my efforts to enlighten and inspire through my writing, my art, or my public platforms. I refuse to remain silent about the issues facing my people or my community. In a way, I myself am an embodiment of the corporate nightmare. Just not the way Corporate America expected.

If you think I'm going too far, just look at this country's treatment of Colin Kaepernick. By all accounts, this man should be considered an American hero. But by simply choosing to take a knee during the national anthem in protest of this country's treatment of Black people, he became one of the most hated people in the country, and now has been made an example of by NFL ownership, being passed over for a job by every NFL franchise for months after being released from the '49ers. All this despite the fact

that he is clearly and by far the best, most talented quarterback available. Because of his fearless act of protest, the entire country has been forced to look the issue of race and police brutality against unarmed people of color in the eye. But NFL ownership doesn't care about the issues of Black America. It doesn't matter how talented you are, if you don't "know your place" as a Black man in this country, you're expendable.

The NFL isn't necessarily slavery, But it definitely has its historical roots in chattel commerce. I can still remember everything about my experience at the 2009 NFL combine. I have never in my life felt more like a slave than I did that weekend. I remember long days of being measured, poked, prodded and pulled in a thousand different directions by a hundred different sets of hands. I remember long nights of interviews and questions that had nothing to do with the game or my ability to play it, but everything to do with me knowing my place and being "coachable" which is code for "controllable." I remember countless rooms overflowing with old, mostly white men holding clipboards and choosing their favorite physical specimens to "examine" more closely. The cold hallways that we we're paraded down,

full of people, always watching, always touching, looking at us in our underwear or ass naked; critiquing every detail of our bodies. I can remember thinking over and over again, "this can't all be necessary." I believe that the process was meant to be intrusive and humiliating for the athletes. I believe we were all supposed to understand that we were no longer considered people. Welcome to the NFL kid. You're officially about to become our property.... now go run fast and jump high before u end up spending the rest of your life back in the hood.

Looking back, in wonder

I often times wonder how my life would be different if I never got to attend that Ravens game as a child. What if I never decided to set my life's course on a path that would eventually land me in the NFL? I do not at all regret any of the decisions that led me on that path. It led me to be where I am right now, with the platform to reach and affect change in the lives of tens of thousands of people through my art and my writing. Still, I cannot help but to think about the kind of man I would have become had athletics not been at the forefront of my focus as a child and young adult.

What might have happened if I had been as serious about my education as I was about my athletic career?

As a child, I was a horrible student. I constantly struggled in each of the schools I attended while I excelled on the athletic field. While most of my struggles dealt primarily with a lack of interest in the subject matters than a lack of intelligence, I still was diagnosed with ADHD and I was prescribed the same medication that today is keeping so many Black kids doped up in school. Luckily for me, my parents cared enough to take me off of it immediately. My parents were after me constantly, throughout my childhood, about the importance of my education. For some reason, it never took root until my high-school years.

Wake up, young man!

I remember the day my father walked into my room, sat down on the chair next to the bed where I was lying, and told me the harsh truth about the reality that stood ahead of me.

"Son, you're in your freshman year of high school now. So you've got three years…"

I looked at him with a confused stare, unable to process the meaning of this proclamation. He looked down at me with a very direct and piercing look of seriousness, and he elaborated.

"You told me a couple of years back that you're going to play in the NFL. In order to do that, you're going to want to attend a Division One college or university."

I immediately started to understand his meaning.

My father leaned back in his chair and took a deep breath, as if he was about to unload some deep, dark secret on me. "I can afford to send you to Morgan State," he said, the only college in the state of Maryland with a Division One football team other than the University of Maryland, College Park, which was far out of his price range. Morgan is Division 1-AA, which is considered a step down athletically from the likes of Maryland. "It's a Historically Black College that is not known as a football powerhouse," my father said, "so it is a great school, and you will get a good education there, but it will be a lot harder for you to make it to the next level. In order for you to have the best chance at getting into that kind

of school you really want to go to, you're going to have to get a scholarship. So you have three years to earn a scholarship, or you can go to Morgan State, the Army, or the work force. Either way, in three years, you're leaving this house."

That was a defining moment for my young adulthood.

A big move for the better

At that point in my life, my family had relocated from Baltimore to Howard County, Maryland, one of the country's richest counties and a place that was highly regarded for the quality of its public-school system. The move was great for my siblings' and my education, but had taken a heavy financial toll on my father, who struggled to make ends meet in such an expensive place while still working for the Baltimore City Fire Department with a wife and four kids to feed.

From the minute we first arrived in the county, I always understood that my family's economic status was different than most of my new classmates' families. Most of them were from wealthy or upper-middle-class families. Even most of the other Black kids out there were experiencing a way of life that I never

knew. They always dressed in the newest and most expensive clothes that my parents could not afford to buy for me, and they were used to a certain privilege to which I had never become accustomed. Most of them were not worried about how they were going to pay for college. Their parents made enough to set aside large college funds while they were in elementary school. It was not until later on in my high-school years that I was necessarily popular among my peers.

Up until that point, I was just the big artist kid with cheap tennis shoes, who was not into video games or Jordans or dirt bikes, gangs or drugs. I was on the receiving end of a lot of jibes just for being different, for not fitting in. Once I became a star athlete in high school, people finally accepted my differences, and me. But they never made the mistake of letting me think we were the same.

Bad treatment builds vengeful attitude

At some point, my resentment toward them turned to anger.

I never wanted to fit in, not with those unwelcoming classmates. I let that anger fuel the pursuit of my goal of being the one that made it. I worked harder than any and every one of my teammates, to be the best athlete I could be. I got up early every day, and ran a mile to school with weights in my book-bag. I remember some white people riding past as I was running, calling me "nigger" and "monkey" out of their windows as they sped by. I didn't let it get to me though, If I recognized them, I would fight them when I saw them later on, but most of the time it was too dark. I worked out before school, after school, during school, all year, all the time. My desire to succeed became like some kind of animalistic survival instinct. I didn't drink or smoke, and I never partied much with those people to whom I couldn't relate. I had few real friends, only three or four that I

still talk to today. My life revolved around football and earning scholarships to Division One schools across the country.

But what if I had gone about it differently?

What might have been?

I went to school with people who today are doing some amazing things in the real world: Marine biologists, doctors, lawyers, politicians and engineers who are changing the world every day. While I was working out, most of them were studying. If I had applied the same dedication and passion that I displayed on the football field to my education, how much more could I have accomplished at this point in my life than just football?

The worst thing about Ghetto Dreams is that so many of America's Blacks still aspire to achieve them when our salvation is in our education. We don't realize the weight of the burden that we put on our children by forcing them to adopt and chase these Ghetto Dreams instead of teaching them how to define and pursue the real American Dream for themselves. That starts with us first educating ourselves to define the reality of what that dream looks like for ourselves.

The American Dream was never conceived for us.

We Black Americans are the forgotten ones, who have been disenfranchised, whose voices have fallen on deaf ears for way too long. We can no longer continue to go on accepting Ghetto dreams as our only ideas for success. Instead of chasing Ghetto dreams, we need to start to manifest our dreams for the Ghetto.

We need to build a true infrastructure within our inner-city communities that once again provide accessible jobs, resources and economic opportunity, for Black people with Black dollars. We need to encourage more of our

young people to be creators and innovators, doctors, engineers, scientists, artisans and entrepreneurs to change the idea of what success really is in our culture. We have to start challenging ourselves and our children to break those stereotypes. We need to start celebrating our young more for their differences of style and outlook than criticizing and ostracizing them for daring to be different.

Maybe then one day, we all can know the American Dream.

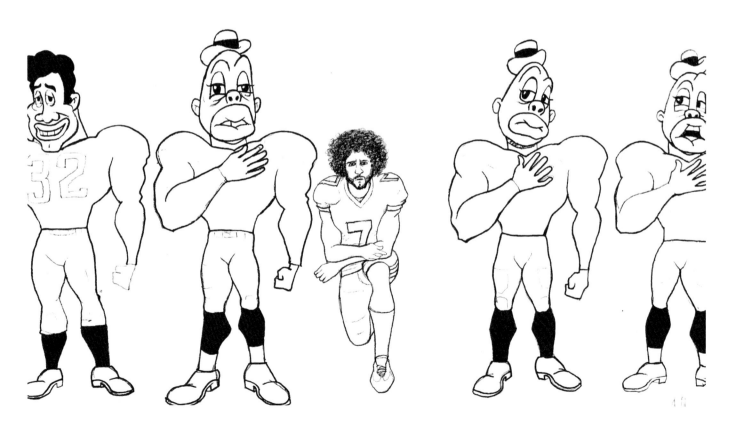

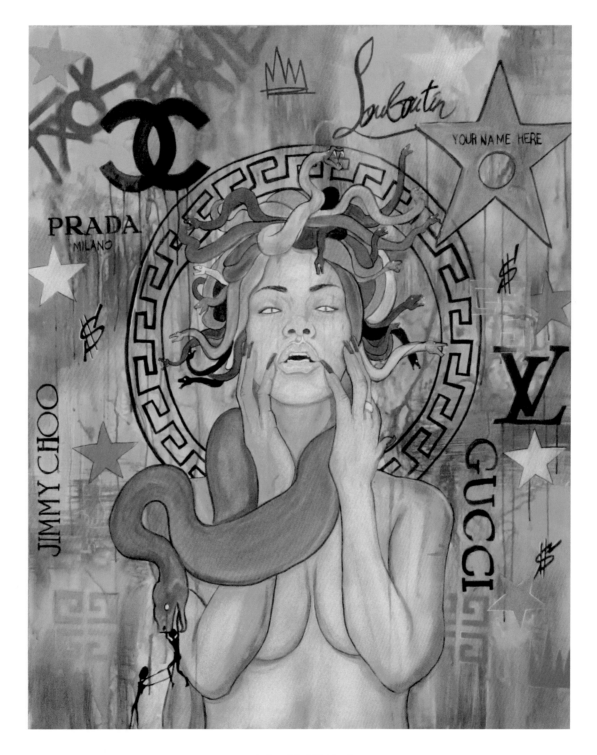

Conflicted

Sometimes I think
Of what a hypocrite I have become.
Not much more than most I figure,
And a lot less of one than some.
But does that make me justified
Or even more to blame,
Than the King who calls himself a Nigga'
Because he was never taught his true royal name?
Being raised to think success means
Dope clothes,
Whips and chains.
Am I guilty of being blinded
To the truth while chasing fame?
Have I traded in my shackles?
For diamonds and gold chains?
Could I be selfish or wrong?
For wanting the whole world to remember my name?
Am I wrong for living the life that I love?
Am I right in loving the life that I live?
Could it be wrong?
That the ones I love
Are worth more than the life that I live...?

Letters 2 Langston

Living.
In a world
Where our dreams
Are always floating
Just above our reality.
So we chase them by day
Just to barely grasp them
In our sleep.
Such an unpleasant reality
Makes one…
Eventually,
Question their own sanity.

That's what happens when a dream is deferred

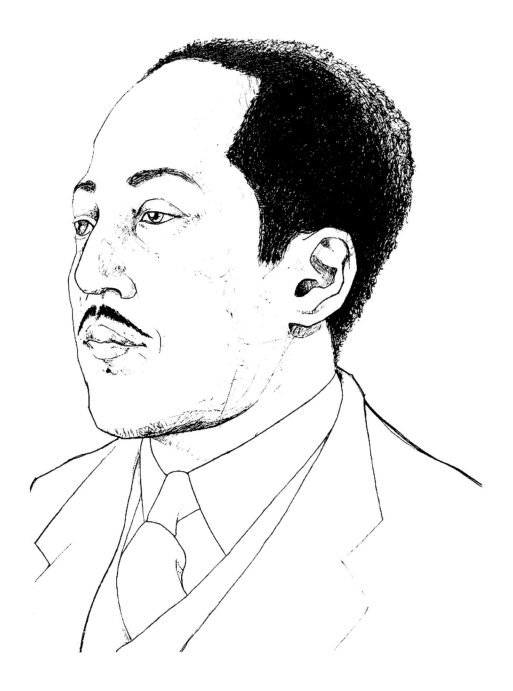

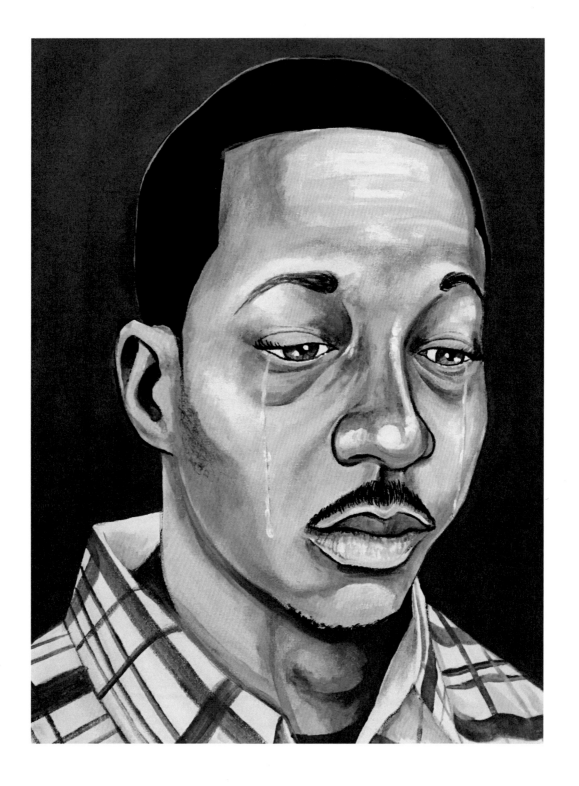

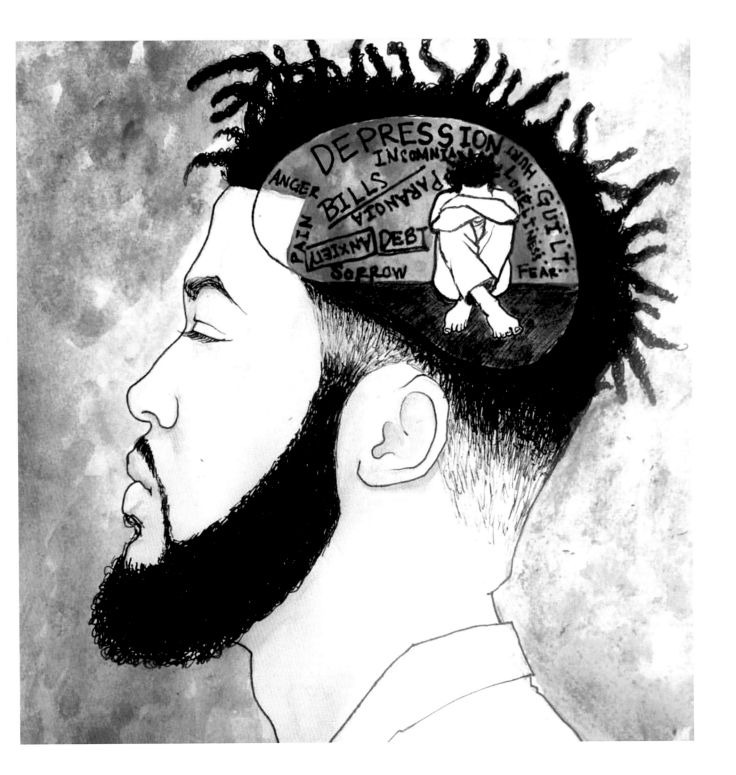

Depression

Sometimes I go days without eating
Sometimes I go nights without sleeping
Sometimes I deprive myself of human touch
Sometimes I go days without speaking
Sometimes I listen without hearing
Sometimes the pain is too Deep
Sometimes the noise is too quiet
Sometimes the silence is deafening.
I find myself lost
Unable to cope with frustration
Unable to see past the shame
Unable to escape this suffocation
Drowning my liver…in dark liquor
Numbing my brain
To the pain of today
While dreading the pain of tomorrow

How do I fill this void?

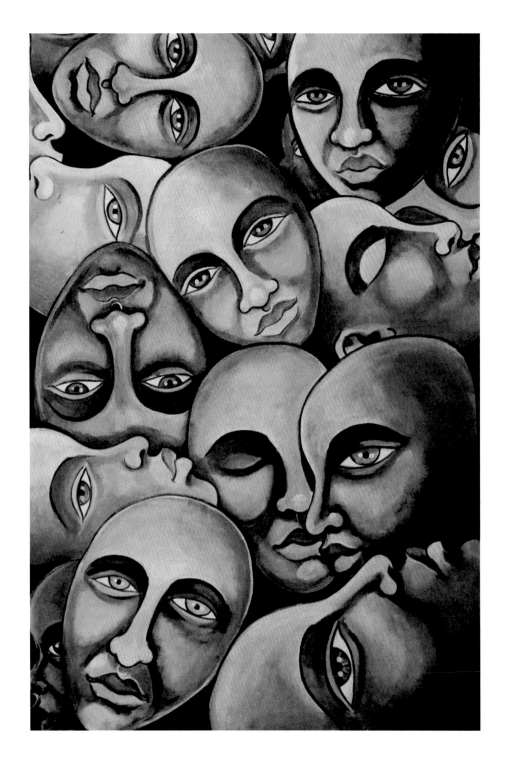

Corner Boys

Corner boys Standing strong
Conducting
Corner Traffic
Corner Crossing Guards on duty
Selling of white death
In glass vials
To glass-eyed breathing corpses
 More dead than alive
For wet wrinkled dollar bills
Of dead presidents
For fistfuls of change
Of dead presidents
For back alley Blow-Jobs
And SUV tricks
Breaking
Backs of
Broken Women
Trying to mask
Their own Brokenness
Too hard to be soft
Too cold to be warm
Too strong to be weak
Too mean to be sweet
Too broken to heal
Too painful to feel
Too empty to be full
Too brave to be vulnerable

Longing …
For lifestyles
They never knew
Or understood
Because

They were Never meant to
The only life
They know
Is on that corner…

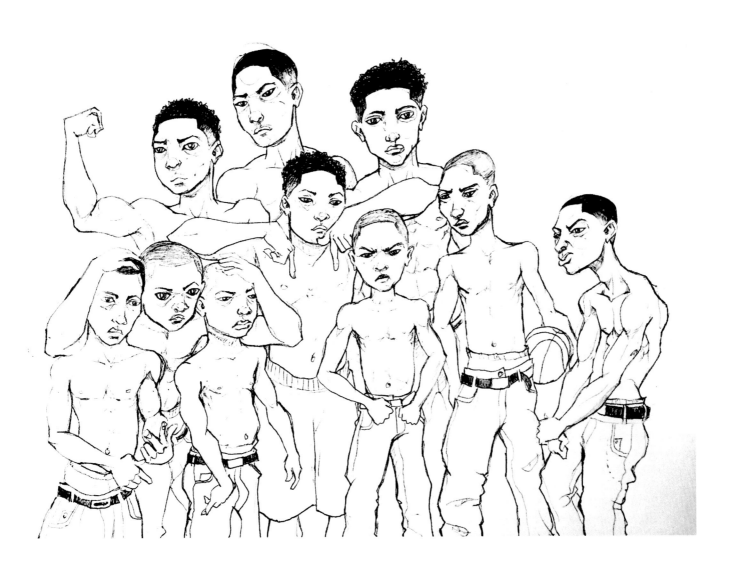

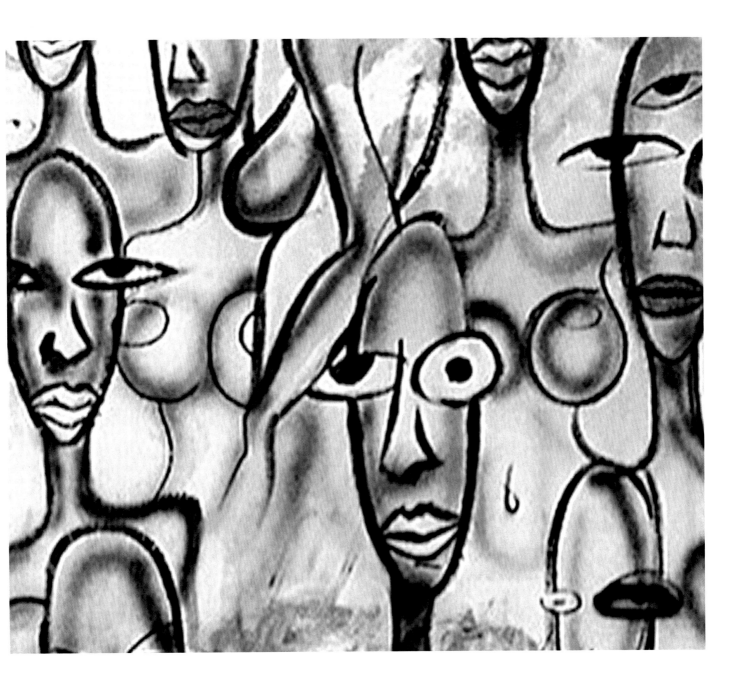

My Tribe

Most of my mentors…
were kingpins,
and hustlers.
My best friends…
are all addicts, pimps & whores.
My therapist…
is a Badass stripper
Named Diamond…
From West Baltimore.
All of us,
 In our own ways…
 Broken.
Bonding over our many broken ways.
The children
of the light,
That became the children,
 of the night.
They spend there's chasing money & sex.
I spend mine writing and painting and evading regret.
I feel separated from them…
Yet, I count myself among them.
The same dopamine keeps us all up at night.

Ghettos

Capitalism…

 Rewards the rich

Feeds on the poor

 Mates with bigotry

And Breeds…

Social…

 Political…

 Educational…

Colonies…

 For the poor

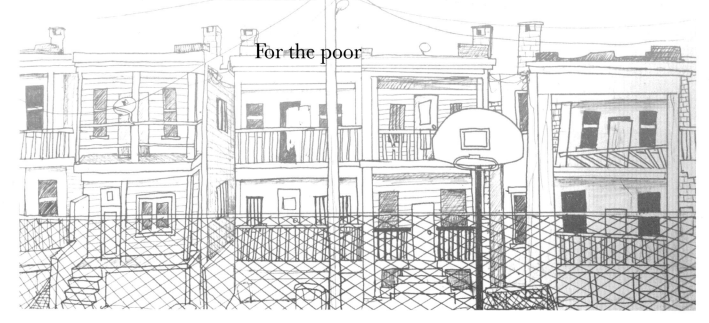

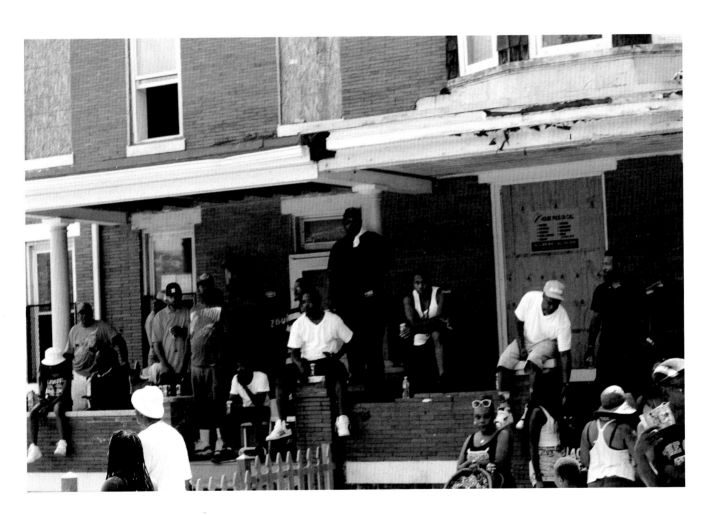

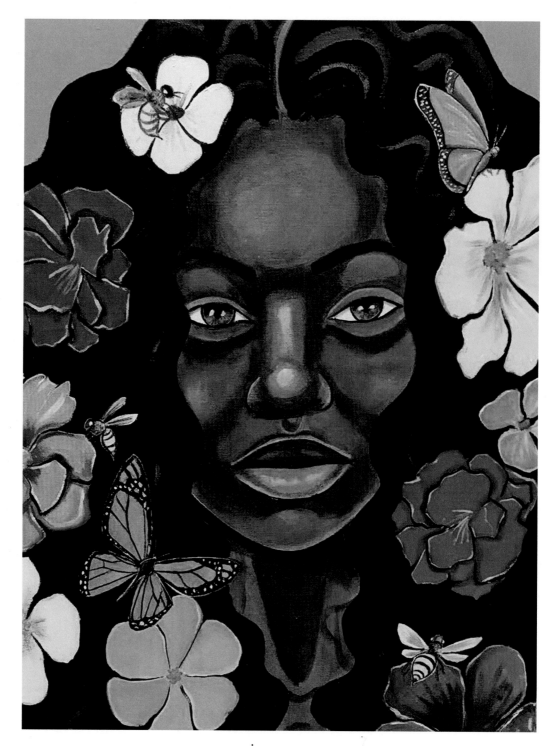

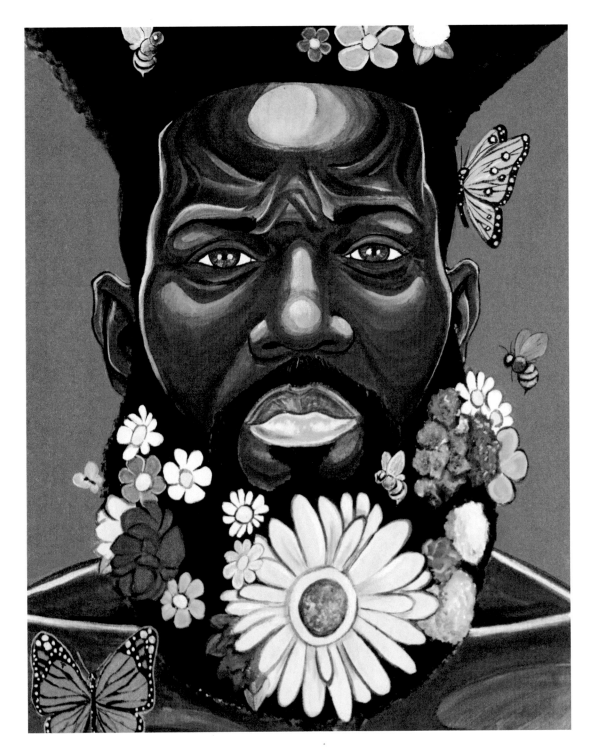

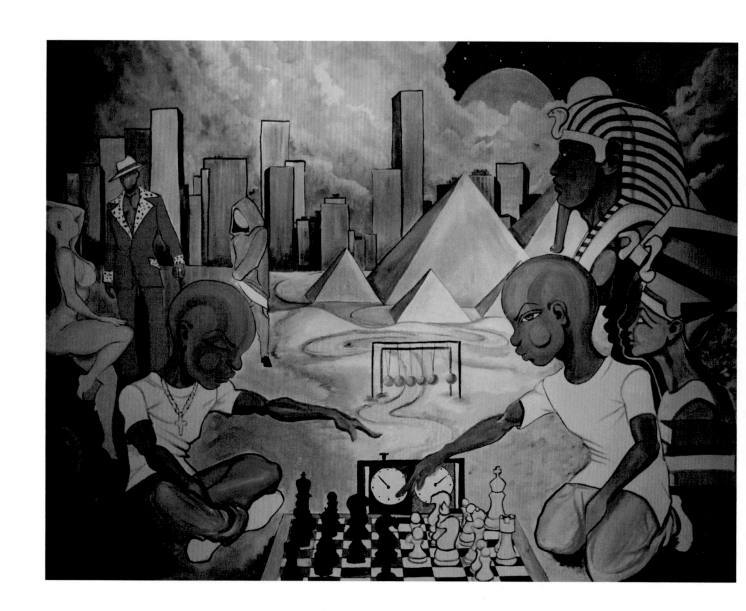

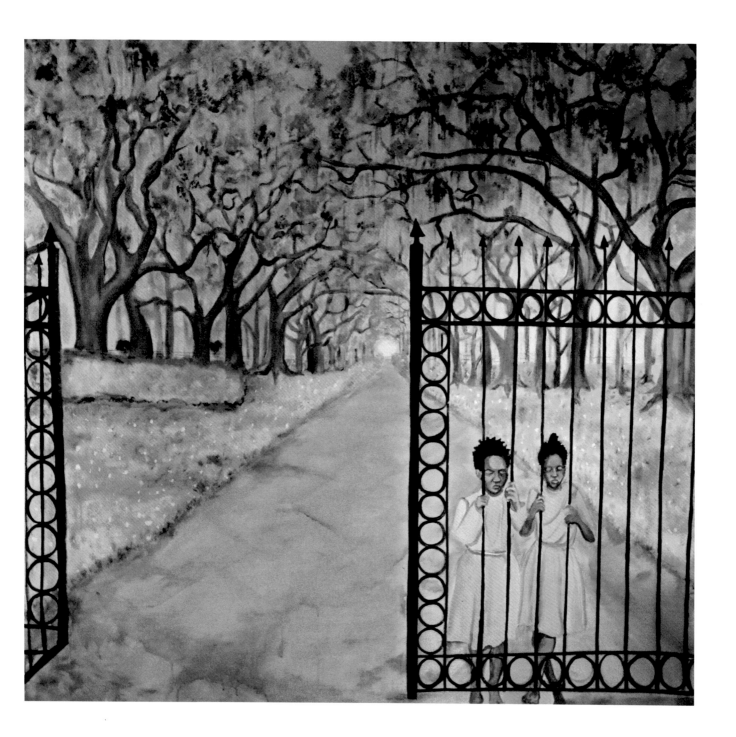

The New Black

If you are a Black man or woman living in America, you were born in poverty, a young Black body born into a world and raised in an environment not made for you to thrive and succeed.

You may not have been born in the slums of the Ghetto, or in any of the many colonized communities littered through our urban landscape. You may not be the offspring of parents who lacked in education or economic opportunity. You may be from a somewhat privileged background where you were allowed to believe that you have access to the American Dream. But whenever you are introduced to, or seen by someone of any other social class or economic background that makes them feel, in principle, superior to you based on the merit of their economic status, all they see is another product of the poor underclass of a violent and impoverished Black community. That's where you're from — until you show them otherwise. No matter how much money your family comes from; no matter how many millionaires are in your lineage, no matter how many degrees you have, to a stranger, you are one of the countless members of a race of people they don't understand or, in most cases, don't care to understand at all.

Don't be misled, here

The funny thing is that Black Americans have been fooled to think we can escape from under the shadow of this generalization by achieving the American ideal of success, economic stability and mobility for ourselves and for that of our families — by following Booker T. Washington's model of success; work hard and eventually they will accept you.

We work any job we can find that allows us to make enough to escape the harsh conditions of violence, poverty, and addiction facing Black people across the nation in our inner cities. In most cases we will even lie cheat, steal from, or destroy anyone in the way of our ascension up the ladder towards our goals; inter-communal violence is at epidemic levels in many of our most populated urban areas across the country. With most of our population suffocating under the chokehold of poverty and oppression, their light at the end of the tunnel is the hope of one day experiencing the lifestyles of the rich and famous for themselves. So we spend money that we don't have on things we don't need, just trying to buy ourselves a temporary piece of that experience.

Frazier's model of success not for all

The Black Bourgeoisie is another term for the African American upper class, made infamous by the book by Edward Franklin Frazier. It consists of Black professionals in fields such as medicine, law, business and entertainment. Typically, members of this class make upwards of $200,000 a year. This group of "Black elite" makes up less than 1 percent of the total Black population in this country, and is the representation of what we as a people still believe success looks like for us today in America. According to the values laid out by Frazier, Black people could make it in America if they just studied hard, worked hard, saved their money, and stayed out of trouble.

During the time of Jim-Crow Laws, because of legal segregation, many Blacks in America were forced to open their own businesses that served their own people.

Blacks in America owned everything from hotels, restaurants, and insurance agencies to funeral homes, insurance companies, and retail stores. We had a Black Wall Street in Tulsa, that was fire-bombed by Oklahoma's whites, with local government support; we had schools, land, property, and an established, thriving

Bourgeoisie

affluent Black community in the District of Columbia. This was actually the highest level of business ownership for Black people in the history of this country. We were forced to try and build our own nation within this nation, and we were succeeding in the face of systemic racism, violence, and disenfranchisement.

Open doors that vacuumed strength
After the Civil Rights Act of 1964, many of our Black businesses suffered greatly because of their inability to compete with the white-owned establishments that Blacks could now patronize that had better access to financing. We started shopping at their stores instead of continuing to recycle dollars in our own neighborhood businesses. We started attending their colleges and universities instead of the Historically Black Colleges and Universities that have always educated, empowered, and supported us. We started to join their fraternities instead of the ones created by us to support the future of our legacy.

We bought in to the idea of our newfound entitlement to the American Dream at the expense of our own infrastructure; only to find out that our entitlement to that dream never really existed in the first place.

Even after the collapse of many of our Black-owned businesses, there was a time when big American business and industry was still based primarily in our inner-city communities, close to the cheap labor available in our most impacted city neighborhoods. Black men and women had access to jobs and economic opportunity for themselves through these industrial corporations and could afford to provide their families with food, clothing and shelter. Labor unions were created, workers lobbied for medical benefits and opportunities for economic advancement. Blacks finally began to make large-scale advances in the framework of Corporate America as industry thrived.

The suburban surge changes things
Then, after the end of the Second World War, most of those industrial companies closed up shop in the inner cities and relocated to the suburbs. As the jobs in the urban community continued to evaporate, in came the drug epidemic. First heroin and then crack cocaine hit the urban community like boxer Mike Tyson did his first 20 opponents. As violence, crime and addiction ran rampant in our cities, most of the rich and upper-middle-class white families also moved out to the suburbs to economically and racially segregated communities. This also became a defining moment in the history of the Black Bourgeoisie. At a time where we could have been pooling resources, buying land, investing in Black business ownership, building up infrastructure for our people suffering in our urban neighborhoods, most of them decided to chase the whites out to the suburbs, distancing themselves from the issues facing Black people in an attempt to find acceptance in their new surroundings.

This dramatically affected the social fabric of our neighborhoods. Businesses that were once Black-owned and employed closed-up shop. Jobs further eroded and became even more scarce in our poorest communities.

Leaving's not 'making it'
I never understood why so many Black people equate success with "making it out of the 'Hood" instead of improving the neighborhoods where they arose. The idea of us wanting to leave our surroundings as they are and run away to better lives with no threat

of struggle or opposition is an illusion far too many of us believe to be real. The other side of America that the Black Bourgeoisie dreams about knowing for themselves was never made for us. The whites who left after segregation died never made a place at the table for Black men and women to have a piece of the American Dream.

•They don't want us in their gated, suburban communities;
• They don't want us in the big-money sections of downtown.
• They don't want us in the best schools with their children;
• They don't want us in their restaurants, or at their bars.
• They don't want us in their world.

They make it clear where they would like us to remain by how we are treated, whenever we try to partake in their fraternal order of extravagance, greed, and wealth outside of the colonized and impoverished areas that we call home.
To them, our place that we belong in is the slums of the Ghetto, or behind the cages of jail cells, or in coffins buried six feet deep into the earth. We are much easier for the rich to forget about when were out of sight, when our issues and grievances are not right in front of their faces. And in their struggle for acceptance in a world that was never meant to accept them in the first place, the Black Bourgeoisie collectively opted to also remove themselves from the struggle for Black liberation in their individual pursuit of the illusion of belonging in the company of the colonizers.

What might still be . . .

If put to proper use, the education, experiences, and collective resources of the Black Bourgeoisie could be used and leveraged to build sustainable infrastructure in the Black community to rival that of any demographic in the nation. Instead, they largely choose to remain silent on the biggest issues facing our people, and in their absence, the Black community as a whole still strug-

gles for its identity, void of the typical paths to success afforded to the other side.

The importance of this group and the resources that they could provide our neighborhoods cannot be understated. The Black Middle-class demands good schools, better housing committees, more integrity in local government, and a better quality of life then that of our impoverished inner city communities. Yet, most choose to use their influence to improve circumstances for themselves individually rather than for their people as a whole.

Time for true leaders to step up
Part of me wants to believe that the Black elite has no real power in the grand scheme of things, and not that they just don't care enough to do what it takes to make a difference. I want to believe that even the collective spending power of iconic forces in the Black community like Oprah, Magic Johnson, Bob Johnson, Michael Jordan, Jay-Z, Beyoncé, and others is not enough to finance the intricate and massive grassroots initiatives necessary to change the circumstances of an entire people. Sadly, this is just untrue. While they couldn't change all of the problems facing the infrastructure of the Black community, they and those like them could make a big enough impact on the culture to start to shift our way of thinking. They could, if they wanted to, push to make the Black Bourgeoisie as a whole take more ownership in their fight for Black liberation, humanity, and equality, 51 years after it was promised to us on paper.

The truth is it starts with us — all of us. Each and every one of us has to make an individual decision to be a part of the change we want to see by making a commitment to our people and our community. We need to start practicing nepotism a lot more in our business dealings. Nation-building starts with the people of the nation deciding to unify and build resources for themselves.

The movement is in the people. Our people decide who our leaders are and what we believe. And a true leader is someone with the heart of the people and an enlightened mind that only desires what's best for them.

Seeing is believing, at the top

When I was in the NFL, as a young Black millionaire who was both naïve and highly opinionated, I got a chance to peek behind the curtain and see how real money acts and find out exactly where I fell on the totem pole of wealth in this capitalist economic structure. I was invited to a dinner with the owner of the team I played for and a host of other guests in his elitist billionaire's club. In a room full of people talking about subjects like population control and stock-market speculation to oil and technology, I felt lost and out of place. I felt as if I was meant to understand that I didn't belong.

But I also was meant to understand the fact that people like this are what real money looks like, sounds like and acts like, and how much that differed from my perception of what wealth actually was. I realized quickly that real money didn't talk like me, it didn't dress like me, or look like me. The people in that room definitely didn't look at me and see a person, they saw a Black body owned by the man throwing the party. To them I was just his newest toy or another piece of flesh-and-bone to be maneuvered on his chess board. Over the course of the night, countless party patrons entertained me with conversation, only to visually size me up. Several grown men in attendance found random excuses to grab or touch me so they could physically assess for themselves the new franchise product. They would grab me on the arm or around the shoulder just to feel the muscles beneath my suit jacket and inquire about my diet and workout regimen. In a way, it was humiliating.

I was made to feel like an animal at the zoo; I could tell that I wasn't a human being to these people. Just Black meat in a fancy suit, trying my best to fit in.

Small change in a big scene

My money meant nothing to them; it was pennies compared to their lucrative fortunes. They all owned hotel chains, restaurants and oil companies. To them I was still a poor Black kid with muscles from the Ghetto. If one of them woke up tomorrow with my money in their bank account, they would probably put a bullet in their brain. They probably all laugh their asses off daily, every time they see someone like myself wearing diamond watches and gold chains, thinking I am truly wealthy. That's how real money sees all of the Black Bourgeoisie, a bunch of poor Black Ghetto kids playing a rich white man's game, just trying to fit in.

In order to change the culture, we have to change the idea of what it is that we are aspiring to be. What if instead of striving to achieve this idea of the American Dream that we are spoon-fed and made to believe we have access to, we got back to the mindset of nation-building that we had before the end of segregation. What if we moved forward with the purpose of building enough resources for our own infrastructure to have a real place and standing for ourselves in this country and economy? If the Black Bourgeoisie felt a moral and cultural responsibility to help provide a pathway to success for those that aspire to follow them by acquiring a real stake in the Black community and creating resources and jobs to benefit and serve their people, there is no limit to what we could build and accomplish for ourselves in this country.

To My Daughters

Don't let the world convince you
That your light shimmers and
shines too bright.
That your strut is
too fierce 2 handle.
That your opinion
is too strong to be liked.
You don't need anyone's permission
To be…yourself…unapologetically.
Your confidence
is evidence
Of God's preparation
For the purpose
of your existence.
Never let a man tell you
What kind of a woman to be.
Your femininity
is yours alone,
And it's whatever you define or make it to be.
Never sacrifice your own purpose
Or your divine spiritual identity.
Just to fit into anyone else's
Superficial categories
of womanhood or beauty.

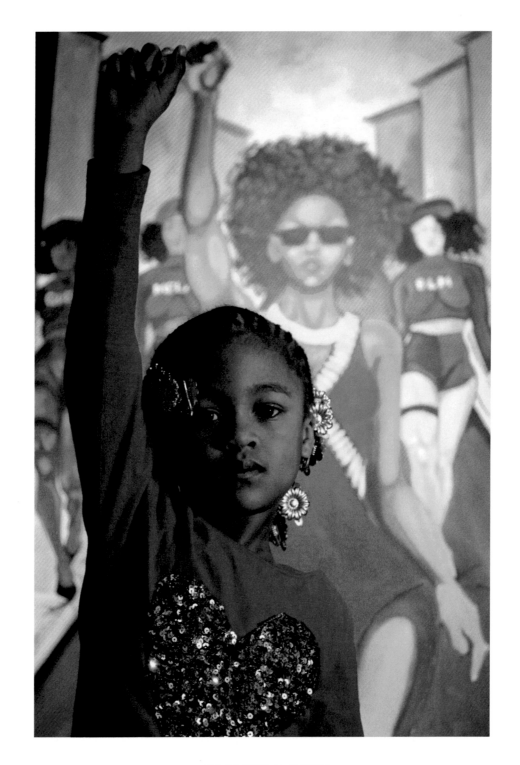

Never trade in your virtues
For castles
made of sand
That shall crumble
with the rising tide of the sea.
Be unbending
Be Unbreaking
Be Unafraid
never compromising your faith or integrity.
When times get tough,
You fight.
Wherever some may bend,
You stand.
Where some may break,
You remain
Steadfast,
Set to purpose of the task at hand.
My prayer for you
Is to remain…
Unbendable
Unbreakable
Unshakable
Always…and forever…
YOU.

Letters 2 Langston

I know all about dreams
I've known dreams
That run deep
As the Nile
Through the heart of our ancient lands
Across foreign horizons to the shores of our noble home
I've lost myself
In my own dreams
At night
Washing up on the golden shores
Of mornings reality
Renewed.

You asked us…
What ever does happen to a dream differed?
Does it dry-up,
Fester,
Wilt… or die
When we stop believing in its word?
When we let go

Of the promise
Of Dreams we hold so dear,
Can we still live lives of meaning
While lost in the abyss of uncertainty & fear?

A dream is never deferred….
It's derailed
The path has been altered
By scheme.
But man can never let life's adversities
Make him stop tirelessly pursuing his dreams
Dreams are the fuel
The force and the tools
That drive us towards our fate.
Our dreams give us a glimpse
Of a world we are meant to create

Lost Boys

I came from Boys,
That came from boys,
That came from boys,
That came from boys…
That
Never
Knew
Their real names…
Or their tongue,
Or their family,
Or their history,

Or their home.

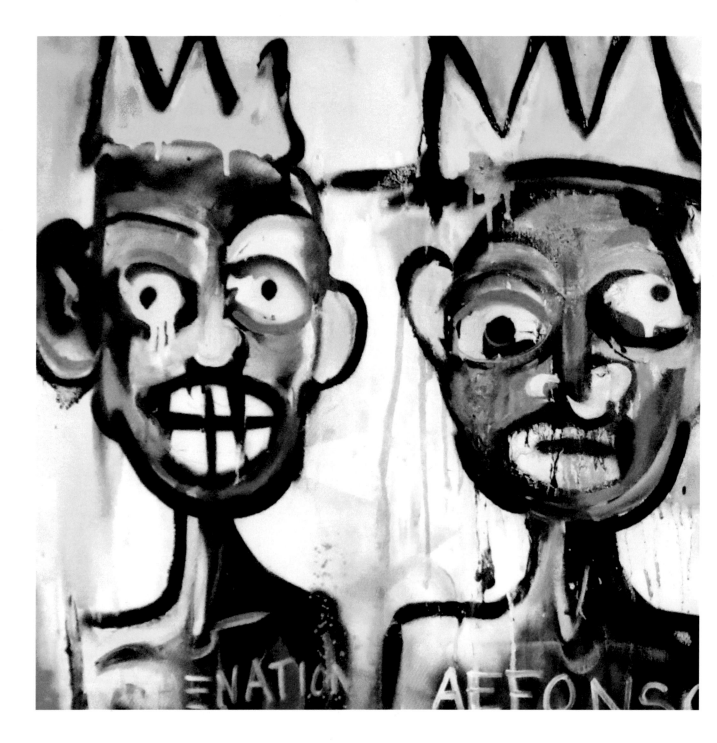

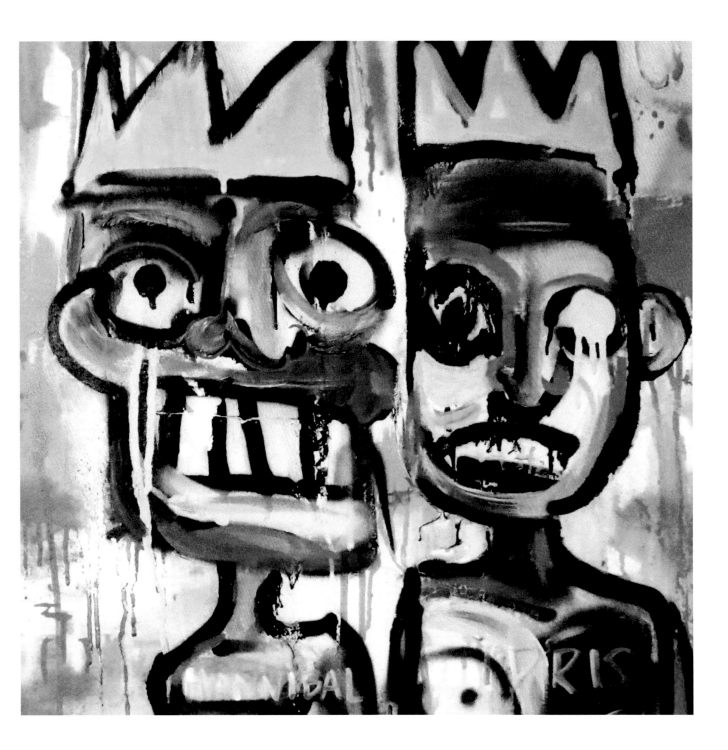

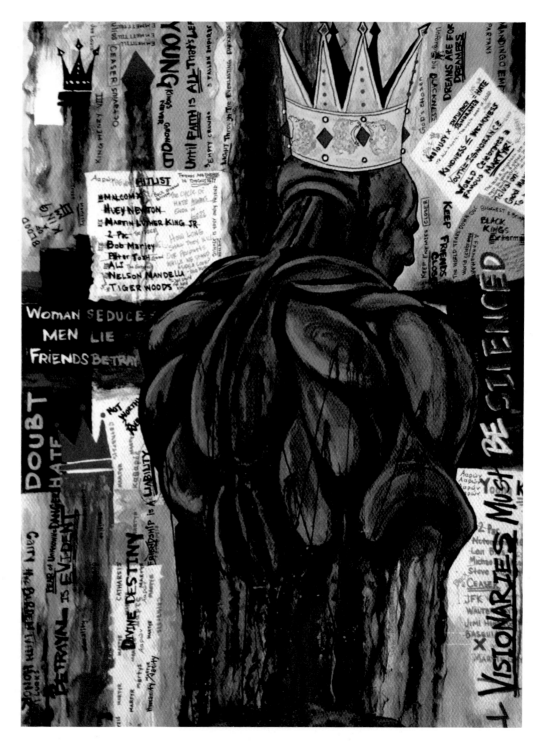

Growing Pains

Growing up,
Trying to stand tall,
with the world's weight
Laying flat across your back…
Oh,
How great it must seem
To be
Young.Gifted.&Black.

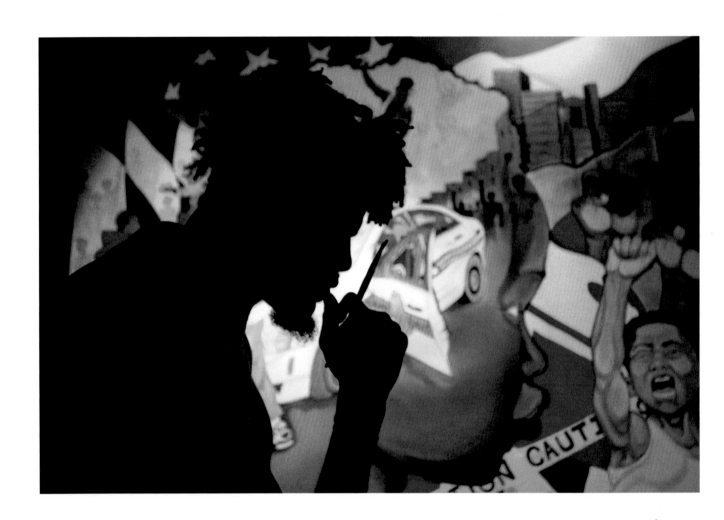

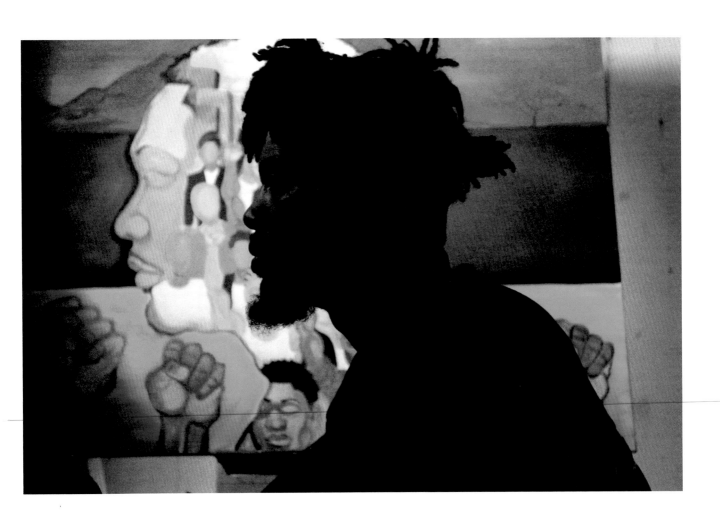

Children Of The Sun

As God bends the sun
making shadows move
Ahead of flesh.
Revealing fallen Angels
with broken feathers
and damaged wings
and shattered dreams.
Sons of the sun
and daughters of the earth.
who have forgotten
their divine purpose
and eternal worth
Terrace Hallways and project stairways reek
Of Freebase fumes, alcohol, sex & pissy sheets
Human beings weren't meant to live
In a dark place like this…
Sidewalks jam-packed
Junkies lost,
Twisted,
drowning in the abyss
Testers came out in 5 yo!
Crackheads on the sidewalk
In the streets, stuck in a trance,
Twisted,
bending,
so far gone
Doin' that devils dance.
Eyes turned to the sky
Like they're trapped in bodies
that have fallen dead,
With tortured souls,

refusing to die.
Squinting…
as if they had forgotten
the sun.
When did we all forget the sun?
When did we forget
Ourselves?
When did we lose us?
In the bitterness of lost souls…
Minds,
Conceived by all minds,
But we have lost a love…
of love.
Is this my face
that I see in the mirror?
I don't know him, and if he is me…
Behold.
I find myself …lost
What was his name?
From what tribe did he descend?
Show me…
how to be
Show me…
How… to be me…
Once Again.
New revelations
Of lessons learned
but long forgotten
Of realities known
but still Unseen.

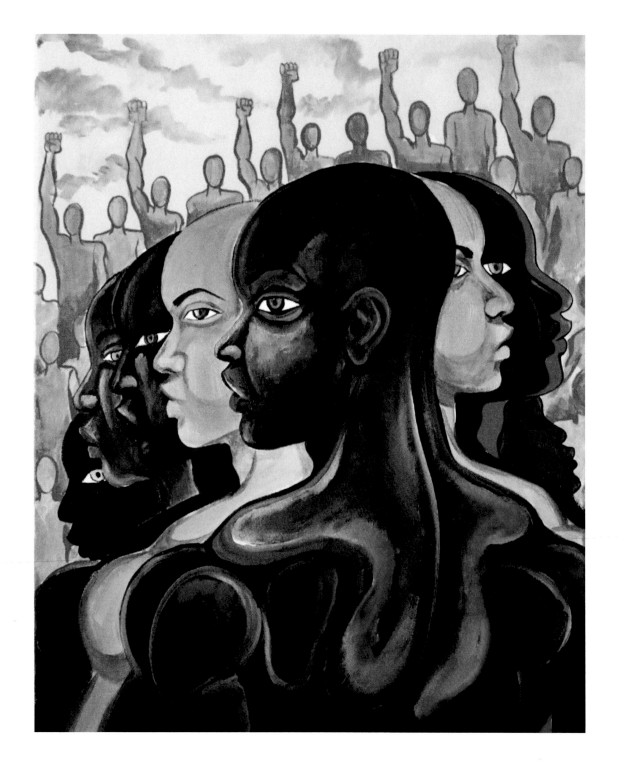

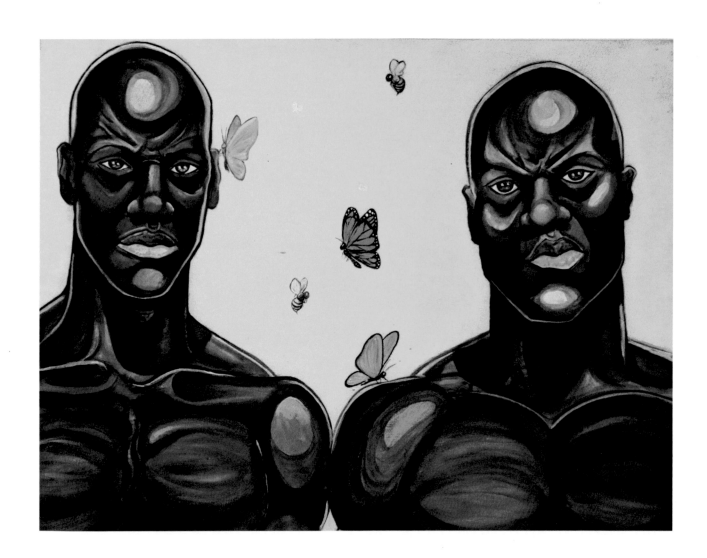

Children Of The Sun 2

You may. One day…
Forget the sun,
But you can't
Escape its light.
It will find you,
No matter where you may hide…
Even in the darkness of night.

Life in the Slums

Living in Baltimore
The city that reads.
But I know it more
as the city that bleeds.
They keep telling me
to Be More
But I'm livin' in Baltimore
Land of the slum lords,
And the Law and order soldiers
Always seem to Break my Body-More
Living life in the trenches…
 Struggling,
 Trying hard not to lose your senses.
But Livin' in the slums
aint never made me a bum.
Or did u forget…
That some of us still read books
where I come from?
We know 400 years
Aint made a mistake yet.
No matter what excuses they provide.
Cuz there aint no such thing,
As unintentional mass-genocide
Led poison
 Deploys in

The land that
the devil destroys in.
Which happens to be the same hoods
Y'all white folks is avoidin'.
So many of my loved ones gone
Fathers
 Mothers
 Daughters
 & Sons.
That's why we pop bottles
To celebrate makin' it to see 21
Then we pour out bottles
& drown our sorrows
for our homies that died too young

Marked for death
 By society
before they exited the womb.
But you know,
 like I know,
Baltimore celebrated 150 years of freedom…
150 years too soon.

The Things I've Seen

I've seen Friends
Turned to Fiends…
Falling asleep on their feet.

I've seen human beings
dwelling in cardboard boxes-n-things.
Making shelter in the streets,
making hotels of sidewalks,
and pillows out of hard concrete.

I've seen Corrupt cops turned criminals.
Robbing killing & stealing
from the ones they swore to protect & die for.

Poverty-Pimpin' politicians
redistributing wealth to the wealthy,
while gentrifying politicizing & dividing
The poor.

Passover-Preaching-Pastors passing over
the addicts and hustlers and whores
takin hard-earned-dollars from their congregations,

blaming victims for their own victimization.
And robing their peasant patrons
Of more…and more…and more

Teachers that aint teachin'
nothing more than standardized lies.
Twisting history into a mystery
that implies their own students' demise.

I've seen Babies raising Babies.

Black don't crack?
Who told you that?
I've Seen that good Black
cracked open by crack
since the 80's.
I've seen Death.
I've seen Life.
I've seen triumph.
I've seen strife.

I seen it all

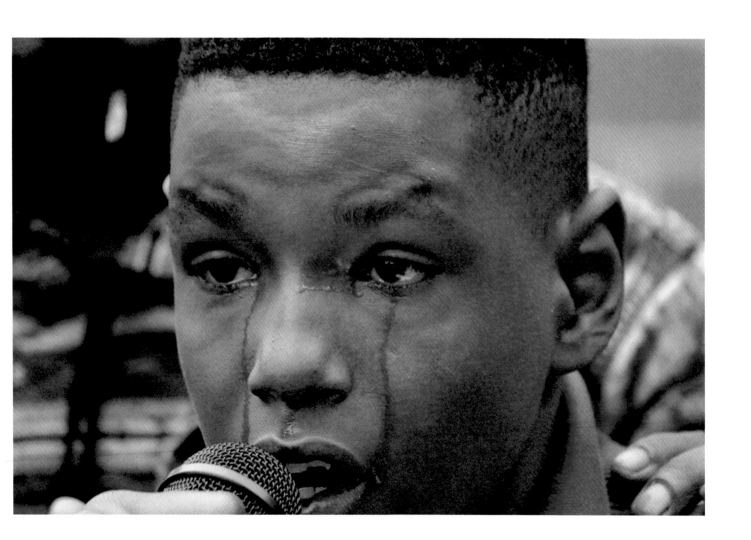

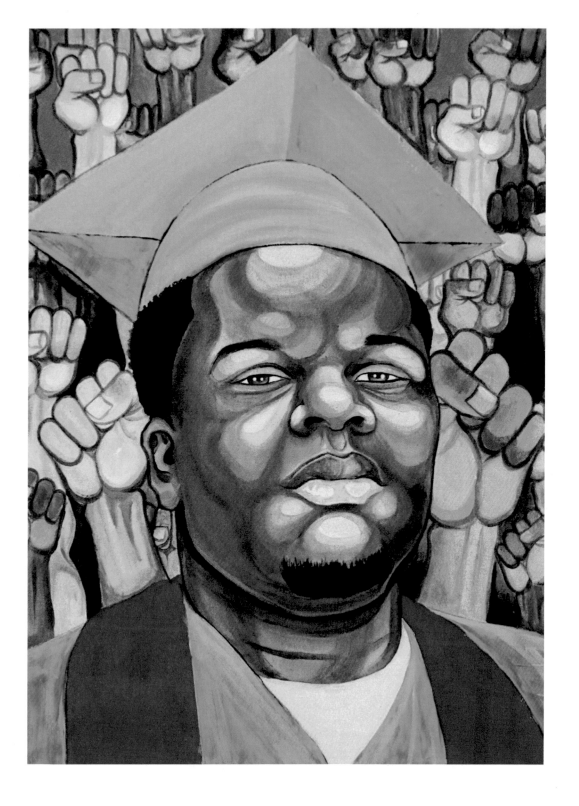

The Role of the Black Church

The other day, my homeboy and I were driving through the city, on our way to a speaking engagement.

I was on the passenger-side seat with my window down, letting the cool early autumn Baltimore breeze sweep across my face and off the twisted locks of my hair as I calmed myself and thought about my talking points for the night.

We drove down Edmondson Avenue and made our way to the East Side. As we rode through each neighborhood, I looked at the people and activities taking place in each section of town around me, as we cruised smoothly toward our destination.

I saw all the faces of the people scattered across the horizons of one poor Black community after another outside my window as we rode by.

The stress painted onto the hardened wrinkle-filled faces of the poor, the sick, and the homeless, panhandling for dollar bills and loose change to feed themselves or to satisfy their crippling habits of addiction, occupied every corner, traffic light, and intersection of town.

Repeated scenes, everywhere

There were constant similarities in each of the neighborhoods we rode through on that day; pretty much all of them were predominantly Black. There were liquor stores that seemed strategically littered on every other block of the most colonized of those communities. There were homeless men and women panhandling at almost every traffic light and intersection along our way through the city streets. Entire blocks were filled with boarded-up and abandoned houses in decay, and the dope-fiends danced and paraded up, down and

through the city streets, on the sidewalks, and in the alleyways of one neighborhood after another.

Some of them almost defied the law of gravity, passing out on their feet without falling, engulfed in the trance of their highs and lost in the labyrinth of addiction, stuck in a trap between this world and the next.

And on every other corner of every single section of town, a huge church building was sitting right in the middle of all the madness.

"I'm tired of seeing all these big churches in broke-ass Black communities," I told my friend.

He looked over at me with a wide-eyed stare of shock and surprise -- "What the

in our Communities

Hell are you talking about, bruh?" he snapped back almost immediately. "Aren't your parent's pastors or somethin'? That's what we need in these crazy communities."

He and I went back and forth for the rest of the ride to the speaking engagement about the role of the Church in the Black Community.

A stinging criticism

My position was simple: There is no reason why there are so many rich churches in the poorest, most violent, neglected, and impoverished Black communities and more is not being done to fix the state of those communities that sustain and support them. "If these churches were really out here doing God's work, these communities wouldn't be this bad."

My friend was adamant. "Boy, you grew up singing in the choir and handing out programs on the Usher-Board, you sound crazy saying stuff like that," he said to me, chuckling between words as he probably pictured me as a kid, diligently participating in the activities of my church home.

I grew up in the Black Pentecostal Church. Both of my parents are now pastors down in Bluffton, South Carolina, but the origins of our family church

history began on the West Side of Baltimore City, Maryland, at a church called First United Church of Jesus Christ, Apostolic.

"The church I grew up in is a lot different than the churches we're seeing on this ride right now," I said to him. "The pastors used to make sure that the church was a resource to the surrounding community. These poor, stressed, and depressed people out here aren't feeling that kind of love from the Church anymore, so they continue to drown themselves to death in crime and addiction. My own father turned his whole life around as a result of the church."

The Church that made a difference in my life

Under the teachings of the late Chief Apostle, Bishop Monroe Saunders Sr., who for my father represented his first true example of a pastor and his flock, living lives of holiness and righteousness. Bishop Sr.'s son, Presiding Prelate Bishop Monroe Saunders Jr., provided the tutelage and teaching to my father, who grew up in a Baptist church but went his own way after leaving for college. Bishop Saunders Jr. helped my father transition from a street-runner, drug user, and alcoholic into a clean and sober-minded, devout Christian and follower of God. Dad was drawn to his

new church home at First United by his pursuits of my mother, who was a devoted member along with the rest of her family. He eventually married her and their relationship bore the fruit of my sister Connie and me before her untimely death during Connie's delivery. It was a devastating blow for my family to take.

The sky a canvas on which to reflect

The sun started to set over the city skyline as we got stuck in traffic. The sky above me was an immaculate canvas of rich yellows, reds, oranges, pinks, and purples, contrasted by the rows of vacant and abandoned houses flanked by the faded silhouettes of the big corporate downtown structures in their background. I reflected on the memory of my father's struggle to make sense out of life after losing his wife, life partner, and best friend.

After my mother's death in 1995, he became even more committed and dependent on the Church and the Lord to guide him through his dark process of grieving. By the time he met my stepmother, he was a licensed minister, preaching the Gospel at many of the churches across the city of Baltimore in our church organization. My new mother, an overseas church missionary herself, was British-born of Jamaican descent, and she also grew up in the Church. She was a strict, loving, kind, God-fearing

woman who was very passionate about the Gospel of Jesus Christ and about the church family. She helped to bring order to our family and in our household. She also strengthened my father's resolve to share the Word of God and teachings of the Church with all of his people.

Street-sellers spark
a memory to rise

I sat there in the middle of traffic, surveying the scenery around me. A big money dice game is goin down on the corner, the people who set up shop on the streets and turned the city's littered sidewalks into concrete marketplaces, selling everything from glasses and hats to incense and African-made skin-care products, made me think of my own father's hustle growing up. In addition to working for the Baltimore City Fire Department, he also had a moving and hauling business, which I helped him to work, he sold dress-shirts and ties, and he also had a snowball stand that he started in order to raise funds for the Church.

My father went from being a licensed minister to an ordained Elder in the clergy to eventually being appointed the President of the Men's Department for our entire international Church Organization by our Presiding Prelate, Bishop Saunders Jr. He would travel to our churches all over the country to preach principles of discipline,

responsibility, relationship with God, and family values to the men of the United Churches. By challenging them to constantly strive for a deeper personal relationship with God, he believed they would in turn become better husbands, fathers, employees, and citizens. Basically, that it would make them better men. He now serves in the position of Overseer with ministry responsibilities in the states of Georgia, Florida, and parts of the Caribbean for the United Churches.

As the traffic jam on the road cleared, and we started to comfortably cruise through the city streets once again, I turned to my friend and said very matter-of-factly, "If my family's church was in Baltimore right now, you would understand it, man. There is something truly missing from these churches right now in a major way."

My example: The Church
as resource center

During my rookie year as an NFL player, I established my home in Baltimore City. I relocated the rest of my immediate family from Baltimore down to South Carolina where my parents started their own church, Kingdom Seekers Family Worship Center in Bluffton, S.C. The church was founded to be more than just an institution of religious instruction, but a resource center for the community itself, outside of the people in the church

membership. Like me, my parents believe that the Black Church has a role and responsibility in the community. My dad sees the Black Church as a nucleus for our culture as a whole, considering that most of our community and family rituals and our value system all stem in some way from the teachings of the Black Church. In times of great crisis and despair, people often draw on the institutions that have been pillars of strength, understanding and dependability in their lives or the lives of their family. For most Black families, the Church is a beacon of light and a constant reminder of their own personal moral compass.

Personal leadership
for national good

My parents believe in the nationalist perspective of pastoring and church leadership, teaching their congregation to learn how to self-build and to create economic opportunity for themselves and those in their communities. As co-pastors, they feel the church should be a resource to whatever the community needs. They believe in teaching economic and fiscal responsibility, imploring their membership to stop waiting on culture to provide opportunity for them and to be proactive in creating it for themselves.

They address important issues facing the Black and Brown community as a whole

through three specific areas: education, knowledge, and enlightenment. To my father, the Church is like a mother to the community, and as pastor, he is the father of his flock. In addition to Sunday School and Bible study, he holds lessons and seminars about economic development and provides education and tutoring resources for the at-risk youth and young adults transitioning to college. My parents even open up their home to church members in need of shelter, wise counsel, or a hot meal. They also share the church building with a Spanish pastor and his flock, so that he can minister to his people in their own native tongue.

No 'mega-church' here

My parent's church is far from the "mega-church" status of institutions like those led by Bishop T.D. Jakes, Creflo Dollar, Jamal Bryant, and others. It has a smaller, devoted membership. Unlike many of the huge structural giants in the Baltimore community that basically go unused every day except for Sunday, my parents have a smaller, more modest and sensible church building that they use as efficiently as possible to maximize its impact on the community. They have a kitchen in the church that is always stocked with food and drinks for anyone who is hungry or thirsty. They have a bathroom with a shower, colognes, and perfumes that is open to be used by anyone coming off the

street who wants to get cleaned up. They even used their own home to host Bible studies and services when they were in transition between church facilities. They also are much different from typical Black church leaders in terms of how they view their respective roles in the community.

Skepticism greeted my comments

"So, what's your issue then?" my friend asked, in an almost irritated tone. "You have no problem with your parents' church and how they operate, so why this attack on the Black churches here in B'more? Because they are bigger and making more money?"

I turned the music down so that I could be clearly heard on my position. "I'm not attacking the Church as an institution," I said as we rode into a newly gentrified section of town, where most of the original residents had been relocated to another poor, colonized neighborhood for the next big-money corporation to come in and build. "If your church is in a poor Black community, then the interests of the church in its affairs should align with, and be directed toward, that community and the people in it."

If the Church is to be our example of what it is to live Christ-like and be a moral compass of the community, telling people how they are supposed to live in

service of the Lord, then the Church should also exist to be in service of that community and its residents. Instead, what we have now is a system where the "Black Church Elite" and its members have disconnected almost entirely from the communities they and their churches call home.

Back to the essential point

"Things used to be different, man," I said to him, reflecting on the church environment in which I grew up. In my youth, I can remember a great deal of attention being paid to the role of the Church to engage in community outreach programs. These programs served as a bridge between the Church and the people of the surrounding neighborhoods. There were also resources for those suffering with drug addiction, alcoholism, and mental illness to assist in their transition to sobriety and mental stability. These resources were open and available to both the Church membership and the people in the surrounding neighborhoods who were not members.

On most Sundays, the old church mothers from the neighborhood would grab the young corner boys they used to babysit by the shirt-collar and drag them up off the streets and into the church pews. It was not an odd occurrence to find a neighborhood drunk or drug

addict seated next to you, still smelling of the whiskey with which they'd drunk themselves to sleep the night before. The goal of the Church that I remember was to completely transform the lives of all who were lost and in need of guidance in life through the tools of knowledge, enlightenment, and a personal relationship with God, the same way it did for my father.

The view that something was lost

As I look around today, most of these resources are scarce, hard to find, and generally inaccessible to those in the Black communities who need them the most. The homeless, the addicted, and the lost souls that once were invited in with open arms and met with a smile and a kind word now are stared at with indifference, widely judged, avoided, and generally neglected by those Black Church elitists who see themselves as superior to them. Single mothers are judged and looked down upon, as if the fathers that walked out of their lives were not also to blame for the broken state of their households. People single out, separate, and distance themselves from the poor, the homeless, and the addicted, instead of showering them with the love, understanding, and compassion necessary to break the shackles of their addiction and mental despair.

"That's not the Church's job though, man," my friend responded, almost dismissing my entire argument.

He did not have my background in the Church, so some of what I was explaining fell on deaf ears. I started to school him a bit on the history of the Church's significance in the lives of our people.

"The Black church has always played a monumental role in the narrative of Black people in America."

The pivotal time of Civil Rights

During the Civil Rights Movement, our churches served as our organizing headquarters, spiritual guidance centers, homeless shelters, and the vocal mouthpiece of the movement for Black liberation and equality. Pastors like Adam Clayton Powell, Martin Luther King Jr, and Islamic leaders like Malcolm X, Elijah Muhammad, and Louis Farrakhan spearheaded the movement through their platforms as the heads of their religious institutions. They spoke messages against the systemic government oppression and repression crushing lives in Black communities across the country. The Church institutions become the new platform from which Black revolutionary messages were spread across America, and there was nothing the government could do about it.

That all changed when Lyndon B. Johnson added churches to the section

501(c)3 of the Tax Code defining non-profit institutions in 1954. Then a senator, Johnson was no friend of the Church. His agenda sought to silence the church and eliminate its platform for political influence on the shaping of public policy, and that change legally hamstrung political activism by Church leaders.

Explaining the bad effects

"So that's your real issue then," my friend said. "These churches being down with the government?" he asked, as we started to near our destination. I started to explain how once incorporated under the authority of the U.S. government, churches and their pastors would lose their First Amendment rights to freedom of speech and religion. They would lose the ability to speak out against government forces or organize to influence political issues. For the 501(c)3 churches to continue speaking out against the tyranny of government and the political forces oppressing people of color in our inner-cities would be to put them at risk of losing their tax-exempt status. Churches incorporated under the government umbrella would no longer be able to use their platform and resources as tools for political mobilization in the community. Incorporated churches were now considered "creatures of the state," meaning the churches themselves and all the resources connected to their institutions were now government property, and thus were subject to government control. Any incorporated church caught trying to influence

legislation or speak against political leaders could face a lawsuit or even imprisonment of its leaders by the federal government.

Free the Church from the restraints

"I've always had a personal issue with these government-incorporated churches because of my upbringing," I said. "My parents have always believed in a firm separation between Church and state." They pastor a Free Church that is not under the blanket of any government influence, thus my father's teachings and his messages are unfiltered and uninfluenced by the poison of political control. I personally believe that any Church leader who is willing to sacrifice the cultural influence and authenticity in the messages of the Church and the mobilizing power that they contain for a tax break is not someone who is fit to lead, especially considering the fact that the churches themselves were never taxable in the first place. The founding fathers of this country were mostly non-conformist preachers who made sure to clearly protect the Church institution by placing it outside the jurisdiction of civil government through the First Amendment.

Compromises destroy authenticity

"There is a desperate need in our communities to make a change in the culture, and a change will not come if there is a lack of trust from the community members towards the authenticity of the messages of

the Church's Leadership." And when you have so many of the Church elite competing for an opportunity for political gain and influence, the members in the community begin to feel disconnected from the true mission of what the Church is supposed to stand for. Once the foundation of any structure is eroded, the structure itself will fall.

Back in the spring and summer months of April-June 2015, we saw the Black Church elite on full display in the aftermath of the death of Freddie Gray because of his rotten treatment by police on the streets of Baltimore. The Black pastors were out in their Sundays' best, competing for camera time and platforms to promote their own churches as well as themselves. They would arrive at the protests and rallies wearing expensive tailor-made suits and driving in Mercedes Benzes, Bentleys, Rolls Royces, and every other exotic car in their elaborate collections. The juxtaposition of the idea of such wealth and excess being flaunted in the faces of the most outraged, poor, and disenfranchised people in the city was unsettling to say the least. These "leaders" were present on the front lines for about as long as the cameras were; anywhere there was a camera, there was a pastor or a politician in front of it, promising change and using Freddie's name as an opportunity for shameless self-promotion.

Meanwhile, the situation worsens

Since that time, the murder rate in the city of Baltimore has skyrocketed, schools

are being shut down in some of our poorest and most violent communities that need them the most, addiction is killing our men, woman, and even our children daily at alarming rates. Where are the pastors and politicians that just months ago were out making empty promises of change, hope, and a better way for the city? How many of them are now using their churches to organize and mobilize plans moving forward? The answer: Most of them are now busy running for political office. Instead of lobbying their influence to change the system of government, they want to join it. Like their church followings, they want to further distance themselves from the economic and social issues and hardships facing poor Black people in this country as a whole.

The isolation of arrogance
Black Church folks can be some of the most arrogant, judgmental, self-absorbed, and selfish people walking around in the world today. Every week, they dress up in their Sunday's-best suits and dresses; the women wear fine hats with huge pins and accessories, and carry big elaborate purses full of junk food, mints, and fresh dollar bills for the Offering. Sunday after Sunday, with their noses turned up, they pridefully march right past the poor, addicted, and homeless on the streets, into their huge church doors and walk down the Sanctuary's aisles to their seats with their shoulders back and their heads held high, like they are in a fashion show or something. The pastor judges them, and then they all judge each other, along with everyone else in life that they meet. They separate and isolate themselves from the "sinners" among them instead of sharing God's love. They drive away many of the very souls they were called to save. A shift in behavior and interaction is needed to mend the intellectual and social wounds and bridge the divide between the Church and the people in the community once again.

The thing that was lost is the vision
At the end of the day, I understand it from both ends. These churches need the money and resources from the community in order to function and maintain sustainability. But I do believe that in the effort to maximize profitability for the Church institution

as a whole, we have lost sight of what is important — the people. The community needs to be able to rely on the Church for its vast resources also. If your church is located in a community drowning in alcohol and drug addiction, then your members should know the smell of alcoholism and drug residue themselves, because so many are being brought into the Sanctuary for the love, compassion, and knowledge they need in order to overcome their vices on their road to sobriety. If your church is in an area with mass homelessness, then its body of believers should be involved in an effort to place them in homeless shelters. If your church is in an area that suffers from joblessness, then the church leadership and its members must make a dedicated effort towards providing economic opportunity and access to the job market. If the children in the church or the surrounding communities are struggling with their education, tutoring, and mentorship resources must be made available to them. If the system of government plaguing the communities of our church homes is corrupt, then the churches must be bold enough to address it with their congregations. There is no room for cowardice in the hearts of our church leaders in their handling of the issues still facing Black people in America — 50 years after we were promised the right to equality.

A Call to carry forth Jesus' Appeal
The Sun had fully set by this time, as we pulled into the parking lot of our destination, a little coffee shop venue on the outskirts of the city. The streets were paved and the sidewalks were clean. The cool night air blew right through my jacket, sending goose-bumps up my chest. It was chilly outside but I was warm and my palms were slightly moist. I was actually nervous. Before we walked in, we stopped so that he could smoke a cigarette. We finished our conversation with a simple sentiment, an appeal to humanity. "Jesus was a follower of God," I said as he blew smoke into the night air. "He never asked to be adored and praised by his following, he just preached the love of God and lived his life as an example to all."
My friend put out his cigarette under the heel of his boot and looked me in the eyes, finally understanding my point before I elaborated. "What are these pastors and church leaders doing

that truly embodies what Christ stood for?" He nodded in understanding as I continued. "A prophet's whole life should be an example of love, compassion, holiness, and industriousness. He should live to show man the perfect path by example, not by judgmental sermons and absentee community involvement."

Embracing the moment

It was about time for the panel to start, so we ended our discussion and headed inside. Before we stepped in, I took a pause to clear my head and just look up into the now-darkened sky. It was a quiet night. The stars gleamed from behind the clouds and the city's downtown skyline was a picturesque landscape glowing and fading into the distance. I embraced the sight, the moment itself, and the symphony of silence that accompanied them. This was indeed the language of God. I wondered if what I had said to my friend had truly sunk in. While I could not be sure if it had an effect, I was sure that his perspective was now changed from what he had known that morning, and that's all I could ask for the chance to change perspective.

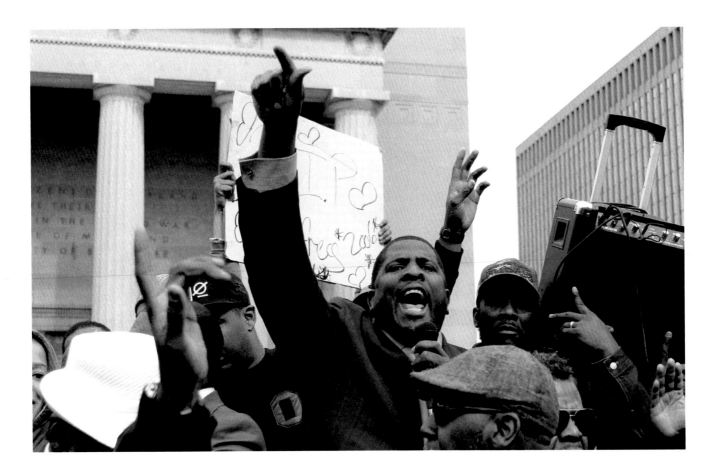

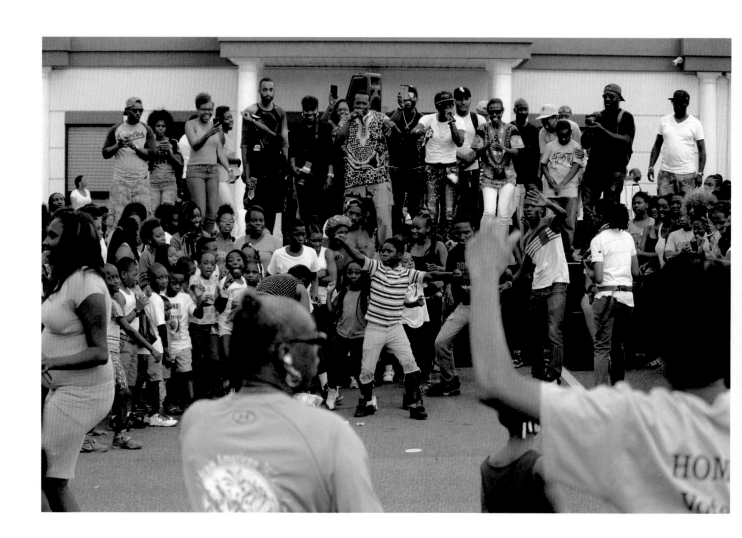

This Is For My People

This is for the church folk,
singing and dancing and speaking in unknown tongues,
and their revivals and their jubilees and their congregations,
assembling weekly to worship, tithe, and pray,
hoping Lord Jesus will come back down from heaven
and fix all their problems for them one day.

This is for the forgotten and invisible ones
that nobody ever sees,
that spend long nights window-washing, hotel cleaning,
and scrubbing bathrooms on hands and knees.
The ones still spending long summer days
in the hot fields of the south.
The ones picking the weeds, planting seeds,
plowing the fields, cutting grass,
and raking leaves.

This is for my childhood comrades,
hooping and playing football
in the dusty patchy grass fields
littered with unwanted sofas
and piss-stained mattresses and junkies' needles
and Black N Mild's and half pints of cheap vodka,
and ghetto dreams.

This is for all those years of poor kids
being crowded into poorer classrooms,
getting told what to say,
and learn and do and think,
being taught how to be told

where to go, what to learn,
not to ask questions,
to always believe everything they are told,
to understand beyond all things
that they are Black,
and thus…inferior.

This is for my homies
locked down behind cages
of iron and steel
on hard cots,
with no heat and a toilet and a face bowl
and prison food and loose cigarettes,
and lonely corner tales
of girls, guns, and game,
and books and letters from the outside
to keep them company.

This is for all of Tupac's seeds,
the young boys and girls that took root
in the cracks of the concrete in the slums,
watered by the tears of praying mothers
and weeping widows,
strengthened by the same rocks
that contained them,
rooted in the soil of broken glass,
and fractured dreams,
and unrealized potential,
in spite of their circumstance,
they still sprouted into roses

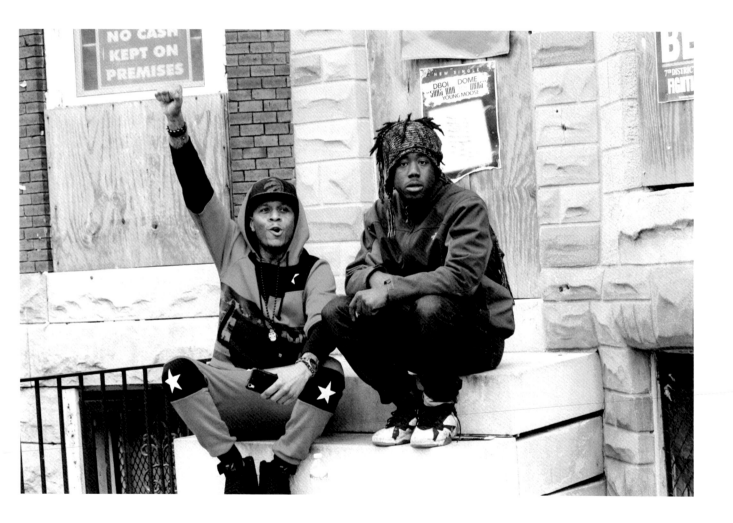

for all the corner-boys and dope fiends to see
and marvel at their resilience.
Its brilliant!

This is for all the men and women
that chose to grow outside the box,
and live free.
Unbound by the limits and boundaries
of reason,
and barriers of responsibility.
For the club-rats and the hood-rats,
and the weed-heads and the corner hustlers,
nickel and diming their way
till tomorrow.

This is for my brothers and sisters…

This is for all my people marching
and raising hell in the streets,
for my soldiers, standing strong in the trenches
in Afghanistan, and Fergusson and Iraq
and Uganda and Libya and Flint and Syria
and Chicago and Israel and Baltimore
and Somalia and Detroit and Egypt
and Philadelphia and Mali and Cleveland
and Sudan and Oakland and NYC.

This is for all My Africans everywhere

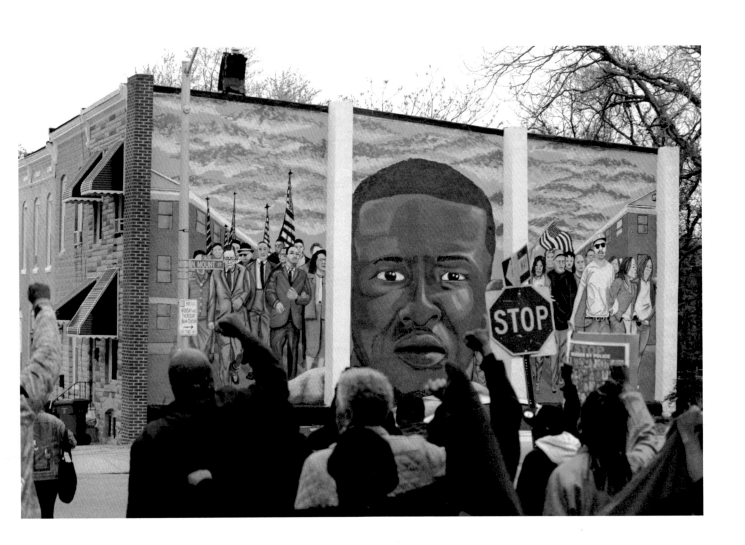

A Walk Around the Way

In the morning,
When I walk my dog,
I like to sit
On the steps
of a vacant stoop.
Light-me-a-blunt,
Pull out my notebook,
And bust down
a line or two.
You see a lot of living…
and dying…
taking a walk
around my way.
An all-day marathon
of horror
comedy
& action.
On repeat

Every. Single. Day.
The funny thing about the struggle
is the irony in the way,
that in the midst of it all,
we don't just find the beauty,
We create it.
We embody it.
We emulate & emit it
We mask our pain
and trauma
so well

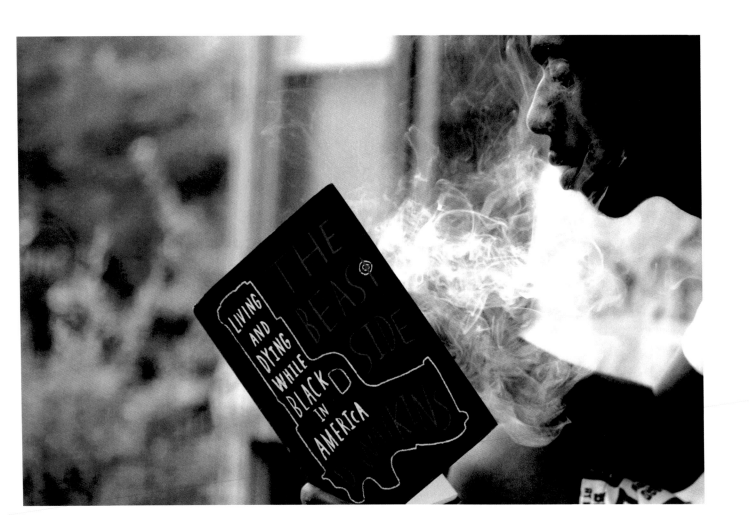

Disguise our depression
with such ease.
As if it was second nature
To hide our shame
and ignore mental disease.
At times,
Even the most broken among us,
Can seem almost indestructible to me.
But I've seen
the hardest men…
Cracked & broken open
By Bricks, Bats & Bullets.
Immune.
To their indestructability.
I've seen Victims of violent abuse,
that became violent abusers.
I've seen sons & daughters of dope fiends,
that became prescription drug users.
I've seen young hood prodigies,
receive their lofty prophecies.
Then take that never-ending tumble,
down the public staircase,
From celebrity…
To poverty.

I've seen
Hypocrisy
Disguised as Democracy
Chopped-down, fixed-up,
and served right back to me.

What we are…

What we shall be…
There can be no certainty.
But that's the beauty…
of the Now.
Because we get no guarantees.
We tell ourselves.
"Your life is what you make it.
You can be whatever you dream,
Do whatever you want to do."
But once harsher realities are realized
What am I, then, to do?
Tell me!
How does one begin
To subdue his own virtue?
And how does one cope,
With the sourness of sorrow…
When their wildest dreams don't come true?
Living life. Obsessed.
By a dire need to possess…
what we could never fully grasp,
but always fought like hell to get.
But still, we learned to find,
A joy
In life…
That we were never supposed to know.
When all the plants around us
withered and died
we still found a way to bloom & to grow.

Working long just to play hard,
until we reach the graveyard.
Trembling…

In hollow dirt tombs,
beneath cold stone,
Forever restless.
Who else but us,
are so taught,
This language of hopelessness?
Happiness ever on the horizon,
but were crippled in Brokenness

You can keep your privilege…
I'll always take our struggle
I'll take our hustle
I'll take our muscle
Because this fight I'm in for my life
has sharpened my bloody knuckles.
And regardless of whether or not u play fair,
Me and mine aint goin' anywhere.
So unless you want this guerrilla warfare,
take your gentrification elsewhere.
Cuz aint no millionaire, billionaire, or trillionaire
got the hardware
to come & kick us up-outta-here.

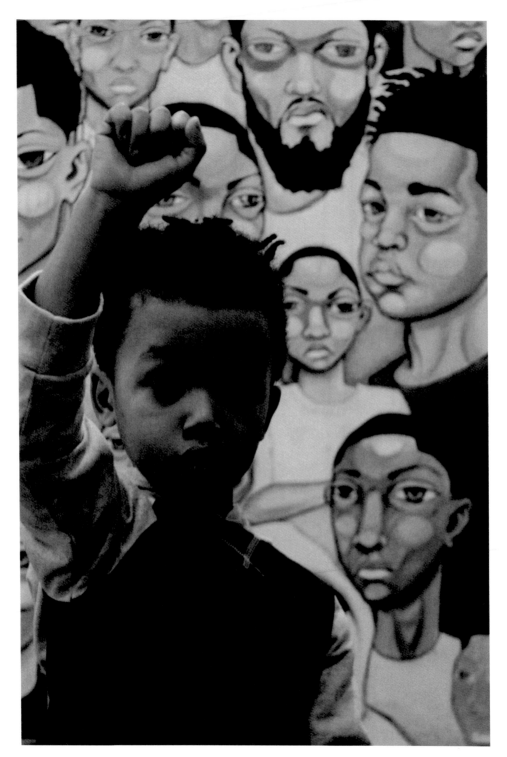

We All Should Be the Next

Many of the children running the streets of Baltimore City were not born into stable home environments. Many of them are locked into a school system that is failing them. They feel berated, belittled and beat down by an aggressive and over-zealous police force. Too many of them are criminalized, colonized and dehumanized by a society that rejects them and blames them for their own victimization, oppression, and misfortune. A great number of those children do not have both parents in the home, but in spite of these dark times and their bitter misfortune, they always had Keion.

The late and very great Keion Carpenter was not an extremely tall man for a former professional athlete. He stood just less than six feet tall, and walked with a slight limp in his step that he usually disguised as a strut. He had a big, endearing, gap-toothed-smile that almost always adorned his face when he was among friends. But despite his stature, to the people of Baltimore and almost everyone else who knew him, Keion was a giant.

He died in a tragic accident while vacationing with his family in Florida, and his gifts will surely be missed.

A man who didn't respect obstacles

In a city more known for its crumbling infrastructure, sky-high murder rate, suffocating drug addiction rate, and drowning levels of poverty, Keion Carpenter was the one with the Golden Ticket. He overcame every obstacle that fell in his way to achieve both athletically and academically, earning an athletic scholarship to the Virginia Polytechnic University. As a Hokie, he ran plays for Coach Frank Beamer before graduating in 1999, and he fought his way into the NFL as an undrafted Free Agent with the Buffalo Bills. He played in Buffalo for three years, and went on to play three for more years with the Atlanta Falcons.

Known for his scrappy style of play, blue-collar work ethic, and his fearless guts as a hard-hitting defensive back, Keion was well known for his toughness.

Remembering where he came from

Upon retirement, Keion made a decision that would change his life forever, along with the lives of thousands of families and the young children he worked with through his nonprofit, the Carpenter House. Keion chose to come home to the city that raised him, and to use his NFL platform and resources to help change the city and the lives of the people in it for the better.

By the time we officially met for the first time, Keion was already four years into establishing his goal of transforming the lives of the people and children of Baltimore City and his new adopted home, Atlanta, where he also spent a lot of his time doing community work. In both cities, he established sports camps and outreach programs. He'd grown connected to Atlanta and identified with the plight of its people during his time playing there. I was an ambitious but naive 20-year-old college junior, preparing to leave school early to enter the NFL Draft in 2009. Assured that the potential millions I was about to make

Keion Carpenter

would allow me to completely change my life and the life of my family, along with fixing the problems of my hometown through my own charity work, Keion offered my first real taste of reality on that subject.

Sage advice I needed
"Slow down lil' Bro', way down," he said, interrupting me in the middle of my young arrogant rant, boasting about all the great things I was about to do. "You don't have any idea how deep the well goes yet when it comes to fixing all that's wrong with this city and the neighborhoods we come from." He explained, "You might think that this check you got coming is enough to change the world, Bro', I been there. But what you need to change the world isn't money, it's what God put in your heart already. That's all you need."

I'll never forget those words. Soon after I was drafted, I got a phone call. To my surprise, it was Keion. He offered a partnership that would go on to change the trajectory of my career and my life in ways that

I couldn't even begin to comprehend at that moment. He went on to show me exactly how he went about establishing his nonprofit and began empowering the most vulnerable of our disadvantaged families and urban youth in Baltimore. We decided to come together with former NFL wide-receiver and fellow Baltimorean Bryant Johnson in a partnership to create Baltimore Team Shutdown, now known as "Shutdown Academy," a youth football and mentorship organization with 22 active chapters across the country to date.

Tutelage that meant something
Over the course of the next few years, Keion took me under his wing and taught me what it really means to "give back." He taught me by showing me, with deeds and not just words, exactly what it means to be selfless. He taught me by being accessible, attentive, and always present in the moment with whomever we worked with. He taught me what it means to really touch people and make spiritual connections with them. He taught me what it means to

minister to people, not in the Church, but on the streets, where they needed it most. He taught me how serve them. He taught me that kindness and goodness mean so much more than simple acts of convenience, that they are essential components to how we should live our lives and deal with people on a daily basis. As he showed, they are also the key to transformative change in the lives of the people we are able to touch. He showed me what it really looks like to dedicate 110-percent of yourself to the idea that we all have to become our own agents of change in order to re-create the kind of city we want to live in.

Job 1: Fathering the children
During this time, I also came to know and admire Keion as a father. Being in the NFL, I saw first- hand how the game and its demands robbed children of their fathers' time, presence, and proximity, making absentee fathers out of otherwise good men. Every one of those stereotypes were shattered the day I met Keion Carpenter. He absolutely adored his children. His three girls were divine

royalty to him, and his two sons were his pride and joy. He enjoyed every aspect of fatherhood.

Most days, he was a soccer dad disguised as a tough guy. He loved taking his kids to practices and games as much as he did being present in every other aspect of their lives. As a new father myself at the time, I benefited from his counseling, and learned the importance of doing whatever it takes to be there for your children. He would always challenge all fathers within earshot to do the same, wherever he was.

It was personal for him.

Keion saw our youth as we should all see them, as our last best hope for a brighter tomorrow. He was adamant about us as Black men being willing to get uncomfortably involved with our children, living in a society that stereotypes Black men as all being absent from their children's lives. He challenged all men to be the types of dads who aren't too cool to go to the school and have lunch with their daughters, or to have uncomfortable but necessary conversations with their sons about how to treat women with respect in a society that generally doesn't defend them.

Coaching fills big shoes

For the kids who knew him as Coach Keion, he was more than just a mentor or role model. He was a lifeline to some, a surrogate father for others, a big brother to many, and a lifelong friend and counselor to all, because when Keion Carpenter said that he had your back, he didn't just mean it in the figurative sense, you really were stuck with him for life. And for the rest of my life, I'll be forever grateful to have been so connected to someone that I started off respecting as a role model, then came to know as a friend, and eventually came to love as a brother.

Now that he is gone, he is to be remembered forever as exactly what he was, a hero.

No hour of the night was too late to wake Keion Carpenter with a call or a text. No situation was too insignificant or too seemingly insurmountable to warrant his attention. All he needed to be drawn into action was for someone to be in need, especially our youth. There were no lengths to which Keion was not prepared to go, when he knew one of our babies or one of their families needed help. He would literally give someone the shirt off his back, food off his plate and money out of his pocket without hesitation, if he believed it would bring the least bit of hope to someone who felt they could not find another way. He was truly doing God's work here on Earth.

Contagious satisfaction

Through my work with Keion, I came to know and fall in love with the satisfaction and fulfillment that comes from making real efforts to transform people's lives in a tangible way. I began to draw strength from the personal connections forged through the relationships I was able to build with people while in the middle of their struggle. I began to see grass-roots work and community building that Keion introduced me to as a personal responsibility rather than a necessity born of convenience and privilege. Over time, community service activities became such a big part of my life that I realized my grass-roots work had grown to be more emotionally satisfying than what I accomplished in my football career.

A year later, I made the decision to step away from the game to do my artwork and community activism

full time. Keion was one of the first people I talked to about it afterwards. We talked about what led to it, then we prayed, and since that moment, he supported my decision and newfound direction wholeheartedly, offering his support in any and every way possible. It took me until today to really begin to grasp just how much Keion himself factored into the transition that led to my decision. I now stand forever in his debt for opening my eyes and helping me to realize that it is what you do with your life for others and not what you do as a pawn on some field of play for people's entertainment that defines who you are as a man.

A giant taken too soon, a large shadow remains

It will be weeks, maybe even months before the real weight of Keion Carpenter's tragic death after an accident in December 2016 is felt in its full capacity. He had been playing with his son in Miami, Florida, and injured himself in a fatal fall. Keion was only 39, still in the prime of his life, and for me and for so many others, in his wake he left a deep, dark void.

How do you replace the value of a man with such an insatiable appetite and desire for serving others and changing lives with no thought of payment, reward, or personal recognition? You may not have known Keion, but if you live in the city of Baltimore, believe me or not, his life has probably affected you, directly or indirectly. Maybe you have met one of the thousands of young people to matriculate through the Commitment 4 Change Youth Camp, or maybe you know a few of the hundreds of kids who play on teams in one of the chapters of the Shutdown Academy.

You may live near one of the hundreds of families Keion helped to find affordable housing through Carpenter House, in a city known for its predatory landlord associations and unfair lending practices that leave many citizens living in substandard conditions. Or maybe your own child has been taught by one of the many young Black educators and teacher's aides he helped to find postings in Baltimore's struggling school system, who went on to provide a safety net to young people with learning disabilities, extreme cases of trauma, mental-health issues, or worse. Most

importantly, you could have crossed paths with one of the countless individuals whose lives were on a destructive track before receiving Keion Carpenter's mentorship.

A trail that will last

Whether many people know it or not, Keion's fingerprints are all over this city and will continue to be for years and even generations to come because of his tireless commitment and dedication to the people and city of Baltimore. Numerous young people who began their sports careers under his tutelage have now made their way to becoming Division One student-athletes, earning full athletic scholarships to get free educations at some of the nation's top academic institutions. That education and the opportunities it opens will change their lives forever, all because of Keion's dedication, loyalty, and influence. Great young achievers like Tavon Austin, William Crest, Raymond Jackson, Daelun Darrien, Charles Tapper, Trevor Williams, Lawrence Cager, Jaquan Davis, and Adrian Amos are now a part of his legacy. All of them are Baltimore legends in their own right, but their success also is a testament to how priceless Keion's contributions were.

In a world where most of our youth equate success with growing up, getting rich, and getting out, Keion represented the reality of what success really should look like: Growing up, getting paid, and bringing those much-needed resources and connections back to their communities and the people who so desperately need them.

His legacy long to be valued

Keion was, and will remain one of the most incredible and irreplaceable human beings I have ever met. He spent his life in the service of others, and it stands as high praise to say that as great an athlete as he was, his accomplishments on the field pale in comparison to his off-the-field achievements as a man, a father, a son, friend, and human being. To honor his legacy is to honor the best parts of ourselves and our city, because he represented us. He was a voice for the voiceless, an advocate for the oppressed, brutalized, and disenfranchised, and a face for those that are often made to feel invisible. He would post daily motivations every day on his social media pages to encourage his followers to Be More.

Knowing him has changed my life in ways that I still have not yet begun to understand or comprehend. I am still so thankful for the contributions that he made in my life while he was here. I look back on his time here and I cannot help but think of all of the success stories to which he has contributed.

The void left behind

I will miss Keion in so many different ways. I will miss our late-night counseling sessions just talking about life, fatherhood, relationships, politics, etc. I will miss his laugh and his uniquely disarming personality. I will miss his fearless passion for the youth of the city of Baltimore. More than anything, I will just miss and be forever grateful for his friendship.

And like many others, I will be thankful for his commitment to the people of Baltimore City.

We should all strive to further Keion's Legacy by making sure that the organizations and resources to which he dedicated his life are maintained and sustained in his absence. And by making sure that the hundreds of young people still being serviced by these organizations can continue to reap their benefits. We should all honor his memory by making sure the goals that he was fighting for are achieved.

We all should take it upon ourselves to fill the void and be the next Keion Carpenter!

Rest in Power to a true Baltimore Legend.

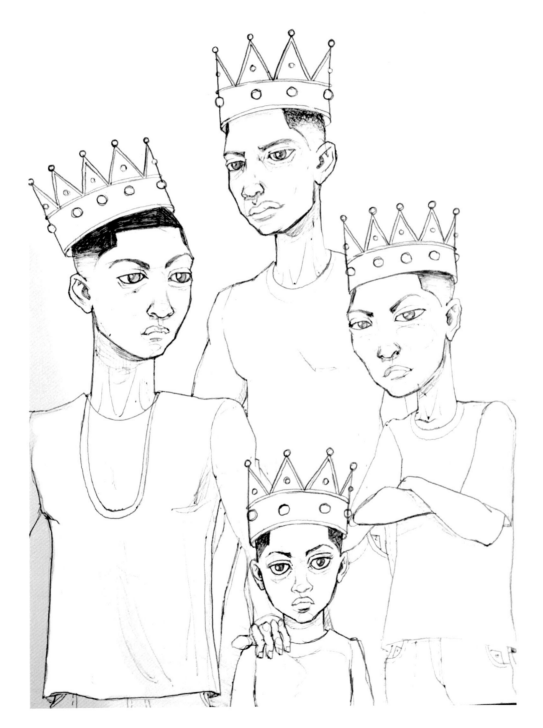

To Black Boys

You.

Are all…

KINGS.

Anyone.

Tell you otherwise…

Is a WHORE

Don't stress it.

Rock your crown

Its yours young G'.

Only you…

Know how to finesse it.

My Blackness

It's not my job
To make you comfortable
With my Blackness!
I wear my Blackness with pride,
As if it were a golden crown.
You can see the Blackness
In the strength within my eyes.
You can see the Blackness
 In the strong step's stride
You can hear the Blackness
In the deep bass of my voice.
You can see the blackness
In my wide round nose.
You can see the Blackness
In my full brown lips
Do you so fear...
 The Black steel in my bones?
And the power in the locks of my hair?
Do you fear the Gods flowing through my veins?
And the African drums beating tribal rhythms in my chest?

It's not my job
To make you comfortable
With my Blackness!
I know what you fear…

The stories of the Kings and Queens I descended from,
So you stole my history and left me with your name.
 Tried to erase my history
 Tried to kill my culture in vain
 Tried to leave me blind, deaf and dumb in a den of wolves

But still, My Legacy Remains!
It's not my job
To make you comfortable
With my Blackness!

Tho, you tried
Everything you could
To break my spirit and my will,
But my Blackness
Is the one thing that
Nothing you do could ever break or ever kill!

Does my Blackness so offend you?
Are you threatened?
By the Blackness
In the soil of my black seeds?
Do the fruits that my loins will bear
Make you drown in envy and greed?
Does my pride
In my blackness
Annoy you?
Does my confidence
Threaten your privilege?
Does my self-love
Enrage you?
Does it keep you awake at night?
To know that I'm fearless?
Does me being educated
So insult your intelligence?

Believe it or not, I am cloaked in Black excellence
 A descendant of Black Royalty and Elegance.
 Educated in Black history and eloquence.
 & Rooted in the strength of my melanin.

To Little Black Girls
(young feminists in the making)

Little Black Girls…
It's not
My place
As a man
To tell you…
What you should be
What you should dream of
What you should want to see
What you should work to be
Little Black girls…
It's not
My place
As a man
To tell you…
How beautiful you are
How intelligent you are
How great you can be
It's not my place
Because
You were born beautiful
Long before you received my confirmation
You were divinely created to be intelligent
You don't need my substantiation
The seeds of your greatness were planted

Before I could ever begin to see them bloom
Don't let the world force you
to become a woman too soon.
Little Black girls…
Never let
Society
Make you feel like you have to be glamorous
Never let
Any man that you meet
Make you feel like you are inadequate
Never let
The Black skin that you wear
Ever make you to feel you are inferior
Never let
The curls and knots in your hair
Ever make you believe it's not magical
To all Little Black Girls everywhere…
Wear your blackness and your culture with pride
Live your lives on terms that are completely your own
Fulfill every dream that you have inside
It's not
My job
As a man
To define you…
To control you…
Or to marginalize what you say
My job is
To protect you…
Support you…
And get the hell out of your way!

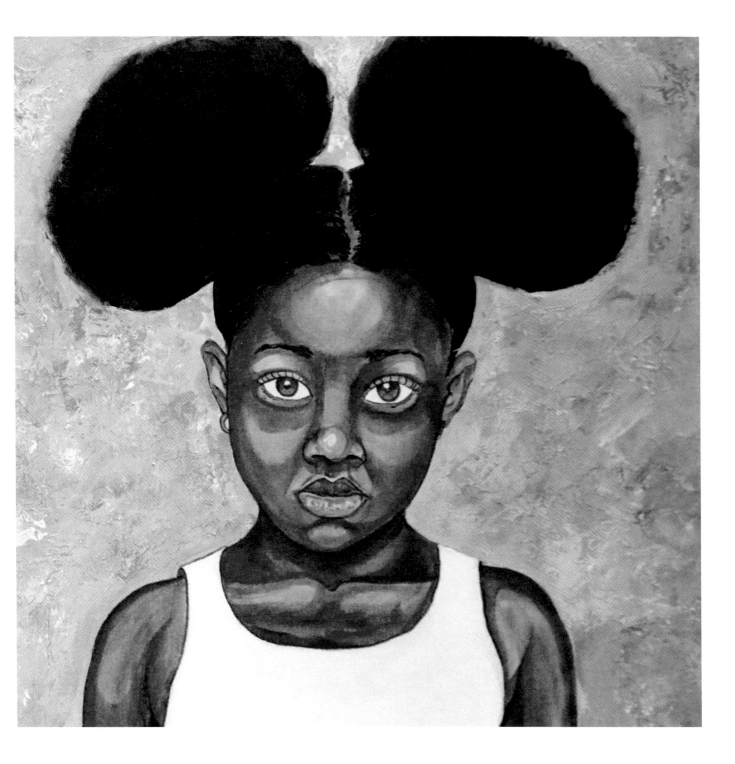

To My Son

It wasn't until you came
That I remembered…
U made me remember
What it felt like to fall asleep in my father's arms.
I remember them being massive as oak trees
But gentle as a blanket of feathers to me.
U made me remember
Pretending to be fast asleep…
So he would run his hands across my hair
While I listened to my Dad's heartbeat.
I remember…
There never being a safer place for me
To lay my head to rest,
Than against the gentle warmth of love
Felt while lying across my father's chest.
U made me remember…
What it felt like to be carried upstairs at night to my room,
Being made to feel secure and when you would tuck me in my bed
And tell me I was loved.
I remember staying awake too late
To spend my nights watching shows I couldn't understand or relate
Just to spend extra moments laughing with my Dad.
You make me remember a treasured time,
When a father's love was free
And that's the only type of love
That will exist for my son and me.

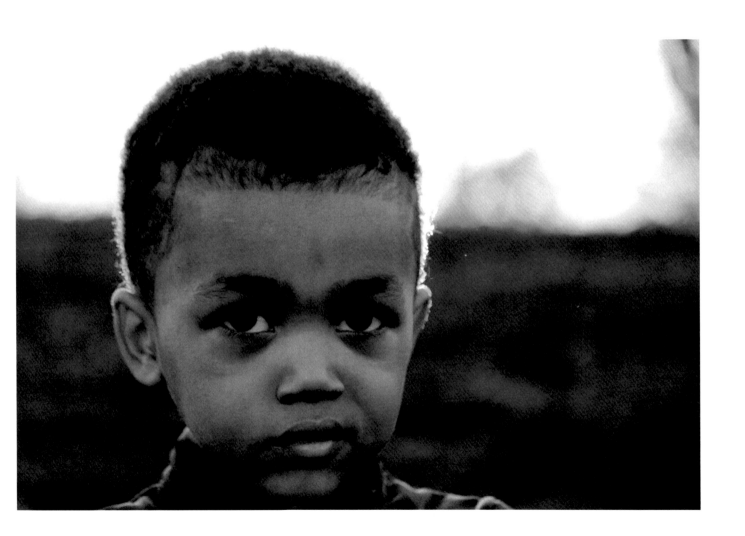

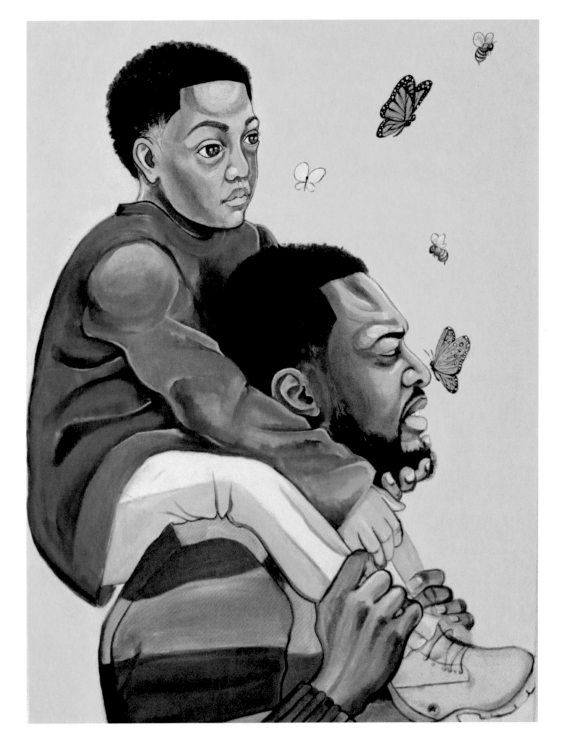

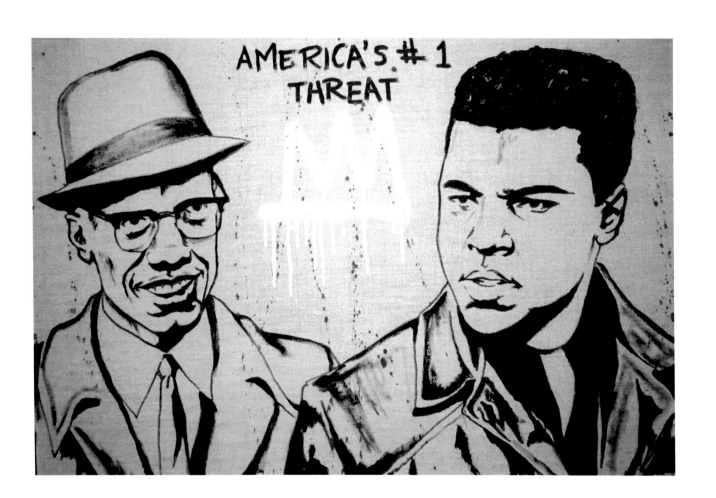

Dear Uncle Sam,

Just a FYI…
 The Scared Niggas'
 You used to run up-outta-town…
Are All Dead Now.
The rest of us
Are much too tired…
Tired of being afraid.
 Tired of being polite.
 Tired of being ignored.
 Tired of Being Gunned Down.
Were tired of being denied…
Of equal rights,
Of proper education,
Of decent housing,
Of our Humanity.
When you killed Mike Brown,
We raised our hands up…
 We cried out don't shoot!
 You were unresponsive.
When you killed Eric Garner…
We shed tears of grief.
 We cried out We Can't Breathe!
 You said nothing.
When you killed Tamir Rice…
We raised our fists.
 We warned you. We couldn't take this shit no more!
 Still, our warnings fell on deaf ears.
 You refused to hear the wounded Lion's
Roar!
So, when you killed Freddie Gray…

Your streets,
 Your property,
 Your city,

They all had to burn.

For that's the only language
That you seem to understand.
We've asked you nicely for years,
Now its time for our demands.
When you were fed up…
With uppity Negroes,
You sent hooded Lynchmen
 To burn our homes.
When you were fed up…
With Black Wallstreet's excellence,
 You firebombed our businesses and free school zones
When you were fed up…
 With our church's messages
 You decided to have them burned
Now that we're done begging…
A reply…
 In your own language
 Had to be returned…

Can you hear us now?

Sincerely,
-Baltimoreans

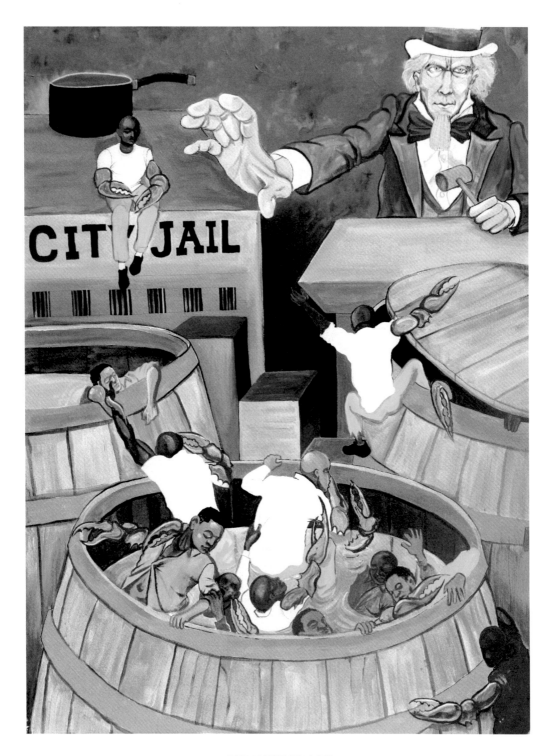

To White

Dear White America,

Obviously, this book's content, its narratives and the subject matter within were not tailored to fit you. As a Black man living in America, my language, my art, my experiences, opinions and accounts of my history are directed towards Black America — the people with whom I share my culture. As the people who have played the role of " The Oppressed" for the duration of this nation's existence, I feel it is important to address the issues that face my people in the Black community first, before I can even think about addressing white America as a whole.

The early Irish Catholics in this country took care of their own first, unapologetically and without worry about any backlash they would face because of it. So did the early Jewish and Italian communities. In my opinion, the Black community can do no less.

As the eloquent civil-rights activist Stokely Carmichael once stated, "Group solidarity must first be achieved before our people can operate effectively from a bargaining position of strength and community."

Read on, if you can
Let us first acknowledge that most "conservatives" probably closed this book after reading the first essay. So, just the fact that you're still reading this book, to me at least, shows a willingness to at least try and understand some of the issues facing Black America and to think about ways of addressing these issues. Then, perhaps we can work toward a place where we can genuinely throw off all barriers of separation and fight together to build a better nation, of which we can all have a truly equal and independent share.

While this book may not have been directed toward your demographic, it was definitely written with you in mind.

Unlike some of my counterparts, I do believe there is a critical need for a united front between all races and cultures in our fight against racial and social injustice, income inequality, monopolized public education, and in general with community activism and organizing. This includes a need for the participation of White America — especially poor White America. As time goes on and this country's policies continue to evolve, many of the challenges facing Blacks and Latin Americans can also be shown to have powerful resonance in poor white communities. Many of those issues and challenges now are just as much about economic inequality as they are about racial and cultural differences.

Black unity must come first
There is a need for us to all culturally unite in our attacking of these issues as a whole, but that cannot happen as long as the Black community cannot unite as a community and take advantage of our many unused resources while addressing our own complicity in our current condition in this country. Once we do that, we can start to build resources and infrastructure for ourselves as a community, in order for us to truly move and negotiate from a real position of power when addressing the needs of our community.

We must set out to achieve our goals while still maintaining our own cultural integrity, which includes our personal pride in ourselves and in our community. So we have to be a drivers of the changes we want to see take place, so we can be involved with every step in the process of identifying and addressing the issues facing our communities. We need seats on our own school boards, and our own community leaders need to be the heads of all neighborhood initiatives, organizations and committees. We do not need outsiders in paternal, leadership-role positions, arbitrarily making all of our decisions for us, and determining our direction moving forward. That is our responsibility, not yours.

Partnerships must have value
Too many people want to have coalitions between the Black community and organizations that have no interest

America

in improving our community. They want partnerships with unjust and immoral organizations whose interests conflict with those of the Black Community. So many ostensibly well-meaning whites want us to negotiate on the illusion of good faith and integrity when we have been shown, time and time again, that there is no interest on the part of these Big Business institutions in seeing the state of the Black Community change for the better. Your heart may indeed be in a good place, but the reality is that unless you are living in our communities with us and sharing in our struggles, to us you are an outsider — and well-intentioned outsiders who don't understand our most pressing issues often end up doing more harm than good.

Strong support begins where you are

If you want to help Black people, help us in White America. Speak up and speak out about the racism that is surely taking place in your own communities, where it is allowed to prevail and fester. Understand that the realities Black people face in this country will never be real for you. You will never know or understand our struggle, and you will never truly feel our pain. If you want to help, acknowledge your own privilege, connect Black organizations with the people, resources, and opportunities that can help with our objectives. Help us to organize and lobby for change on issues of political and public policy that

most affect us. If you really want to help, contribute your support, provide us some resources and get the hell out of the way.

We can take it from there.

I do not say any of this to be harsh, but I have to be blunt and clear in my points. We do not need any more white "Messiahs" to come lead us out of the wilderness to whatever "Promised Land" it is that you see for us. We know exactly what direction we need to be headed toward. We neither need nor want your influence or your guidance to get there.

We don't need your approval to get started, just your support.

Once we have properly addressed some of these issues in our own neighborhoods, and have been able to self-define our own set of goals and platforms for change, then we can begin to coalesce with the organizations that make sense to us. And it starts with uniting the poorest classes together in joint efforts for progressive economic change and political reform.

We welcome coalitions of strength

There does indeed need to be a coalition of poor Blacks and poor whites. That is the only real coalition that makes sense to me, especially with the huge crisis of income inequality facing our country as a whole and affecting the poorest of both the Black and white communities.

That is one of the only campaigns in which our communities can equally share leadership roles. There are others, such as the fight to upgrade inadequate schools and the struggle to end our confinement in poor housing conditions. Still, it is clear that such a coalition can only be effective if we are both operating from equal positions of power, and that requires us both, individually getting our own houses in order first.

With all that being said, I will end with this. I understand that for those of you who cannot identify with the realities of issues like race and inequality, all of the attention being paid to the BlackLivesMatter Movement seems over the top. I'm writing this today to tell you, it is not over the top at all. For people who have been in the beneficiary position of unequal and unfair legislation and practice since this country's birth, the issue of equality can sound and feel quite oppressive. Some of you believe that true equality for us all in some way means your rights are to be taken away. That is just your sense of privilege messing with you. Be easy. Blacks have no intention of treating any other race as we have been treated. We just want full recognition and respect for our humanity. Like everyone else, we want and the ability to define and pursue our own success and the direction of our communities.

So, with that being said, are you still down to help us out or not?

African Family

All my unknown family

My brothers and sisters

My Kings and Queens

My Gods and Goddesses

All my Black Family Everywhere…

I may not know you

But I love you

I love you like God loves you…

I may not know your name

But I know your pain

I may not know your life story

But in many ways

I'm a reflection of your same struggle…

I may not know you

But I love you

We are all divinely connected

I wear your skin

I wear your heritage

I wear your expectations

We face the same obstacles

We overcome the same adversities

We beat the same statistics

I may not know you

But we are family

So I love you as you are

I love the greatness stored within you

I love you for your flaws

I don't know you

But I love you

So if you are in need…
I will help you
If you are sick…
I will look after you
If you're in trouble…
I will go to war with you
Because we wear the same crown…
My Kings and Queens
And that's just what families do

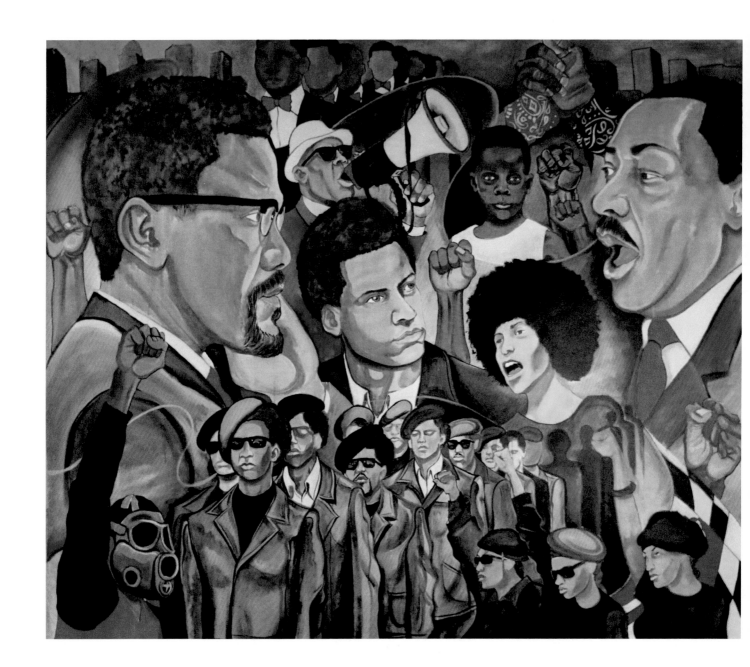

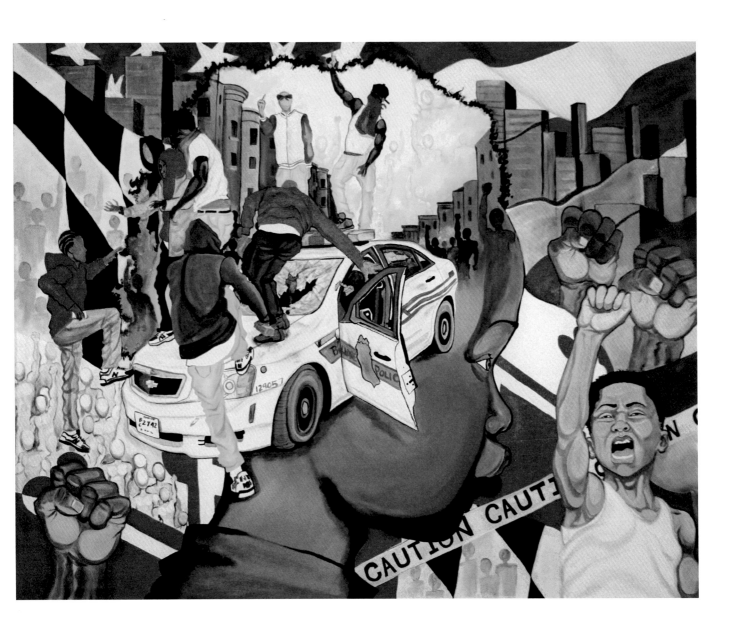

The Way

What is the way forward in America?
We sit at an interesting precipice at this point in human history. We have reached a point where, for years, America has fought a battle against declared and undeclared enemies both foreign and domestic. We waged a Revolutionary War against England, a Civil War that split the country into two separate territories over the issue of Black enslavement, we waged wars of empire against Mexico and Spain, and engaged in two World Wars in the 20th Century. We've waged wars in Africa, fought to dislodge dictators in the Middle East, and fought still more wars in Asia.

At this point, we've had a Black President sitting in the White House for two complete terms, and for many years we've had Black representatives in Congress, Black senators, governors, mayors, and City Council members. Despite this progress, Black and Brown citizens still are enduring the highest-ever incarceration rates in American history. The wealth gap between the rich and the poor continues to grow, and the social, racial, and political unrest in this country is growing toward a breaking point, made all the more clear by mass media's sensationalizing contribution to the social discord, fueling the flames of racial tensions wherever possible.

Bizarre behavior, a bizarre election, bizarre results

Even in our most recent U.S. presidential election, the discard was exacerbated. The two most popular candidates to survive the presidential primaries were a liberal, democratic socialist preaching political revolution, and a conservative, red-headed, bigoted lunatic, with absolutely no concept of social, political or diplomatic reality. The winner is a man who proposes to build a Great Wall between the U.S. and Mexico and to deport all illegal immigrants, people who just so happen to

make up a huge part of our low-wage work force, especially in the South. Issues like climate change, police brutality, Income inequality, a separate-and-unequal education system, and the rise of a massive prison-industrial complex are once again at the forefront of our society as the main issues facing our country.

The rich continue to get richer, the middle class is being erased, and the poor don't even exist anymore in the minds of policy-makers. This generation has watched the middle class evaporate for years, right in front of our eyes, until we reach this point where the majority of Americans are either impoverished and in debt or carefree and filthy rich.

The main mass of people stand watching

One thing has been made clear: There is an obvious and drastic divide between the common people of America and a corrupt, fraudulent, capitalist system of government. America does not want to have to face issues of race, income and social inequality honestly and squarely. It is so much easier to point to the fact that there was a Black President elected as the single accomplishment that eradicated all issues of race and inequality and ushered in this new mythical post-racial era that conservatives are always talking about.

If anything, Barack Obama's presidency all but dispelled this myth entirely. Never in the history of this country has there been a president who faced as much opposition on every major piece of legislation he proposed. Instead of truly embracing a new era of diplomacy and equality in our nation's democracy, one in which we are working towards improving the lives of the Black and the poor, America as a

Forward

racist capitalist-driven institution went into survival/preservation-mode. In the aftermath of President Obama's election, the so-called Tea Party was born, which in my opinion is as much a terrorist organization as it is a political party.

All of a sudden, conservatives are raising deafening cries to "Make America Great Again," giving rise to the political phenomenon known as Donald Trump.

A seamy status revealed

For most Black Americans, Obama's presidency was the first time we were exposed to the reality of how powerless our President actually was to personally see basic funds, resources and institutions allocated to the communities and demographics that most need them. We learned first-hand how our leaders are only as powerful and influential as the kingmakers allow them to be. We learned first-hand how Big Business really runs our country.

Donald Trump's election serves as evidence of that. As a political neophyte, one might think that he would try to surround himself with people who understand the political process, diplomacy, and public policy. Instead he has chosen a host of Big-Business tycoons as his cabinet appointees. In the days since he has taken office, Trump has already attempted to pass a health-care plan that would affect the poor, Black and Brown citizens disproportionately, promulgated travel bans on Muslims (twice), and falsely accused his predecessor of illegally wiretapping him. Trump also has launched an all-out assault on press freedoms, attempting to control the messages of media and public discourse through online tweets, lies, and countless bully tactics that are unprecedented for a man who holds office as the leader of the Free World.

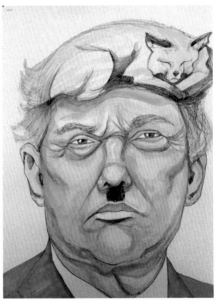

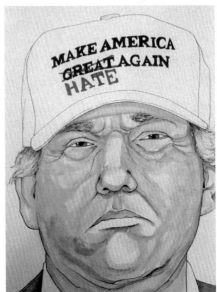

Left in the political lurch

In the years following our well-documented struggle to acquire the right to vote and have a say of our own in the political process, America's Blacks now find ourselves as a whole extremely unaware and uneducated in the area of political policies that affect us as Americans. Many Black and Brown American citizens see our political voices as useless resources of necessity, rather than the cornerstone in our platform of building toward true racial and social equality.

We would rather march, tweet, blog and complain, than to actually organize to take full advantage of our vote, and to begin re-tooling and completely revamping the political process and its racist policies towards poor Black people.

That is the big problem. Marching is cool, but it alone will not get anything accomplished in 2017. Tweeting, re-tweeting, sharing and blogging stories on social media make great tools for the sharing of information, but at the end of the day, it's no different than standing on a soap box in the middle of a crowded sidewalk at lunchtime and screaming your complaints out to whoever will listen. You can spread lots of information, but it will not change a thing.

We've wasted too much time over the years politely marching, laughing, raising signs, holding hands, and chanting "We Shall Overcome" while we pose for cameras and bathe in our own self-admonishment, thinking were actually getting something done while the little progress that has been made over the years literally erodes beneath our feet.

White America got fooled

Modest demands and hypocritical smiles over the years have misled White America to believing that, in spite of these dynamic issues, all is good and we are content with our position as second-class citizens. That is simply not the case. We don't have time to play nice anymore, not when our communities are being erased and our children's lives are at stake, the middle class is disappearing, and the poorest among us are subjected to sub-human living conditions, police brutality, and inadequate educational system. We cannot afford to speak lightly and tread softly while Black communities across the country are in a violent state of crisis.

It is better for us as a people to be forceful, direct, and truthful when addressing the issues facing our neighborhoods. Only when we do so, can we deal from a position of clarity instead of misunderstanding. The limits of tyranny and oppression are directly determined by the endurance of the people being oppressed. We have endured for long enough expecting the "good will" of this nation to be bestowed upon us. The time has come to stop waiting and take action — with deeds, not words, both in legislatures and in the streets of our communities.

Monochrome vision must end

Our much-needed changes in the making of laws will not be served by simply electing Black politicians to office. We cannot just use color as our only determining factor in finding representatives to advocate politically on our behalf. We have to be able to define for ourselves on a community-by-community basis exactly what our biggest issues and grievances are and how they can be best addressed, politically, and support only the politicians willing to cooperate with that agenda. We cannot continue to have Black political leadership that can be bought, that will pacify their voices on the issues that demand change, and rationalize it as progress. Those politicians are not serving the best interest of our community. They are simply the new token rewards that capitalism allows us to have to provide the illusion of potential change always being on the horizon.

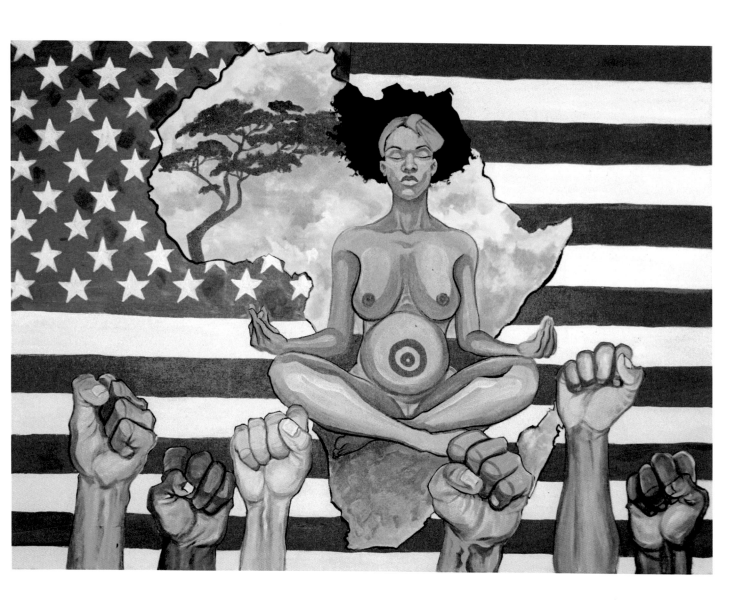

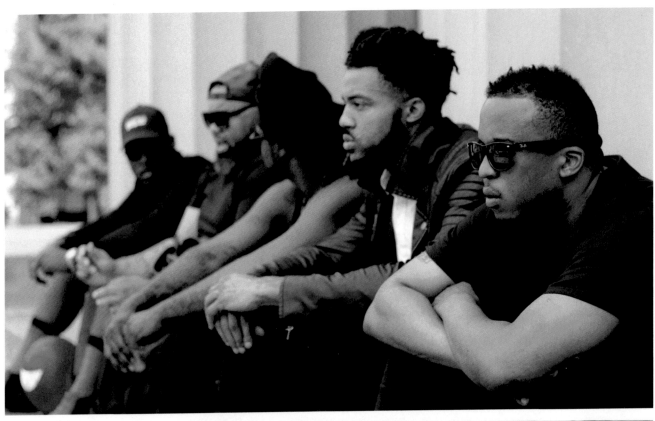
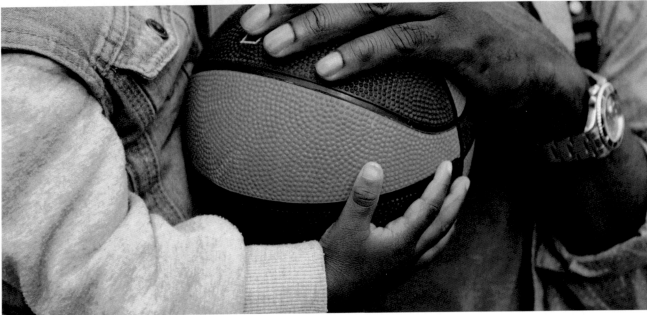

The march forward will be hard

The way forward for us as a people will not be an easy one. When you forcefully challenge any system directly and clearly, you can't expect that same system to reward you for your boldness and allow you to remain comfortable. Any of our would-be "leaders" who would seek to challenge such an establishment cannot do so effectively and maintain any real security in that system. Some people will lose jobs, some of us will lose position in social standing, and they will be alienated by some and condemned by others. But with a united front, it is possible to do this and maintain a singular direction. If we establish a true network of resources, jobs and economic opportunity, we could offer them to any of our qualified brothers and sisters who have been fired or isolated for speaking out or for taking action on behalf of the Black Community.

It is clear, however, that we have to be able to build up our community to a point where we can provide for and sustain ourselves in a way that we are not dependent on the same system that we are trying to reform to provide security for us. We need to remove all crutches of dependency to the establishment in order to stand on our own and control our environment. Only once we have developed a true sense of community for ourselves, can we then begin to effectively deal with the problem of race.

Time to give our youth a voice

Up until this point, none of our politicians or organizations has been able to give voice to, and properly articulate the growing militancy of our Black youth in urban areas around our nation over the past 10 years. I saw it first-hand in the youth here in Baltimore as these very public, state-sanctioned murders were covered by the media. When Travon Martin was gunned down in cold blood for wearing a hoodie in the wrong neighborhood, young Blacks were shocked. When Mike Brown was shot down in the street with his hands up, they were mad. Each time they heard Eric Garner scream out "I can't breathe," they got angry. When Tamir Rice lost his life, Black youth got angrier; when nothing happened they were steaming. When Freddie Gray got his spine severed, they were fed up. When he died, enough was enough.

The time for polite requests and niceties had officially come to an end. I am not condoning all the actions that took place in the uprising following that day, but I am acknowledging my belief that what happened in the streets of Baltimore and Fergusson is the only language that America seems to understand. Action rarely follows marches and protests; it follows riots and chaos, or a potential threat of the two.

The capital connection

In a system where property and capital are valued more than human lives, you have to threaten property and disrupt the flow of capital.

We cannot just march anymore. The conventional ways of diplomatic and peaceful demands for our unalienable rights and basic humanity for all human beings are over. They have done nothing but convince the "conservative" base that we still are willing to tolerate inhumane treatment from a self-proclaimed nation of freedom, liberty and justice for all.

What about us? It took us a while, but Black people in this country have finally figured out that as much as we would like to think that it is, Justice ain't free — not for us, at least. Now our youth have sent a clear message back to America. We are ready to fight for ours! And that fight is not always going to be a peaceful one.

Lashing out, we will be heard

When our youth feel neglected, forgotten, hopeless and worthless, they lash out in the only language that they know, the language America herself taught them — that of desperation. Rocks get thrown, things get broken, property gets damaged, things get burned, but you see them, now. What is it going to take for us to care before the rocks get thrown and stuff gets burned-up? At what point is the simple fact of them being human beings in need of basic resources in order to prosper enough for us to mobilize and take action on their behalf?

We do not owe America any more reassurances of complicity or promises of nonviolence and civility in our quest to get access to what the law itself declares is ours by birthright. That is not me being an advocate of violence; it's me being an advocate of humanity.

I am saying that we won't fight to save our present society -- not as long as that society continues to function at our expense. We are going to fight to create the type of society that allows us to live freely and prosperously. We are going to work toward the goals that we have defined for ourselves by any and all means necessary.

This fight is no longer about civil rights; it's about human rights. But as it relates to the human rights of Black people in this country, they have been neglected for too long.

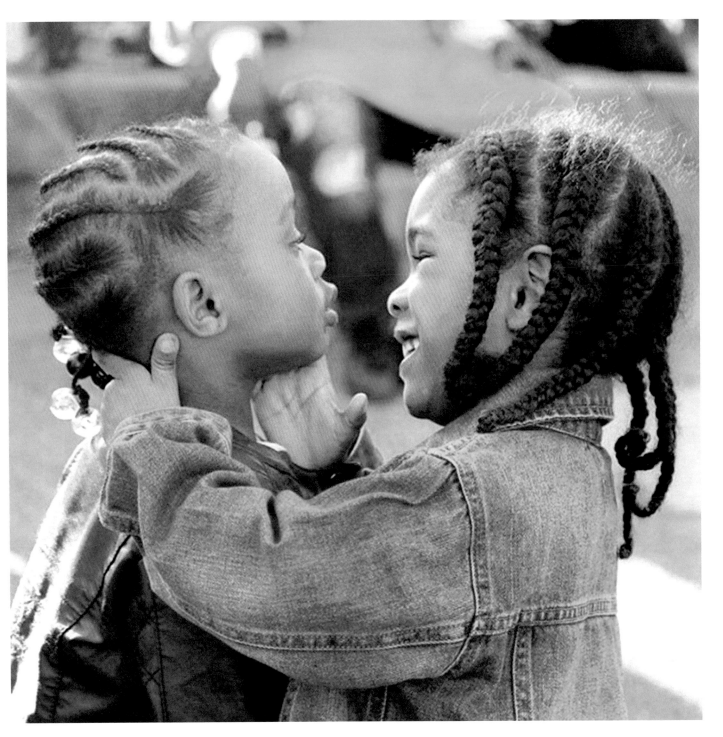

EPILOGUE

Baltimore has always been known for "the city that reads," so it's not surprising that New York Times Bestselling author D. Watkins, met Aaron Maybin at a book club. During this time, D's work "wasn't big, but it was starting to get a buzz," which he recalls it in 2014. At a later date, these two Baltimore artists met at "Play," a hookah bar in the city, where they exchanged numbers and social media handles. D and Aaron were both intrigued by each others work, and quickly became fans of one another. The third time they met was at the "A Great Day in Baltimore" photo shoot that was organized by Kyle Pompey (a Baltimore photographer) who wanted to capture some of the city's sharpest talents in one picture.

One thing that D admires about Aaron is that "he's a creative person who starts early and goes all day long." D claims that "many people don't have the stamina to wait, or put energy into any one thing all day." D witnessed Aaron's over the first couple months of their friendship. "When I first met you, you were on one level, then a few months later you were on a much higher plateau artistically and intellectually."

D. Watkins—No one will grow as an artist at the speed of Aaron if they're not working as hard and diligently as him.

Aaron and D both shared laughs and remembered their first time working together which was during the completion of D. Watkins first book, The Beast Side which is a collection of essay about poor race relations in Baltimore and and throughout the rest of the country. Aaron painted an image of D, which D wanted to put as the back cover.

I sat beside these two artist, I was stuffing my face with corner store honey roasted peanuts that probably had loads of gluten and GMO's, and some cheap red wine that I was drinking out of a water bottle. Their convo then transitioned to Colin Kaepernick and his protesting of the National Anthem to bring awareness to police brutality. D believes that Aaron shows his support by painting images of the American flag in a lot of his work and showing how phony the symbolism is. "This flag is supposed to represent freedom and equality to all, and it doesn't," D responds after Aaron asks him his thoughts about

By Kondwani Fidel

Kaepernick and his protest. Aaron paints these images of the flags adjacent to oppressed people who the flag doesn't represent. Aaron then shares with D, the reason he has proximity to the people and patriotism because he is first and foremost a black man in a racist country, but he also played in the NFL and he grew up with a father who was a fire fighter. Aaron vividly remembers attending memorials of his father's coworkers who died in the line of duty.

Aaron: "What are your thoughts on activism?"

D: "I don't believe in people who say they wanna help but don't know how. When I visit colleges, students ask me all the time, 'how do I help?' You're a thinker, a planner, and you made it to an ivy league school. Helping people is not complex. How much people psyche themselves out about how hard it is to help out and becoming effective is the complex part."

Aaron then asked D, "What first got us connected on art and building?," and D replied, "I think you appreciate genius dawg. Your book will create conversation and spark interest. You have a perspective of a person who comes from Baltimore, but who has also traveled the world. We are the first generation of artists and writers who are laying it down how it's never been laid down. When it all boils down, the people will wanna know, who were the Baltimore artist who really wanted Baltimore city kids reading their stuff?" I then saw the passion and fire burning in D's eyes as he continued to go on about taking over schools and curriculums in Baltimore. "My work is being taught in schools because I fought for it. No-one gave me nothing," D says.

Aaron: "We know that there's a renaissance going on in Baltimore and when it's all said and done, we'll be in it. We work closely to the youth. How do you think those seeds will blossom?

D: "The work that we are collectively doing is inspiring a generation of future creatives. There will be many missed opportunities with our

peers because many of them aren't in control of themselves, their feelings, their own realities, or their business. They're so used to not getting looks and opportunities, so when they get em, they don't know what to do with em. We are diamonds in the rough. The real artist never die. Watch, some of these people who are identifying as being a part of the Baltimore renaissance won't even be doing art in 5 years.

Aaron: "I've bee an artist my whole life. It didn't become cool to be an artist until about 10 years ago. How do you interpret the real artist from the fake?"

D: "All we have to focus on is the greater good of the people. There were fake artist before us and there will be fake artist after us."

Aaron: "You're a writer, an interviewer, you do film, and you're a professor. What is the hardest part about working in multiple fields of artistry?"

D: "The most difficult part is giving the fair amount of energy to each craft. You want your interview skills to be as good as your writing skills and your editing skills. But there are only 24 hours in a day and when you have different forms of artistry you are sacrificing something."

Aaron: "How do you think that we can as artist get back to putting out vast amount of artwork that speaks for the hood and people who aren't avid readers, and the people who can't afford to subscribe to pop culture. How can we make that the norm?"

D: I feel like a lot of us are doing it. There are two things happening: One, the people who are the best at framing those stories are getting young people who don't identify as artist excited about art. These stories are also making young people value their stories and seeing the beauty in them. don't recognize value in their own stories, until someone shows them the beauty in it. Two, you have people like myself who choose to go through the school system to get my stuff out there because every child has to go to school at some point in their lives. Therefore, my work will be accessible to students who come from and live in my community.

D and Aaron then went back and forth discussing how black artists can be the ultimate definition of the American Dream, while having undeniable talent, however, because of their skin completion and their lived experiences, these same artists will not get recognized as being great. There are many brilliant black artists out here but people will never give them a listen or an opportunity to further their career because of where they grew up. Outsiders might not see this brilliance because they don't think enough of the culture that these these black artists subscribe to, however, many "critics," will still have an opinion. Giving opinions about artist that you've never listened to or studied is dangerous," says D. D recalls when his essay "Too Poor For Pop Culture" went viral. People loved the piece but looked down on him. People were enchanted with the essay, its popularity, and D's writing style. However, they were disenchanted by the writer, and the people in the story who come from that forgotten corner of black America.

<center>***</center>

Aaron: "What are your thoughts on social justice artists?"

D: "Rap music exposed me to leaders like Malcolm X and organizations like The Black Panthers, not school. There has always been artist debunking fear, white supremacy, and doing the heavy lifting. "If you are making art with the sole purpose to make change but you don't really wanna do that, but you're trying to do it just because, then I just feel like it's not where your heart is. The people always know when you're being phony. Especially the kids, they know who got love for em and who don't.

"Aaron Maybin's book is necessary, it's beautiful, and well put together," D relays. He is happy to know him as a person and a creative.

"I can't wait to see how people will perceive the book. I can't wait to see how you lay it down for the next generation of people who want to be artist." — D. Watkins.

Kondwani Fidel is the author of Raw Wounds and an MFA candidate at the University of Baltimore concentrating on creative writing and publishing arts. He is from and currently lives in Baltimore.

Thank

Throughout the entire process of me writing this book, my biggest obstacle has to be the thank you section. No matter how many times I go through them in my head, I always feel like I'm leaving people out.

Thank you first and for most to my family. To my children: Tacori, Arian, Aria, and Aliya, thank you for your love and inspiration. Thank you for teaching me how to love someone more than myself. To my father, a thousand lifetimes wouldn't be long enough to thank you for your love, your sacrifice, the life lessons that you have instilled in me can't ever be replaced. To my mother, life has not been the same since this world lost you. But I thank you for giving me life and for your love and your commitment to setting me on the right path. Thank you to the mother that God Gave me. Nobody else in this world sacrificed more to make me the man that I am today. Thank you for always loving me as your son and guiding me through life's struggles. To my siblings: Connie, Luke, and Thillah, thank you for being my biggest support system and the inspiration to drive my passion to succeed.

To Taliah, thank you for your friendship and the blessing of my first born child. Thank you for the love, commitment, dedication and compassion that you have given to our daughter.

Yous

To Tiffani, my friend, my partner, my love. Thank you for the gift of our children. Thank you for your support and your loyalty. Thank you for being my crutches when I fall, and for being my strength when I am weak.

Thank u to my family. Quentin, Angel, George, Johnny, & big Aaron.

Thank you to my amazing graphic designer Nikiea Redmond, my editor Garland Thomas, D. Watkins, Chezia Cager, my mentor Larry Poncho Brown, Lisa Vitali, Dave and Lorrie Richards, Lavar Arrington, Sean Barnes, Marsha Jews, & Leslie King Hammond.

Thank you to my extended family Catalina Byrd, Lauren (semantics), Akil Patterson, Marvin, Nicole Chang, Sequenta Hill, Stokey Cannady, Emory Jones, Marcy, Michael Ragland, and the rest of the Artcxlt.

Thank you most of all to the readers...I wrote this book for you.

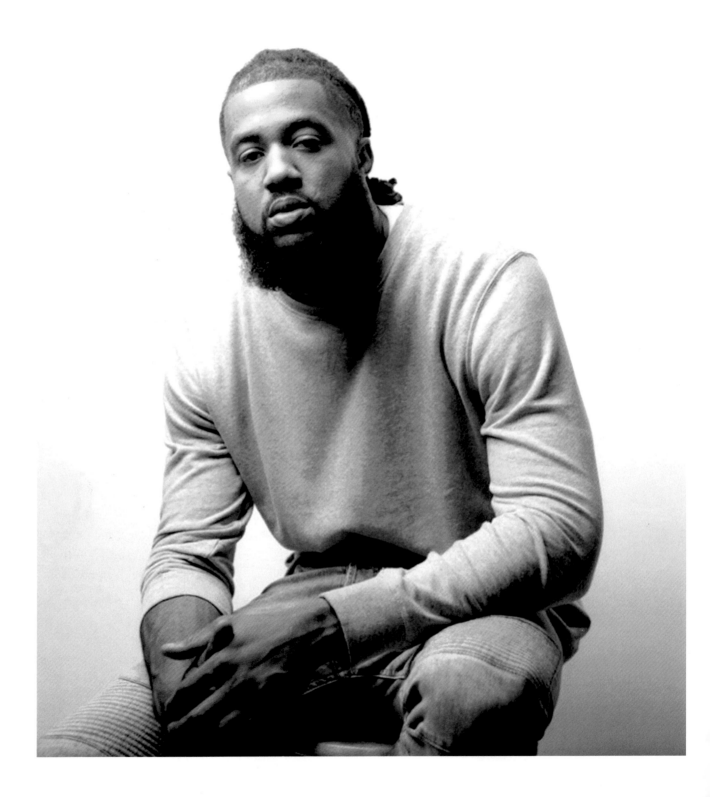

About the Artist

Aaron Maybin is a 29-year-old Art-Activist and former professional football player from Baltimore City, Maryland. Selected as the 11th overall pick in the 2009 NFL Draft by the Buffalo Bills as a former All-American defensive end at Penn State University. Aaron went on to play in the NFL for the New York Jets and the Cincinnati Bengals in a 5-year career before making the decision to walk away from football to pursue a career as a professional artist, activist, writer, educator and community organizer. His transition from full-time NFL superstar to full-time artist and philanthropist has been extensively covered by ESPN, CBS, Fox 45, and garnered an HBO documentary warmly received by critics. His art, photography, and writing deal with many socially relevant themes and issues, drawn from his own personal experiences as a pro athlete and growing up as a young Black man in America. Aaron uses his platform and gifts to advocate for racial and economic equality, arts education, and programing in underprivileged communities across the country. In 2009, Aaron established Project Mayhem to provide aid, both personal and economic, to help underprivileged and at risk youth excel beyond their current conditions. Through his work with Project Mayhem and as a teacher, Aaron has implemented art workshops and curriculums into several Schools in the Baltimore City area that have had budget cuts due to a lack of State Funding. Aaron is a Fox45 Martin Luther King Jr. Champion of Courage Award recipient for 2016, and a Baltimore Arts Realty Corporation (BARCO) executive board member. He continues to advocate for public policy to see Art programs restored in the schools and more economic opportunities to be provided for the underprivileged people of Baltimore.